GREGORY BATTCOCK was born in New York City in 1937. He holds degrees in art history from Michigan State University, Hunter College, and the Accademia di Belle Arti in Rome. He is a painter, and lectures in art history and criticism at Hunter and Queens Colleges. Critical articles by Mr. Battcock have appeared in *Art Education*, *Art and Literature*, and *Film Culture*.

THE NEW ART
A Critical Anthology

Edited by Gregory Battcock

New York
E. P. Dutton & Co., Inc.

A Dutton Paperback

ACKNOWLEDGMENTS

Grateful acknowledgment is made to the following for permission to quote from copyright material:

MARCEL DUCHAMP: "The Creative Act." Reprinted by permission of the author and The American Federation of Arts.

LEO STEINBERG: "Contemporary Art and the Plight of Its Public." Reprinted from *Harper's Magazine*, March, 1962, by permission of the author. Copyright, ©, 1962, by Harper's Magazine, Inc.

E. C. GOOSSEN: "The Big Canvas." Reprinted from *Art International*, Vol. 2, No. 8, November, 1958, by permission of the author.

SAM HUNTER: "New Directions in American Painting." Reprinted from the catalog of the exhibition "New Directions in American Painting" held at the Poses Institute of Fine Arts, Brandeis University, 1963, by permission of the author and the Poses Institute of Fine Arts.

ALAN SOLOMON: "The New Art." Reprinted from the catalog of "The Popular Image" exhibition held at the Washington Gallery of Modern Art, 1963, by permission of the author and the Washington Gallery of Modern Art.

LAWRENCE ALLOWAY: "Notes on Op Art." Printed by permission of the author.

HENRY GELDZAHLER: "The Art Audience and the Critic." Reprinted from *The Hudson Review*, Vol. XVIII, No. 1, Spring, 1965, by permission of the editor. Copyright, ©, 1965, by *The Hudson Review*, Inc.

CLEMENT GREENBERG: "Modernist Painting." Reprinted from *Art and Literature*, No. 4, Spring, 1965, by permission of the author.

DORE ASHTON: "In Praise of Illusion." Reprinted from *Arts and Architecture*, March, 1965, by permission of the author.

MAX KOZLOFF: "Critical Schizophrenia and the Intentionalist Method." Reprinted by permission of the author and The American Federation of Arts.

ALLEN LEEPA: "Anti-Art and Criticism." Printed by permission of the author.

Susan Sontag: "Non-Writing and the Art Scene." Reprinted from *Book Week*, July 25, 1965, by permission of the author.

Thomas B. Hess: "A Tale of Two Cities." Reprinted from *Location*, Vol. 1, No. 2, Summer, 1964, by permission of the author.

Nicolas Calas: "And Now the Sphinx." Printed by permission of the author.

Lucy R. Lippard: "New York Letter 1965: Reinhardt, Duchamp, Morris." Reprinted from *Art International*, Vol. 9, Nos. 3 and 4, 1965, by permission of the author.

Ad Reinhardt: "Writings." Reprinted from *Art News*, May, 1957, and February, 1964; from *Art International*, Vol. VI, No. 10, December, 1962; and from the catalog of the "Americans 1963" exhibition at The Museum of Modern Art; by permission of the author.

John Cage: "Jasper Johns: Stories and Ideas." Reprinted from the catalog of the Jasper Johns exhibition held at The Jewish Museum, New York, 1964, by permission of the author.

Leo Steinberg: "Paul Brach's Pictures." Reprinted from *Art International*, Vol. 8, No. 3, April, 1964, by permission of the author.

Samuel Adams Green: "Andy Warhol." Excerpts reprinted from the catalog of the Warhol retrospective exhibition held at the Institute of Contemporary Art, Philadelphia, 1965, by permission of the author.

Gregory Battcock: "Humanism and Reality—Thek and Warhol." Printed by permission of the author.

Kenneth King: "Toward a Trans-Literal and Trans-Technical Dance-Theater." Printed by permission of the author.

Martin Ries: "Endowments for the Great Society." Reprinted from *Art Voices*, Vol. 4, No. 3, Summer, 1965, by permission of the author.

To Tosh Carrillo

For her assistance in the preparation of this anthology I wish to thank Jill Siraisi. Gratitude is due Max Kozloff and John O. H. Stigall for timely suggestions and advice.

CONTENTS

10 Contents

ILLUSTRATIONS

INTRODUCTION

TODAY'S CRITIC is beginning to seem almost as essential to to the development—indeed, the identification—of art as the artist himself. The purpose of this volume is to bring together some of the best recent critical essays on the new art in the United States. Most of these articles date from after 1960, and were originally published in periodicals and museum catalogues. They are as new as the art they describe. But in keeping with the new role of the critic as interpreter, the pieces included in this anthology do more than simply describe, or even define, their subject; their authors are actively and consciously engaged in the preparation of a new aesthetic, so much so that it is on occasion difficult to disassociate their work from the art it purports to evaluate. This intimate relationship between contemporary art and contemporary criticism is illustrated in each of the articles that follows.

The modern critic is no longer content with simple description used as a basis for value judgments, or even with the more sophisticated processes of artistic definition. It is the artist who has forced him to shift his ground. Today, the idea dominates—the artist's interest has shifted from exclusively pictorial values to consideration of the extensions of the medium. In essence, this constitutes a new approach to the artist's age-old task of defining a relationship between art and life. But in his efforts to come to terms with reality, the artist of today

13

necessarily alienates most of his potential audience. The vast majority of the population cannot endure the challenge to conventional value structures and existing social psychology represented by the statements of contemporary artists. For art is not merely a question of understanding, but of acceptance and response. Since people have so much to lose by facing up to the challenge of art, they will not—cannot—do so. Insecurity, intolerance, and reaction are all incompatible with art appreciation. Art is humanism and reality, and, as such, cannot be seen accurately in terms of the past. At this point, responsible criticism becomes absolutely essential. The critic has, as it were, to paint the painting anew and make it more acceptable, less of the threat that it often is. It is scarcely an exaggeration to say that the art of our time simply could not exist without the efforts of the critic. It is, however, to be remembered that words are words and art is art; in presenting art, the critic cannot restate or reproduce it. All he can do is assume some of the concern for clarification abandoned by the artist in his effort to leave himself free to experiment as obscurely as he likes, unhampered by any need to compromise his integrity for the sake of public approval.

Objections to this state of affairs can logically be only of degree, not of kind, since an art of total clarity wouldn't be art, and would need no criticism at all (just as the soap opera in its context on television is not art and therefore needs neither aesthetic nor didactic interpretation). But the absence of positive criticism is hardly conceivable in a complex society such as our own, where, of necessity, many different levels of artistic appreciation and commitment exist side by side in different (and sometimes in the same) individuals. Modern art is a discipline, not a World's Fair; all three members of its essential triad—artist, critic, and viewer—obtain only such

rewards as they are prepared to work for or for which they have the love to spare.

The art of our time, in all its violence and obscurity, is produced in a society in a state of rapid flux that is often blurred in origin, content, and direction. The artist and, in consequence, his interpreter the critic are probably among the few people who can be relied upon for some sort of intuitive understanding of the contemporary situation. In a world that has altered almost out of recognition in less than a lifetime, most people unable and unwilling to cope with the present still respond to the inner dictates of an earlier age. The righteous deplore our changing morals, when in fact our morals are not changing nearly fast enough. And if our response to the present is inadequate and outdated, what of a future in which changes that have been experienced so far will probably be as nothing to those that will result from the continuing advance of twentieth-century technology, the population explosion, and the new awareness of the nonwhite peoples?

The specific innovations of the new criticism can best be seen by comparing it with the old. In the first place, since the main concerns of the modern critic are no longer those of his predecessors, his critical vocabulary, too, is different from theirs. Bernard Berenson, for example, wrote about proportion, composition, facial expression, color, and the nude, and his approach was primarily that of a historian with a concern for connoisseurship. Other critics and art historians in the earlier part of the twentieth century—among them T. E. Hulme, E. H. Gombrich, Clive Bell, Kenneth Clark, Leo Stein, and E. Gilson—concerned themselves with style, philosophy, and relationships between art and literature and between

art and the other arts. Contemporary critics show little interest in such relationships because they have already accepted the fact that the traditional distinctions between the various arts are gradually breaking down, and they recognize the need to begin to think in terms of new definitions of the nature and limitations of an art object. Previously, too, psychoanalytic explorations in art were a concern of twentieth-century aesthetics—the work of Daniel Schnieder, Ernst Kris, Otto Rank, and E. H. Gombrich springs to mind. Yet another object was the classification of artworks into the categories Primitivism, Expressionism, Romanticism, and so forth. Often these critical concepts were not specifically linked to particular works of art or artists, but only generally applied. Numerous examples of this type of critical thinking occur in Venturi's classic *History of Art Criticism.*

To turn from content to form, the monograph on a single artist, which is perhaps the major vehicle for the presentation of basic ideas in the field of aesthetics today, is itself a relatively new concept that can be said to date from the publication of Roger Fry's excellent work on Cézanne in 1927. Among contemporary critics the monograph is a highly useful form that combines a detailed survey of specific artworks with a philosophical or theoretical contribution to the new aesthetic. It is peculiar to the new criticism, insofar as it presents not only a direct confrontation with the new art in question but also a confrontation with its cultural, moral, and social logic.

Another characteristic aspect of the new criticism is revealed in the way its practitioners tend to review group or retrospective exhibitions almost solely in terms of the selectivity displayed by the person responsible for the show, while paying little or no attention to the merit of the individual artworks or artists included. This apparent

peculiarity is very much a part of the new way of looking at art: the position of the curator or director is regarded as equivalent to that of the artists whose work he selects, since he is the *creator* of the exhibition, if not of the individual works within it. The critic's own right to creativity comes through his relationship with the artist whom he alone fully understands, appreciates, and can interpret to others. The genesis of these ideas can be traced in the writings of Croce, Kandinsky, and elsewhere, but only now have they become a common basis for critical practice. Kandinsky, for example, wrote, "To understand is to elevate the onlooker to the artist's level."[1] J. P. Hodin, whose works have been widely read by contemporary criticis, early recognized the direction that criticism was taking when he wrote, ". . . a critic of sound judgment, knowledge and instinct can mean much for the artist,"[2] and he predicted the new role of the monograph in contemporary criticism when he remarked, "The direct contact between artist and critic also makes possible a critical confrontation of the intentions of the artist with the work in which he has realized them." In the same essay, Hodin also emphasizes the need for and inevitability of subjective criticism, and sets the tone for the new criticism with the comment, "Only living contact with the artist can establish unequivocally what he had in mind."[3]

The recent trends in critical practice take their place well within the mainstream of twentieth-century critical tradition. The writers contained in this anthology can indeed best be appreciated if read against a background of earlier work, such as the essays of Henri Focillon, Nik-

[1] Wassily Kandinsky, *On the Spiritual in Art* (New York, Museum of Non-Objective Painting, 1946), p. 13.

[2] J. P. Hodin, *The Dilemma of Being Modern* (New York, Farrar, Strauss, 1959), p. 221.

[3] *Ibid.*, p. 222.

olaus Pevsner, D. H. Kahnweiler, Lazlo Moholy-Nagy, and Richard Huelsenbeek. To the knowledge of the writer, no general survey of modern art criticism has yet been attempted. Wylie Sypher's *Art History: An Anthology of Modern Criticism* is concerned with the development of criticism from the late nineteenth century, and contains no examples of the modern approach.

The articles that follow were selected primarily to demonstrate current trends and to illustrate the high quality of the work in which they are embodied; moreover, the new criticism relies heavily on close and direct contact with the artists and art objects with which it is concerned, and constitutes excellent source material for a survey of the new art in all its various forms. The new art is not a single school with characteristics that can be pinpointed easily, but rather a broadly based movement manifesting itself in a wide range of styles that, however superficially dissimilar, are yet readily identifiable and consistent. Ortega y Gasset notes: "It is amazing how compact a unity every historical epoch presents throughout its various manifestations. One and the same inspiration, one and the same biological style are recognizable in the several branches of art."[4]

It is hoped that the publication of the present volume will encourage recognition of the educational value of the new criticism. In many colleges today, traditionally arranged art-history programs still seem to deny the existence of contemporary art and artists. Yet the great need of most liberal-arts students is a direct approach to living art. For this, familiarity with modern art and modern criticism is more likely to be of use than the customary surveys of the history of western art. In some

[4] Ortega y Gasset, *The Dehumanization of Art* (Doubleday, New York, 1956), p. 4.

forward-looking institutions, understanding of the principles of the new criticism has already resulted in programs with a primary emphasis on looking at and talking about contemporary art. It is gradually coming to be recognized that the ability and willingness to respond to the art of today are essential prerequisites to any real understanding of the art of the past.

GREGORY BATTCOCK

THE NEW ART

THE CREATIVE ACT*
by Marcel Duchamp

The choice of an essay by Marcel Duchamp for the beginning of this book reflects the continuing relevance of his work to contemporary art. In his article on Duchamp in The New Yorker *(February 6, 1965), Calvin Tomkins quotes Willem de Kooning as saying: "Duchamp is a one-man movement, but a movement for each person and open to everybody."*

LET US CONSIDER two important factors, the two poles of the creation of art: the artist on one hand, and on the other the spectator who later becomes the posterity.

To all appearances, the artist acts like a mediumistic being who, from the labyrinth beyond time and space, seeks his way out to a clearing.

If we give the attributes of a medium to the artist, we must then deny him the state of consciousness on the esthetic plane about what he is doing or why he is doing it. All his decisions in the artistic execution of the work rest with pure intuition and cannot be translated into a self-analysis, spoken or written, or even thought out.

T. S. Eliot, in his essay on "Tradition and Individual Talent," writes: "The more perfect the artist, the more completely separate in him will be the man who suffers and the mind which creates; the more perfectly will the

* A paper presented to the Convention of the American Federation of Arts at Houston, Texas, April, 1957.

mind digest and translate the passions which are its material."

Millions of artists create; only a few thousands are discussed or accepted by the spectator, and many less again are consecrated by posterity.

In the last analysis, the artist may shout from all the rooftops that he is a genius; he will have to wait for the verdict of the spectator in order that his declarations take a social value and that, finally, posterity includes him in the primers of art history.

I know that this statement will not meet with the approval of many artists who refuse this mediumistic role and insist on the validity of their awareness in the creative act—yet, art history has consistently decided upon the virtues of a work of art through considerations completely divorced from the rationalized explanations of the artist.

If the artist, as a human being, full of the best intentions toward himself and the whole world, plays no role at all in the judgment of his own work, how can one describe the phenomenon which prompts the spectator to react critically to the work of art? In other words how does this reaction come about?

This phenomenon is comparable to a transference from the artist to the spectator in the form of an esthetic osmosis taking place through the inert matter, such as pigment, piano, or marble.

But before we go further, I want to clarify our understanding of the word "art"—to be sure, without an attempt to a definition.

What I have in mind is that art may be bad, good, or indifferent, but, whatever adjective is used, we must call it art, and bad art is still art in the same way as a bad emotion is still an emotion.

Therefore, when I refer to "art coefficient," it will be understood that I refer not only to great art, but I am

trying to describe the subjective mechanism which produces art in a raw state—*à l'état brut*—bad, good, or indifferent.

In the creative act, the artist goes from intention to realization through a chain of totally subjective reactions. His struggle toward the realization is a series of efforts, pains, satisfactions, refusals, decisions, which also canont and must not be fully self-conscious, at least on the esthetic plane.

The result of this struggle is a difference between the intention and its realization, a difference which the artist is not aware of.

Consequently, in the chain of reactions accompanying the creative act, a link is missing. This gap which represents the inability of the artist to express fully his intention; this difference between what he intended to realize and did realize, is the personal "art coefficient" contained in the work.

In other words, the personal "art coefficient" is like an arithmetical relation between the unexpressed but intended and the unintentionally expressed.

To avoid a misunderstanding, we must remember that this "art coefficient" is a personal expression of art "*à l'état brut*," that is still in a raw state, which must be "refined" as pure sugar from molasses, by the spectator; the digit of this coefficient has no bearing whatsoever on this verdict. The creative act takes another aspect when the spectator experiences the phenomenon of transmutation; through the change from inert matter into a work of art, an actual transubstantiation has taken place, and the role of the spectator is to determine the weight of the work on the esthetic scale.

All in all, the creative act is not performed by the artist alone; the spectator brings the work in contact with the external world by deciphering and interpreting its inner qualifications and thus adds his contribution to

the creative act. This becomes even more obvious when posterity gives its final verdict and sometimes rehabilitates forgotten artists.

CONTEMPORARY ART AND THE PLIGHT OF ITS PUBLIC*

by Leo Steinberg

Leo Steinberg is well known in New York for his lectures at the Metropolitan Museum. Born in Moscow, he moved as a child with his family to Berlin and London, then settled in New York after World War II. This article is based on the first of a series of lectures which Professor Steinberg gave at the Museum of Modern Art in the spring of 1960. He is Associate Professor of Art at Hunter College.

A FEW WORDS in defense of my topic, because some of my friends have doubted that it was worth talking about. One well-known abstract painter said to me, "Oh, the public, we're always worrying about the public." Another asked: "What is this plight they're supposed to be in? After all, art doesn't have to be for everybody. Either people get it, and then they enjoy it; or else they don't get it, and then they don't need it. So what's the predicament?"

Well, I shall try to explain what I think it is, and before that, *whose* I think it is. In other words, I shall try to explain what I mean by "the public."

In 1906, Matisse exhibited a picture which he called *The Joy of Life* (now in the Barnes Foundation in Merion, Pennsylvania). It was, as we now know, one of

the great breakthrough paintings of this century. The subject was an old-fashioned bacchanal—nude figures outdoors, stretched on the grass, dancing, making music or love, picking flowers, and so on. It was his most ambitious undertaking—the largest painting he had yet produced; and it made people very angry. Angriest of all was Paul Signac, a leading modern painter, who was the vice-president of the Salon des Indépendants. He would have kept the picture out, and it was hung only because that year Matisse happened to be on the hanging committee, so that his painting did not have to pass a jury. But Signac wrote to a friend: "Matisse seems to have gone to the dogs. Upon a canvas of two and a half meters, he has surrounded some strange characters with a line as thick as your thumb. Then he has covered the whole thing with a flat, well-defined tint, which, however pure, seems disgusting. It evokes the multicolored shop fronts of the merchants of paint, varnishes, and household goods."

I cite this affair merely to suggest that Signac, a respected modern who had been in the avant-garde for years, was at that moment a member of Matisse's public, acting typically like a member of his public.

One year later, Matisse went to Picasso's studio to look at Picasso's latest painting, the *Demoiselles d'Avignon*, now in the Museum of Modern Art in New York. This, we now know, was another breakthrough for contemporary art; and this time it was Matisse who got angry. The picture, he said, was an outrage, an attempt to ridicule the whole modern movement. He swore that he would "sink Picasso" and make him regret his hoax.

It seems to me that Matisse, at that moment, was acting, typically, like a member of Picasso's public.

Such incidents are not exceptional. They illustrate a general rule that whenever there appears an art that is truly new and original, the men who denounce it first and loudest are artists. Obviously, because they are the

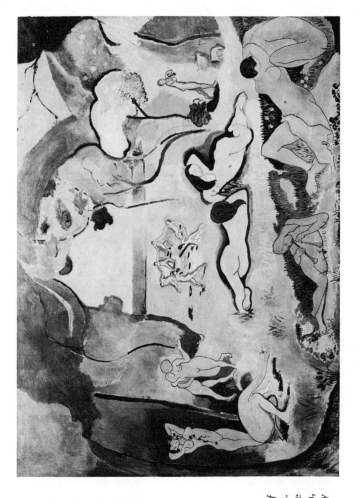

Henri Matisse: *The Joy of Life*. 1906. Oil on canvas. In the collection of The Barnes Foundation, Merion, Pa. Copyright ©, 1966, by The Barnes Foundation.

most engaged. No critic, no outraged bourgeois, can match an artist's passion in repudiation.

The men who kept Courbet and Manet and the Impressionists and the Postimpressionists out of the salons were all painters. They were mostly academic painters. But it is not necessarily the academic painter who defends his own established manner against a novel way of making pictures or a threatened shift in taste. The leader of a revolutionary movement in art may get just as mad over a new departure, because there are few things so maddening as insubordination or betrayal in a revolutionary cause. And I think is was this sense of betrayal that made Matisse so angry in 1907 when he saw what he called "Picasso's hoax."

It serves no useful purpose to forget that Matisse's contribution to early Cubism—made at the height of his own creativity—was an attitude of absolute and arrogant incomprehension. In 1908, as juror for the avant-garde Salon d'Automne, he rejected Braque's new landscapes "with little cubes"—just as, by 1912, the triumphant Cubists were to reject Duchamp's *Nude Descending a Stair*. Therefore, instead of repeating that only academic painters spurn the new, why not reverse the charge? Any man becomes academic by virtue of, or with respect to, what he rejects.

The academization of the avant-garde is in continuous process. It has been very noticeable in New York during the past few years. May we not then drop this useless, mythical distinction between—on one side—creative, forward-looking individuals whom we call artists, and—on the other side—a sullen, anonymous, uncomprehending mass, whom we call the public?

In other words, my notion of the public is functional. The word "public" for me does not designate any particular people; it refers to a role played by people, or to a role into which people are thrust or forced by a given experience. And only those who are beyond experience

should be exempt from the charge of belonging to the public.

As to the "plight"—here I mean simply the shock of discomfort, or the bewilderment or the anger or the boredom which some people always feel, and all people sometimes feel, when confronted with an unfamiliar new style. When I was younger, I was taught that this discomfort was of no importance, firstly because only philistines were said to experience it (which is a lie), and secondly because it was believed to be of short duration. This last point certainly appears to be true. No art seems to remain uncomfortable for very long. At any rate, no style of these last hundred years has long retained its early look of unacceptability. Which could lead one to suspect that the initial rejection of so many modern works was a mere historical accident.

In the early 1950's, certain spokesmen for what was then the avant-garde, tried to argue differently for Abstract Expressionism. They suggested that the raw violence and the immediate action which produced these pictures put them beyond the pale of art appreciation and rendered them inherently unacceptable. And as proof they pointed out, with a satisfied gnashing of teeth, that very few people bought these pictures. Today we know that this early reluctance to buy was but the normal time lag of ten years or less. By the late 1950's, the market for Abstract Expressionist art was amazingly active. There was nothing inherently unacceptable about these paintings after all. They just looked outrageous for a brief spell, while we of the reluctant public were coming around.

This rapid domestication of the outrageous is the most characteristic feature of our artistic life, and the time lag between shock received and thanks returned gets progressively shorter. At the present rate of taste adaptation, it takes about seven years for a young artist with a streak of wildness in him to turn from *enfant terrible* into elder

statesman—not so much because he changes, but because the challenge he throws to the public is so quickly met.

So then the shock value of any violently new contemporary style is quickly exhausted. Before long, the new look looks familiar, then normal and handsome, finally authoritative. All is well, you may say. Our initial misjudgment has been corrected; if we, or our fathers, were wrong about Cubism a half-century ago, that's all changed now.

Yes, but one thing has not changed: the relation of any new art—while it is new—to its own moment; or, to put it the other way around: every moment during the past hundred years has had an outrageous art of its own, so that every generation, from Courbet down, has had a crack at the discomfort to be had from modern art. And in this sense it is quite wrong to say that the bewilderment people feel over a new style is of no great account since it doesn't last long. Indeed it does last; it has been with us for a century. And the thrill of pain caused by modern art is like an addiction—so much of a necessity to us, that societies like Soviet Russia, without any outrageous modern art of their own, seem to us to be only half alive. They do not suffer that perpetual anxiety, or periodic frustration, or unease, which is our normal condition, and which I call "The Plight of the Public."

I therefore conclude that this plight does matter because it is both chronic and endemic. That is to say, sooner or later it is everybody's predicament, whether artist or philistine, and therefore well worth taking seriously.

When a new, and apparently incomprehensible, work has appeared on the scene, we always hear of the perceptive critic who hailed it at once as a "new reality," or of the collector who recognized in it a great investment opportunity. Let me, on the other hand, put in a word for those who didn't get it.

THE NEW ART

GREGORY BATTCOCK was born in New York City in 1937. He holds degrees in art history from Michigan State University, Hunter College, and the Accademia di Belle Arti in Rome. He is a painter, and lectures in art history and criticism at Hunter and Queens Colleges. Critical articles by Mr. Battcock have appeared in *Art Education*, *Art and Literature*, and *Film Culture*.

THE NEW ART

A Critical Anthology

Edited by Gregory Battcock

New York
E. P. Dutton & Co., Inc.

*A Dutton
Paperback*

ACKNOWLEDGMENTS

Grateful acknowledgment is made to the following for permission
to quote from copyright material:

MARCEL DUCHAMP: "The Creative Act." Reprinted by permission
of the author and The American Federation of Arts.

LEO STEINBERG: "Contemporary Art and the Plight of Its Public."
Reprinted from *Harper's Magazine*, March, 1962, by permission
of the author. Copyright, ©, 1962, by Harper's Magazine, Inc.

E. C. GOOSSEN: "The Big Canvas." Reprinted from *Art Interna-
tional*, Vol. 2, No. 8, November, 1958, by permission of the
author.

SAM HUNTER: "New Directions in American Painting." Reprinted
from the catalog of the exhibition "New Directions in Ameri-
can Painting" held at the Poses Institute of Fine Arts, Brandeis
University, 1963, by permission of the author and the Poses
Institute of Fine Arts.

ALAN SOLOMON: "The New Art." Reprinted from the catalog of
"The Popular Image" exhibition held at the Washington Gallery
of Modern Art, 1963, by permission of the author and the
Washington Gallery of Modern Art.

LAWRENCE ALLOWAY: "Notes on Op Art." Printed by permission
of the author.

HENRY GELDZAHLER: "The Art Audience and the Critic." Re-
printed from *The Hudson Review*, Vol. XVIII, No. 1, Spring,
1965, by permission of the editor. Copyright, ©, 1965, by *The
Hudson Review*, Inc.

CLEMENT GREENBERG: "Modernist Painting." Reprinted from *Art
and Literature*, No. 4, Spring, 1965, by permission of the author.

DORE ASHTON: "In Praise of Illusion." Reprinted from *Arts and
Architecture*, March, 1965, by permission of the author.

MAX KOZLOFF: "Critical Schizophrenia and the Intentionalist
Method." Reprinted by permission of the author and The
American Federation of Arts.

ALLEN LEEPA: "Anti-Art and Criticism." Printed by permission
of the author.

SUSAN SONTAG: "Non-Writing and the Art Scene." Reprinted from *Book Week*, July 25, 1965, by permission of the author.

THOMAS B. HESS: "A Tale of Two Cities." Reprinted from *Location*, Vol. 1, No. 2, Summer, 1964, by permission of the author.

NICOLAS CALAS: "And Now the Sphinx." Printed by permission of the author.

LUCY R. LIPPARD: "New York Letter 1965: Reinhardt, Duchamp, Morris." Reprinted from *Art International*, Vol. 9, Nos. 3 and 4, 1965, by permission of the author.

AD REINHARDT: "Writings." Reprinted from *Art News*, May, 1957, and February, 1964; from *Art International*, Vol. VI, No. 10, December, 1962; and from the catalog of the "Americans 1963" exhibition at The Museum of Modern Art; by permission of the author.

JOHN CAGE: "Jasper Johns: Stories and Ideas." Reprinted from the catalog of the Jasper Johns exhibition held at The Jewish Museum, New York, 1964, by permission of the author.

LEO STEINBERG: "Paul Brach's Pictures." Reprinted from *Art International*, Vol. 8, No. 3, April, 1964, by permission of the author.

SAMUEL ADAMS GREEN: "Andy Warhol." Excerpts reprinted from the catalog of the Warhol retrospective exhibition held at the Institute of Contemporary Art, Philadelphia, 1965, by permission of the author.

GREGORY BATTCOCK: "Humanism and Reality—Thek and Warhol." Printed by permission of the author.

KENNETH KING: "Toward a Trans-Literal and Trans-Technical Dance-Theater." Printed by permission of the author.

MARTIN RIES: "Endowments for the Great Society." Reprinted from *Art Voices*, Vol. 4, No. 3, Summer, 1965, by permission of the author.

To Tosh Carrillo

For her assistance in the preparation of this anthology I wish to thank Jill Siraisi. Gratitude is due Max Kozloff and John O. H. Stigall for timely suggestions and advice.

CONTENTS

10　Contents

ILLUSTRATIONS

INTRODUCTION

TODAY'S CRITIC is beginning to seem almost as essential to
to the development—indeed, the identification—of art as
the artist himself. The purpose of this volume is to bring
together some of the best recent critical essays on the new
art in the United States. Most of these articles date from
after 1960, and were originally published in periodicals
and museum catalogues. They are as new as the art they
describe. But in keeping with the new role of the critic
as interpreter, the pieces included in this anthology do
more than simply describe, or even define, their subject;
their authors are actively and consciously engaged in the
preparation of a new aesthetic, so much so that it is on
occasion difficult to disassociate their work from the art
it purports to evaluate. This intimate relationship be-
tween contemporary art and contemporary criticism is
illustrated in each of the articles that follows.

The modern critic is no longer content with simple
description used as a basis for value judgments, or even
with the more sophisticated processes of artistic defini-
tion. It is the artist who has forced him to shift his
ground. Today, the idea dominates—the artist's interest
has shifted from exclusively pictorial values to considera-
tion of the extensions of the medium. In essence, this
constitutes a new approach to the artist's age-old task
of defining a relationship between art and life. But in his
efforts to come to terms with reality, the artist of today

necessarily alienates most of his potential audience. The vast majority of the population cannot endure the challenge to conventional value structures and existing social psychology represented by the statements of contemporary artists. For art is not merely a question of understanding, but of acceptance and response. Since people have so much to lose by facing up to the challenge of art, they will not—cannot—do so. Insecurity, intolerance, and reaction are all incompatible with art appreciation. Art is humanism and reality, and, as such, cannot be seen accurately in terms of the past. At this point, responsible criticism becomes absolutely essential. The critic has, as it were, to paint the painting anew and make it more acceptable, less of the threat that it often is. It is scarcely an exaggeration to say that the art of our time simply could not exist without the efforts of the critic. It is, however, to be remembered that words are words and art is art; in presenting art, the critic cannot restate or reproduce it. All he can do is assume some of the concern for clarification abandoned by the artist in his effort to leave himself free to experiment as obscurely as he likes, unhampered by any need to compromise his integrity for the sake of public approval.

Objections to this state of affairs can logically be only of degree, not of kind, since an art of total clarity wouldn't be art, and would need no criticism at all (just as the soap opera in its context on television is not art and therefore needs neither aesthetic nor didactic interpretation). But the absence of positive criticism is hardly conceivable in a complex society such as our own, where, of necessity, many different levels of artistic appreciation and commitment exist side by side in different (and sometimes in the same) individuals. Modern art is a discipline, not a World's Fair; all three members of its essential triad—artist, critic, and viewer—obtain only such

rewards as they are prepared to work for or for which they have the love to spare.

The art of our time, in all its violence and obscurity, is produced in a society in a state of rapid flux that is often blurred in origin, content, and direction. The artist and, in consequence, his interpreter the critic are probably among the few people who can be relied upon for some sort of intuitive understanding of the contemporary situation. In a world that has altered almost out of recognition in less than a lifetime, most people unable and unwilling to cope with the present still respond to the inner dictates of an earlier age. The righteous deplore our changing morals, when in fact our morals are not changing nearly fast enough. And if our response to the present is inadequate and outdated, what of a future in which changes that have been experienced so far will probably be as nothing to those that will result from the continuing advance of twentieth-century technology, the population explosion, and the new awareness of the nonwhite peoples?

The specific innovations of the new criticism can best be seen by comparing it with the old. In the first place, since the main concerns of the modern critic are no longer those of his predecessors, his critical vocabulary, too, is different from theirs. Bernard Berenson, for example, wrote about proportion, composition, facial expression, color, and the nude, and his approach was primarily that of a historian with a concern for connoisseurship. Other critics and art historians in the earlier part of the twentieth century—among them T. E. Hulme, E. H. Gombrich, Clive Bell, Kenneth Clark, Leo Stein, and E. Gilson—concerned themselves with style, philosophy, and relationships between art and literature and between

art and the other arts. Contemporary critics show little interest in such relationships because they have already accepted the fact that the traditional distinctions between the various arts are gradually breaking down, and they recognize the need to begin to think in terms of new definitions of the nature and limitations of an art object. Previously, too, psychoanalytic explorations in art were a concern of twentieth-century aesthetics—the work of Daniel Schnieder, Ernst Kris, Otto Rank, and E. H. Gombrich springs to mind. Yet another object was the classification of artworks into the categories Primitivism, Expressionism, Romanticism, and so forth. Often these critical concepts were not specifically linked to particular works of art or artists, but only generally applied. Numerous examples of this type of critical thinking occur in Venturi's classic *History of Art Criticism.*

To turn from content to form, the monograph on a single artist, which is perhaps the major vehicle for the presentation of basic ideas in the field of aesthetics to-day, is itself a relatively new concept that can be said to date from the publication of Roger Fry's excellent work on Cézanne in 1927. Among contemporary critics the monograph is a highly useful form that combines a detailed survey of specific artworks with a philosophical or theoretical contribution to the new aesthetic. It is peculiar to the new criticism, insofar as it presents not only a direct confrontation with the new art in question but also a confrontation with its cultural, moral, and social logic.

Another characteristic aspect of the new criticism is revealed in the way its practitioners tend to review group or retrospective exhibitions almost solely in terms of the selectivity displayed by the person responsible for the show, while paying little or no attention to the merit of the individual artworks or artists included. This apparent

peculiarity is very much a part of the new way of looking at art: the position of the curator or director is regarded as equivalent to that of the artists whose work he selects, since he is the *creator* of the exhibition, if not of the individual works within it. The critic's own right to creativity comes through his relationship with the artist whom he alone fully understands, appreciates, and can interpret to others. The genesis of these ideas can be traced in the writings of Croce, Kandinsky, and elsewhere, but only now have they become a common basis for critical practice. Kandinsky, for example, wrote, "To understand is to elevate the onlooker to the artist's level."[1] J. P. Hodin, whose works have been widely read by contemporary criticis, early recognized the direction that criticism was taking when he wrote, ". . . a critic of sound judgment, knowledge and instinct can mean much for the artist,"[2] and he predicted the new role of the monograph in contemporary criticism when he remarked, "The direct contact between artist and critic also makes possible a critical confrontation of the intentions of the artist with the work in which he has realized them." In the same essay, Hodin also emphasizes the need for and inevitability of subjective criticism, and sets the tone for the new criticism with the comment, "Only living contact with the artist can establish unequivocally what he had in mind."[3]

The recent trends in critical practice take their place well within the mainstream of twentieth-century critical tradition. The writers contained in this anthology can indeed best be appreciated if read against a background of earlier work, such as the essays of Henri Focillon, Nik-

[1] Wassily Kandinsky, *On the Spiritual in Art* (New York, Museum of Non-Objective Painting, 1946), p. 13.

[2] J. P. Hodin, *The Dilemma of Being Modern* (New York, Farrar, Strauss, 1959), p. 221.

[3] *Ibid.*, p. 222.

olaus Pevsner, D. H. Kahnweiler, Lazlo Moholy-Nagy, and Richard Huelsenbeek. To the knowledge of the writer, no general survey of modern art criticism has yet been attempted. Wylie Sypher's *Art History: An Anthology of Modern Criticism* is concerned with the development of criticism from the late nineteenth century, and contains no examples of the modern approach.

The articles that follow were selected primarily to demonstrate current trends and to illustrate the high quality of the work in which they are embodied; moreover, the new criticism relies heavily on close and direct contact with the artists and art objects with which it is concerned, and constitutes excellent source material for a survey of the new art in all its various forms. The new art is not a single school with characteristics that can be pinpointed easily, but rather a broadly based movement manifesting itself in a wide range of styles that, however superficially dissimilar, are yet readily identifiable and consistent. Ortega y Gasset notes: "It is amazing how compact a unity every historical epoch presents throughout its various manifestations. One and the same inspiration, one and the same biological style are recognizable in the several branches of art."[4]

It is hoped that the publication of the present volume will encourage recognition of the educational value of the new criticism. In many colleges today, traditionally arranged art-history programs still seem to deny the existence of contemporary art and artists. Yet the great need of most liberal-arts students is a direct approach to living art. For this, familiarity with modern art and modern criticism is more likely to be of use than the customary surveys of the history of western art. In some

[4] Ortega y Gasset, *The Dehumanization of Art* (Doubleday, New York, 1956), p. 4.

forward-looking institutions, understanding of the princi-
ples of the new criticism has already resulted in pro-
grams with a primary emphasis on looking at and talking
about contemporary art. It is gradually coming to be
recognized that the ability and willingness to respond
to the art of today are essential prerequisites to any real
understanding of the art of the past.

GREGORY BATTCOCK

THE NEW ART

THE CREATIVE ACT*

by Marcel Duchamp

The choice of an essay by Marcel Duchamp for the beginning of this book reflects the continuing relevance of his work to contemporary art. In his article on Duchamp in The New Yorker *(February 6, 1965), Calvin Tomkins quotes Willem de Kooning as saying: "Duchamp is a one-man movement, but a movement for each person and open to everybody."*

LET US CONSIDER two important factors, the two poles of the creation of art: the artist on one hand, and on the other the spectator who later becomes the posterity.

To all appearances, the artist acts like a mediumistic being who, from the labyrinth beyond time and space, seeks his way out to a clearing.

If we give the attributes of a medium to the artist, we must then deny him the state of consciousness on the esthetic plane about what he is doing or why he is doing it. All his decisions in the artistic execution of the work rest with pure intuition and cannot be translated into a self-analysis, spoken or written, or even thought out.

T. S. Eliot, in his essay on "Tradition and Individual Talent," writes: "The more perfect the artist, the more completely separate in him will be the man who suffers and the mind which creates; the more perfectly will the

* A paper presented to the Convention of the American Federation of Arts at Houston, Texas, April, 1957.

23

mind digest and translate the passions which are its material."

Millions of artists create; only a few thousands are discussed or accepted by the spectator, and many less again are consecrated by posterity.

In the last analysis, the artist may shout from all the rooftops that he is a genius; he will have to wait for the verdict of the spectator in order that his declarations take a social value and that, finally, posterity includes him in the primers of art history.

I know that this statement will not meet with the approval of many artists who refuse this mediumistic role and insist on the validity of their awareness in the creative act—yet, art history has consistently decided upon the virtues of a work of art through considerations completely divorced from the rationalized explanations of the artist.

If the artist, as a human being, full of the best intentions toward himself and the whole world, plays no role at all in the judgment of his own work, how can one describe the phenomenon which prompts the spectator to react critically to the work of art? In other words how does this reaction come about?

This phenomenon is comparable to a transference from the artist to the spectator in the form of an esthetic osmosis taking place through the inert matter, such as pigment, piano, or marble.

But before we go further, I want to clarify our understanding of the word "art"—to be sure, without an attempt to a definition.

What I have in mind is that art may be bad, good, or indifferent, but, whatever adjective is used, we must call it art, and bad art is still art in the same way as a bad emotion is still an emotion.

Therefore, when I refer to "art coefficient," it will be understood that I refer not only to great art, but I am

trying to describe the subjective mechanism which produces art in a raw state—*à l'état brut*—bad, good, or indifferent.

In the creative act, the artist goes from intention to realization through a chain of totally subjective reactions. His struggle toward the realization is a series of efforts, pains, satisfactions, refusals, decisions, which also canont and must not be fully self-conscious, at least on the esthetic plane.

The result of this struggle is a difference between the intention and its realization, a difference which the artist is not aware of.

Consequently, in the chain of reactions accompanying the creative act, a link is missing. This gap which represents the inability of the artist to express fully his intention; this difference between what he intended to realize and did realize, is the personal "art coefficient" contained in the work.

In other words, the personal "art coefficient" is like an arithmetical relation between the unexpressed but intended and the unintentionally expressed.

To avoid a misunderstanding, we must remember that this "art coefficient" is a personal expression of art "*à l'état brut*," that is still in a raw state, which must be "refined" as pure sugar from molasses, by the spectator; the digit of this coefficient has no bearing whatsoever on this verdict. The creative act takes another aspect when the spectator experiences the phenomenon of transmutation; through the change from inert matter into a work of art, an actual transubstantiation has taken place, and the role of the spectator is to determine the weight of the work on the esthetic scale.

All in all, the creative act is not performed by the artist alone; the spectator brings the work in contact with the external world by deciphering and interpreting its inner qualifications and thus adds his contribution to

the creative act. This becomes even more obvious when posterity gives its final verdict and sometimes rehabilitates forgotten artists.

CONTEMPORARY ART AND THE PLIGHT OF ITS PUBLIC*

by Leo Steinberg

Leo Steinberg is well known in New York for his lectures at the Metropolitan Museum. Born in Moscow, he moved as a child with his family to Berlin and London, then settled in New York after World War II. This article is based on the first of a series of lectures which Professor Steinberg gave at the Museum of Modern Art in the spring of 1960. He is Associate Professor of Art at Hunter College.

A FEW WORDS in defense of my topic, because some of my friends have doubted that it was worth talking about. One well-known abstract painter said to me, "Oh, the public, we're always worrying about the public." Another asked: "What is this plight they're supposed to be in? After all, art doesn't have to be for everybody. Either people get it, and then they enjoy it; or else they don't get it, and then they don't need it. So what's the predicament?"

Well, I shall try to explain what I think it is, and before that, *whose* I think it is. In other words, I shall try to explain what I mean by "the public."

In 1906, Matisse exhibited a picture which he called *The Joy of Life* (now in the Barnes Foundation in Merion, Pennsylvania). It was, as we now know, one of

the great breakthrough paintings of this century. The subject was an old-fashioned bacchanal—nude figures outdoors, stretched on the grass, dancing, making music or love, picking flowers, and so on. It was his most ambitious undertaking—the largest painting he had yet produced; and it made people very angry. Angriest of all was Paul Signac, a leading modern painter, who was the vice-president of the Salon des Indépendants. He would have kept the picture out, and it was hung only because that year Matisse happened to be on the hanging committee, so that his painting did not have to pass a jury. But Signac wrote to a friend: "Matisse seems to have gone to the dogs. Upon a canvas of two and a half meters, he has surrounded some strange characters with a line as thick as your thumb. Then he has covered the whole thing with a flat, well-defined tint, which, however pure, seems disgusting. It evokes the multicolored shop fronts of the merchants of paint, varnishes, and household goods."

I cite this affair merely to suggest that Signac, a respected modern who had been in the avant-garde for years, was at that moment a member of Matisse's public, acting typically like a member of his public.

One year later, Matisse went to Picasso's studio to look at Picasso's latest painting, the *Demoiselles d'Avignon*, now in the Museum of Modern Art in New York. This, we now know, was another breakthrough for contemporary art; and this time it was Matisse who got angry. The picture, he said, was an outrage, an attempt to ridicule the whole modern movement. He swore that he would "sink Picasso" and make him regret his hoax.

It seems to me that Matisse, at that moment, was acting, typically, like a member of Picasso's public.

Such incidents are not exceptional. They illustrate a general rule that whenever there appears an art that is truly new and original, the men who denounce it first and loudest are artists. Obviously, because they are the

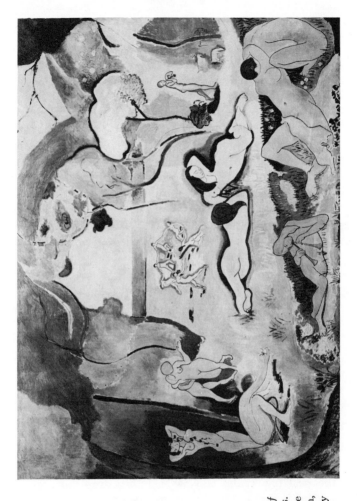

Henri Matisse: *The Joy of Life*. 1906. Oil on canvas. In the collection of The Barnes Foundation, Merion, Pa. Copyright ©, 1966, by The Barnes Foundation.

most engaged. No critic, no outraged bourgeois, can
match an artist's passion in repudiation.

The men who kept Courbet and Manet and the Im-
pressionists and the Postimpressionists out of the salons
were all painters. They were mostly academic painters.
But it is not necessarily the academic painter who de-
fends his own established manner against a novel way
of making pictures or a threatened shift in taste. The
leader of a revolutionary movement in art may get just
as mad over a new departure, because there are few
things so maddening as insubordination or betrayal in a
revolutionary cause. And I think is was this sense of be-
trayal that made Matisse so angry in 1907 when he saw
what he called "Picasso's hoax."

It serves no useful purpose to forget that Matisse's
contribution to early Cubism—made at the height of his
own creativity—was an attitude of absolute and arrogant
incomprehension. In 1908, as juror for the avant-garde
Salon d'Automne, he rejected Braque's new landscapes
"with little cubes"—just as, by 1912, the triumphant
Cubists were to reject Duchamp's *Nude Descending a
Stair*. Therefore, instead of repeating that only academic
painters spurn the new, why not reverse the charge?
Any man becomes academic by virtue of, or with respect
to, what he rejects.

The academization of the avant-garde is in continuous
process. It has been very noticeable in New York during
the past few years. May we not then drop this useless,
mythical distinction between—on one side—creative,
forward-looking individuals whom we call artists, and—
on the other side—a sullen, anonymous, uncomprehend-
ing mass, whom we call the public?

In other words, my notion of the public is functional.
The word "public" for me does not designate any partic-
ular people; it refers to a role played by people, or to a
role into which people are thrust or forced by a given
experience. And only those who are beyond experience

should be exempt from the charge of belonging to the public.

As to the "plight"—here I mean simply the shock of discomfort, or the bewilderment or the anger or the boredom which some people always feel, and all people sometimes feel, when confronted with an unfamiliar new style. When I was younger, I was taught that this discomfort was of no importance, firstly because only philistines were said to experience it (which is a lie), and secondly because it was believed to be of short duration. This last point certainly appears to be true. No art seems to remain uncomfortable for very long. At any rate, no style of these last hundred years has long retained its early look of unacceptability. Which could lead one to suspect that the initial rejection of so many modern works was a mere historical accident.

In the early 1950's, certain spokesmen for what was then the avant-garde, tried to argue differently for Abstract Expressionism. They suggested that the raw violence and the immediate action which produced these pictures put them beyond the pale of art appreciation and rendered them inherently unacceptable. And as proof they pointed out, with a satisfied gnashing of teeth, that very few people bought these pictures. Today we know that this early reluctance to buy was but the normal time lag of ten years or less. By the late 1950's, the market for Abstract Expressionist art was amazingly active. There was nothing inherently unacceptable about these paintings after all. They just looked outrageous for a brief spell, while we of the reluctant public were coming around.

This rapid domestication of the outrageous is the most characteristic feature of our artistic life, and the time lag between shock received and thanks returned gets progressively shorter. At the present rate of taste adaptation, it takes about seven years for a young artist with a streak of wildness in him to turn from *enfant terrible* into elder

statesman—not so much because he changes, but because the challenge he throws to the public is so quickly met.

So then the shock value of any violently new contemporary style is quickly exhausted. Before long, the new look looks familiar, then normal and handsome, finally authoritative. All is well, you may say. Our initial misjudgment has been corrected; if we, or our fathers, were wrong about Cubism a half-century ago, that's all changed now.

Yes, but one thing has not changed: the relation of any new art—while it is new—to its own moment; or, to put it the other way around: every moment during the past hundred years has had an outrageous art of its own, so that every generation, from Courbet down, has had a crack at the discomfort to be had from modern art. And in this sense it is quite wrong to say that the bewilderment people feel over a new style is of no great account since it doesn't last long. Indeed it does last; it has been with us for a century. And the thrill of pain caused by modern art is like an addiction—so much of a necessity to us, that societies like Soviet Russia, without any outrageous modern art of their own, seem to us to be only half alive. They do not suffer that perpetual anxiety, or periodic frustration, or unease, which is our normal condition, and which I call "The Plight of the Public."

I therefore conclude that this plight does matter because it is both chronic and endemic. That is to say, sooner or later it is everybody's predicament, whether artist or philistine, and therefore well worth taking seriously.

When a new, and apparently incomprehensible, work has appeared on the scene, we always hear of the perceptive critic who hailed it at once as a "new reality," or of the collector who recognized in it a great investment opportunity. Let me, on the other hand, put in a word for those who didn't get it.

Confronting a new work of art, they may feel excluded from something they thought they were part of—a sense of being thwarted, or deprived of something. And it is again a painter who put it best. When Georges Braque, in 1908, had his first view of the *Demoiselles d'Avignon*, he said: "It is as though we were supposed to exchange our usual diet for one of tow and paraffin." The important words here are "our usual diet." No use saying to a man, "Look, if you don't like modern painting, why don't you leave it alone? Why do you worry about it?" There are people for whom an incomprehensible shift in art, something that really baffles or disturbs, is more like a drastic change—or better, a drastic reduction in the daily ration on which one has come to depend—as during a forced march, or while in prison. And so long as there are people who feel about art in this way, it is uninteresting to be told that there also exist certain snobs whose pretended feelings disguise a real indifference.

I know that there are people enough who are quite genuinely troubled over certain shifts as they occur in art. And this ought to give to what I call "The Plight of the Public" a certain dignity. There is a sense of loss, of sudden exile, of something willfully denied—sometimes a feeling that one's accumulated culture or experience is hopelessly devalued, leaving one exposed to spiritual destitution. And this experience can hit an artist even harder than an amateur. This sense of loss or bewilderment is too often described simply as a failure of aesthetic appreciation or an inability to perceive the positive values in a novel experience. Sooner or later, we say, the man—if he has it in him—will catch on, or catch up. But there is no dignity or positive content in his resistance to the new.

But suppose you describe this resistance as a difficulty in keeping up with another man's sacrifices or another man's pace of sacrifice. Let me try to explain what I mean by the "sacrifice" in an original work of art. I think again of the *Joy of Life* by Matisse, the picture that so offended

his fellow painters and critics. Matisse here disturbed certain habitual assumptions. For instance, one had always assumed that, faced with a figurative painting, one was entitled to look at the figures in it, that is, to focus on them one by one, as he wished. The painted figures offered enough seeming density to sustain the long gaze. Thus, from all his experience with art, a man felt entitled to some pleasurable reward if he focused on painted figures, especially if these figures were joyous, female, and nude. But in this picture, if one looks at the figures distinctly, there is a curious lack of reward. There is something withheld, for the figures lack coherence or structural articulation. Their outlines are traced without regard to the presence or the function of the bone within, and some of the figures are insulated by a heavy dark padding—those lines "as thick as your thumb" that Signac complained about.

In the old days, one's first reaction would have been to exclaim—"This man can't draw." But we have the painter's preliminary studies for the individual figures of this picture—a succession of splendid drawings—and these show Matisse to have been one of the most knowing draftsmen who ever lived. Yet, after so many preparatory sketches, he arrives, in the completed painting, at a kind of draftsmanship in which his skill seems deliberately mortified or sacrificed. The heavy outlines that accost these figured nymphs prevent any materialization of bulk or density. They seem to drain energy away from the core of the figure, making it radiate into the space about them. Or perhaps it is our vision that is shunted away, so that a figure is no sooner recognized than we are forced to let it go to follow an expanding, rhythmical system. It is somewhat like watching a stone drop into water; your eye follows the expanding circles, and it takes a deliberate, almost a perverse, effort of will to keep focusing on the point of first impact—perhaps because it is so unrewarding. And perhaps Matisse was

trying to make his individual figures disappear for us, like that swallowed stone, so that we should be forced into recognizing a different system.

For the analogue in nature to this kind of drawing is not a scene or a stage on which solid forms are deployed; a truer analogue would be any circulatory system, as of a city or of the blood, where stoppage at any point implies a pathological condition, like a blood clot or traffic jam. And I think Matisse must have felt that "good drawing" in the traditional sense—that is, line and tone designating a solid form of specific character with concrete location in space—that such drawing would have tended to trap and arrest the eye, to stabilize it at a concentration of density, thereby drawing attention to the solids themselves; and this was not the kind of vision that Matisse wanted brought to his pictures.

It is lucky for us not to have been polled in 1906, because we should certainly not have been ready to discard visual habits which had been acquired in the contemplation of real masterpieces, and to toss them overboard, overnight, for one painting. Today this kind of analysis has become commonplace, because an enormous amount of this century's painting derives from Matisse's example. The free-flowing color forms of Kandinsky and of Miró, and all of that painting since, which represents reality or experience as a condition of flux, owe their parentage or their freedom to the permissions claimed in this work.

But in 1906 this could not have been foreseen. And one almost suspects that part of the value of a painting like this comes to it in retrospect, as its potential is gradually actualized, sometimes in the action of others. But when Matisse painted this picture, Degas was still around, with ten more years of life in him. It was surely still possible to draw with bite and precision. No wonder that few were ready to join Matisse in the kind of sacrifice that seemed implied in his waving line. And the first to acclaim the picture was no fellow painter but an amateur

with time on his hands: Leo Stein, the brother of Gertrude, who began, like everyone else, by disliking it, but returned to it again and again—and then, after some weeks, announced that it was a great painting, and proceeded to buy it. He had evidently become persuaded that the sacrifice here was worthwhile in view of a novel and positive experience that could not otherwise be had.

So far as I know, the first critic to speak of a new style in art in terms of sacrifice is Baudelaire. In his essay on Ingres he mentions a "shrinkage of spiritual faculties" which Ingres imposes on himself in order to reach some cool, classic ideal—in the spirit, so he imagines, of Raphael. Baudelaire doesn't like Ingres; he feels that all imagination and movement are banished from his work. But, he says, "I have sufficient insight into Ingres's character to hold that with him this is a heroic immolation, a sacrifice upon the altar of those faculties which he sincerely believes to be nobler and more important." And then, by a remarkable leap, Baudelaire goes on to couple Ingres with Courbet, whom he also doesn't have much use for. He calls Courbet, "a mighty workman, a man of fearsome, indomitable will, who has achieved results which to some minds have already more charm than those of the great masters of the Raphaelesque tradition, owing, doubtless, to their positive solidity and their unabashed indelicacy." But Baudelaire finds in Courbet the same peculiarity of mind as in Ingres, because he also massacred his faculties and silenced his imagination. "But the difference is that the heroic sacrifice offered by M. Ingres, in honor of the idea and the tradition of Raphaelesque Beauty, is performed by M. Courbet on behalf of external, positive, and immediate nature. In their war against the imagination, they are obedient to different motives; but their two opposing varieties of fanaticism lead them to the same immolation."

Baudelaire has rejected Courbet. Does this mean that his sensibility was unequal to that of the painter? Hardly,

for Baudelaire's mind was, if anything, subtler, more sensitive, more adult than that of Courbet. Nor do I think that Baudelaire, as a literary man, can be accused of being typically insensitive to visual or plastic values. His rejection of Courbet simply means that, having his own ideals, he was not prepared to sacrifice the things that Courbet had discarded. Courbet himself, like any good artist, pursued only his own positive goals; the discarded values (for example, fantasy, "ideal beauty") had long lost their positive virtue for him, and thus were no loss. But they were still felt as a loss by Baudelaire, who perhaps imagined that fantasy and ideal beauty were yet unexhausted. And I think this is what it means, or may mean, when we say that a man, faced with a work of modern art, isn't "with it." It may simply mean that, having a strong attachment to certain values, he cannot serve an unfamiliar cult in which these same values are ridiculed.

And this, I think, is our plight most of the time. Contemporary art is constantly inviting us to applaud the destruction of values which we still cherish, while the positive cause, for the sake of which the sacrifices are made, is rarely made clear. So that the sacrifices appear as acts of demolition, or of dismantling, without any motive—just as Courbet's work appeared to Baudelaire to be simply a revolutionary gesture for its own sake.

Let me take an example from nearer home and from my own experience. Early in 1958, a young painter named Jasper Johns had his first one-man show in New York. The pictures he showed—products of many years' work— were puzzling. Carefully painted in oil or encaustic, they were variations on four main themes:

Numbers, running in regular order, row after row all the way down the picture, either in color or white on white.

Letters, arranged in the same way.

The American Flag—not a picture of it, windblown or heroic, but stiffened, rigid, the pattern itself.

And finally, Targets, tricolored, or all white or all green, sometimes with little boxes on top into which the artist had put plaster casts of anatomical parts, recognizably human.

A few other subjects turned up in a single tries—a wire coat hanger, hung on a knob that projected from a dappled gray field. A canvas, which had a smaller stretched canvas stuck to it face to face, so that all you saw was its back; and the title was *Canvas*. Another, called *Drawer*, where the front panel of a wooden drawer with its two projecting knobs had been inserted into the lower part of a canvas, painted all gray.

How did people react? Those who had to say something about it tried to fit these new works into some historical scheme. Some shrugged it off and said, "More of Dada, we've seen this before; after Expressionism comes nonsense and anti-art, just as in the 'twenties.'" One hostile New York critic saw the show as part of a sorrowful devolution, another step in the systematic emptying out of content from modern art.[1] A French critic wrote, "We mustn't cry 'fraud' too soon." But he was merely applying the cautions of the past; his feeling was that he was being duped.

On the other hand, a great number of intelligent men and women in New York responded with intense enthusiasm, but without being able to explain the source of their fascination. A museum director suggested that perhaps it was just the relief from Abstract Expressionism, of which one had seen so much in recent years, that led him to enjoy Jasper Johns; but such negative explanations are never serious. Some people thought that the painter

[1] Since this critic believed that abstract art had long ago been voided of content, he should have seen that it was at least a feat to empty a vacuum.

chose commonplace subjects because, given our habits of overlooking life's simple things, he wanted, for the first time, to render them visible. Others thought that the charm of these paintings resided in the exquisite handling of the medium itself, and that the artist deliberately chose the most commonplace subjects so as to make them *invisible*, that is, to induce absolute concentration on the sensuous surface alone. But this didn't work for two reasons. First, because there was no agreement on whether these things were, in fact, well painted. (One New York critic of routine originality said that the subjects were fine, but that the painting was poor.) And, secondly, because if Johns had wanted his subject matter to become invisible through sheer banality, then he had surely failed—like a debutante who, to be inconspicuous, wears jeans at the ball. Had reticent subject matter been his intention, he would have done better to paint a standard abstraction, where everybody knows not to question the subject. But in these new works, the subjects were overwhelmingly conspicuous, if only because of their context. Hung at general headquarters, a Jasper Johns flag might well have achieved invisibility; set up on a range, a target could well be overlooked; but carefully remade to be seen point-blank in an art gallery, these subjects struck home.

It seems that during this first encounter with Johns's work, few people were sure of how to respond, while some of the dependable avant-garde critics applied tested avant-garde standards—which seemed suddenly to have grown old and ready for dumping.

My own first reaction was normal. I disliked the show, and would gladly have thought it a bore. Yet it depressed me and I wasn't sure why. Then I began to recognize in myself all the classical symptoms of a philistine's reaction to modern art. I was angry at the artist, as if he had invited me to a meal, only to serve something uneatable, like tow and paraffin. I was irritated at some of my friends

for pretending to like it—but with an uneasy suspicion that perhaps they did like it, so that I was really mad at myself for being so dull, and at the whole situation for showing me up.

And meanwhile, the pictures remained with me—working on me and depressing me. The thought of them gave me a distinct sense of threatening loss or destruction. One in particular there was, called *Target with Four Faces*. It was a fairly large canvas consisting of nothing but one three-colored target—red, yellow, and blue; and above it, boxed behind a hinged wooden flap, four life casts of one face—or rather, of the lower part of a face, since the upper portion, including the eyes, had been sheared away. The picture seemed strangely rigid for a work of art and recalled Baudelaire's objection to Ingres: "No more imagination; therefore no more movement." Could any meaning be wrung from it? I thought how the human face in this picture seemed desecrated, being brutally thingified—and not in any acceptable spirit of social protest, but gratuitously, at random. At one point, I wanted the picture to give me a sickening suggestion of human sacrifice, of heads pickled or mounted as trophies. Then, I hoped, the whole thing would come to seem hypnotic and repellent, like a primitive sign of power. But when I looked again, all this romance disappeared. These faces—four of the same—were gathered there for no triumph; they were chopped up, cut away just under the eyes, but with no suggestion of cruelty, merely to make them fit into their boxes; and they were stacked on that upper shelf as a standard commodity. But was this reason enough to get so depressed? If I disliked these things, why not ignore them?

It was not that simple. For what really depressed me was what I felt these works were able to do to all other art. The pictures of de Kooning and Kline, it seemed to me, were suddenly tossed into one pot with Rembrandt and Giotto. All alike suddenly became painters of illusion.

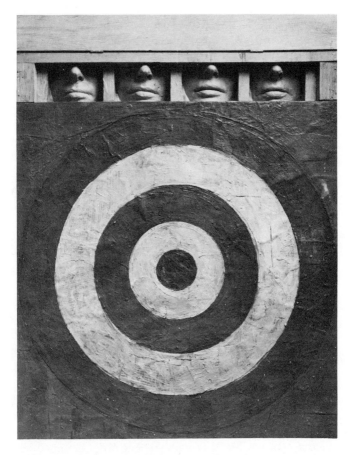

Jasper Johns: *Target With Four Faces.* 1955. Plaster casts, encaustic, and newsprint on canvas. 30″ x 26″. In the collection of The Museum of Modern Art. Photograph courtesy of Leo Castelli Gallery, New York.

After all, when Franz Kline lays down a swath of black paint, that paint is transfigured. You may not know what it represents, but it is at least the path of an energy or part of an object moving in or against a white space. Paint and canvas stand for more than themselves. Pigment is still the medium by which something seen, thought, or felt, something other than pigment itself, is made visible. But here, in this picture by Jasper Johns, one felt the end of illusion. No more manipulation of paint as a medium of transformation. This man, if he wants something three-dimensional, resorts to a plaster cast and builds a box to contain it. When he paints on a canvas, he can only paint what is flat—numbers, letters, a target, a flag. Everything else, it seems, would be make-believe, a childish game—"let's pretend." So, the flat is flat and the solid is three-dimensional, and these are the facts of the case, art or no art. There is no more metamorphosis, no more magic of medium. It looked to me like the death of painting, a rude stop, the end of the track.

I am not a painter myself, but I was interested in the reaction to Jasper Johns of two well-known New York abstract painters: One of them said, "If this is painting, I might as well give up." And the other said, resignedly, "Well, I am still involved with the dream." He, too, felt that an age-old dream of what painting had been, or could be, had been wantonly sacrificed—perhaps by a young man too brash or irreverent to have dreamed yet. And all this seemed much like Baudelaire's feeling about Courbet, that he had done away with imagination.

The pictures, then, kept me pondering, and I kept going back to them. And gradually something came through to me, a solitude more intense than anything I had seen in pictures of mere desolation. In *Target with Faces*, I became aware of an uncanny inversion of values. With mindless inhumanity or indifference, the organic and the

inorganic had been leveled. A dismembered face, multiplied, blinded, repeats four times above the impersonal stare of a bull's-eye. Bull's-eye and blind faces—but juxtaposed as if by habit or accident, without any expressive intent. As if the values that would make a face seem more precious or eloquent or remarkable had ceased to exist; as if those who could hold and impose such values just weren't around.

Then another inversion. I began to wonder what a target really was, and concluded that a target can only exist as a point in space—"over there," at a distance. But the target of Jasper Johns is always "right here"; it is all the field there is. It has lost its definitive "Thereness." I went on to wonder about the human face, and came to the opposite conclusion. A face makes no sense unless it is "here." At a distance, you may see a man's body, a head, even a profile. But as soon as you recognize a thing as a face, it is an object no longer, but one pole in a situation of reciprocal consciousness; it has, like one's own face, absolute "Hereness." So then surely Jasper Johns's *Target with Faces* performs a strange inversion, because a target, that needs to exist at a distance, has been allotted all the available "Hereness," while the faces are shelved.

And once again, I felt that the leveling of those categories which are the subjective markers of space implied a totally nonhuman point of view. It was as if the subjective consciousness, which alone can give meaning to the words "here and there," had ceased to exist.

And then it dawned on me that all of Jasper Johns's pictures conveyed a sense of desolate waiting. The face-to-the-wall canvas waits to be turned; the drawer waits to be opened. That rigid flag—does it wait to be hoisted or recognized? Certainly the targets wait to be shot at. Johns made one painting of a window shade pulled down, which, like any window shade in the world, waits to be raised. The empty hanger waits to receive somebody's clothes. These letters, neatly set forth, wait to spell

something out; and the numbers, arranged as on a tot board, wait to be scored. Even those plaster casts have the look of things temporarily shelved for some purpose. And yet, as you look at these objects, you know with absolute certainty that their time has passed, that nothing will happen, that that shade will never be lifted, those numbers will never add up again, and the coat hanger will never be clothed.

There is in all this work, not simply an ignoring of human subject matter, as in much abstract art, but an implication of absence, and—this is what makes it most poignant—of human absence from a man-made environment. In the end, these pictures by Jasper Johns come to impress me as a dead city might—but a dead city of terrible familiarity. Only objects are left—man-made signs which, in the absence of men, have become objects. And Johns has anticipated their dereliction.

These, then, were some of my broodings as I looked at Johns's pictures. And now I'm faced with a number of questions, and a certain anxiety.

What I have said—was it *found* in the pictures or read into them? Does it accord with the painter's intention? Does it tally with other people's experience, to reassure me that my feelings are sound? I don't know. I can see that these pictures don't necessarily look like art—which has been known to solve far more difficult problems. I don't know whether they are art at all, whether they are great, or good, or likely to go up in price. And whatever experience of painting I've had in the past seems as likely to hinder me as to help. I am challenged to estimate the aesthetic value of, say, a drawer stuck into a canvas. But nothing I've ever seen can teach me how this is to be done. I am alone with this thing, and it is up to me to evaluate it in the absence of available standards. The value which I shall put on this painting tests my personal courage. Here I can discover whether I am prepared to sustain the collision with a novel experience. Am I

escaping it by being overly analytical? Have I been eavesdropping on conversations? Trying to formulate certain meanings seen in this art—are they designed to demonstrate something about myself or are they authentic experience?

They are without end, these questions, and their answers are nowhere in storage. It is a kind of self-analysis that a new image can throw you into and for which I am grateful. I am left in a state of anxious uncertainty by the painting, about painting, about myself. And I suspect that this is all right. In fact, I have little confidence in people who habitually, when exposed to new works of art, know what is great and what will last. Alfred Barr, of the Museum of Modern Art, has said that if one out of ten paintings that the Museum of Modern Art has acquired should remain valid in retrospect, they will have scored very well. I take this to be, not a confession of inadequate judgment, but an assertion about the nature of contemporary art.

Modern art always projects itself into a twilight zone where no values are fixed. It is always born in anxiety, at least since Cézanne. And Picasso once said that what matters most to us in Cézanne, more than his pictures, is his anxiety. It seems to me a function of modern art to transmit this anxiety to the spectator, so that his encounter with the work is—at least while the work is new —a genuine existential predicament. Like Kierkegaard's God, the work molests us with its aggressive absurdity, the way Jasper Johns presented himself to me several years ago. It demands a decision in which you discover something of your own quality; and this decision is always a "leap of faith," to use Kierkegaard's famous term. And like Kierkegaard's God, who demands a sacrifice from Abraham in violation of every moral standard; like Kierkegaard's God, the picture seems arbitrary, cruel, irrational, demanding your faith, while it makes no prom-

ise of future rewards. In other words, it is in the nature of original contemporary art to present itself as a bad risk. And we the public, artists included, should be proud of being in this predicament, because nothing else would seem to us quite true to life; and art, after all, is supposed to be a mirror of life.

I was reading Exodus, Chapter 16, which describes the fall of manna in the desert; and found it very much to the point:

> In the morning, the dew lay round about the host, and when [it] was gone up, behold, upon the face of the wilderness there lay a small round thing, as small as the hoar-frost on the ground. And when the children of Israel saw it, . . . they wist not what it was. And Moses said unto them, This is the bread which the Lord hath given to you to eat. . . . Gather of it every man according to his eating. . . . And the children of Israel did so, and gathered, some more, some less. And when they did mete it with an omer, he that gathered much had nothing over, and he that gathered little had no lack; they gathered every man according to his eating. . . . But some of them left of it until the morning, and it bred worms and stank. . . .

> And the House of Israel called the name thereof Manna; . . . and the taste of it was like wafers made with honey. And Moses said, . . . Fill an omer of it to be kept for your generations; that they may see the bread [that] fed you in the wilderness. . . . So Aaron laid it up before the testimony to be kept. . . .

When I had read this much, I stopped and thought how like contemporary art this manna was; not only in that it was a God-send, or in that it was a desert food,

or in that no one could quite understand it—for "they wist not what it was." Nor even because some of it was immediately put in a museum—"to be kept for your generations"; nor yet because the taste of it has remained a mystery, since the phrase here translated as "wafers made with honey" is in fact a blind guess; the Hebrew word is one that occurs nowhere else in ancient literature, and no one knows what it really means. Whence the legend that manna tasted to every man as he wished; though it came from without, its taste in the mouth was his own making.

But what struck me most as an analogy was this Command—that you were to gather of it every day, according to your eating, and not to lay it up as insurance or investment for the future, making each day's gathering an act of faith.

THE BIG CANVAS*

by E. C. Goossen

E. C. Goossen traces the historical origin of a contemporary phenomenon. He explains the inevitability of the new size and identifies the response it requires. His analysis is of particular interest in the contemporary context, in view of the continuing importance of bigness in art more recent than that referred to in this article.

Born in 1920, Professor Goossen is chairman of the Art Department at Hunter College and was formerly Director of Exhibitions at Bennington College where he also taught. He has been writing art criticism since 1948 for numerous publications, including Arts, Art International *and* Art News *and is author of a monograph on Stuart Davis published in 1959.*

ABOUT THIRTY-FIVE years ago Erwin Panofsky wrote an essay entitled "The History of the Theory of Human Proportions as a Reflection of the History of Styles." It is still one of the best historical studies in the field and has recently been republished. One can see, however, that the development of the theory ran thin on examples as it approached our own century. Since the historian had taken the human figure as central to his theme, he was particularly at a loss when he cast about for material in 1921. He was confronted by Cubism, Dadaism, Constructivism, and others. What remnants of the human

* Originally published in *Art International*, Vol. 2, No. 8, November, 1958, pp. 45–47.

figure there were in painting were disfigured, distorted, and emaciated, to say the least. It would seem there was no way to carry such a study further.

Casting around for examples of the theory of human proportions in the 1950's would seem an even more hopeless affair. There is practically no evidence of the human figure in art today, as everyone has noticed. Yet it is just possible that we might take one of the other seemingly significant changes to have occurred in the past fifty or so years and, aproaching the problem on the oblique, as it were, see if it can shed some light on the question of style, and possibly also on the theory of human proportions.

The Big Picture, or perhaps I should say the Big Canvas, is a peculiar phenomenon of our period. By the Big Canvas I mean something actual, in physical size; a canvas whose footage in both directions is larger than the comprehensive image the eye is capable of taking in from the customary distance. The customary distance is that normally and previously satisfactory for a complete view of the average easel painting, prior to the increase of this average in the past ten years.

The first big canvases of the postwar period were done between 1949 and 1951 by Jackson Pollock and Barnett Newman.[1] Prior to that, there was little of equal size done in the United States except a lot of second-rate official art, and there wasn't so much of it in Europe in this

[1] *Author's Note*: Clyfford Still and Mark Rothko were also pushing the limits of their canvases to an unusual size for that moment (up to 100″). At the time of writing (1958), I was obviously thinking of those pictures by Pollock and Newman two to three times as wide or as high as the average man. All four were showing at Betty Parsons's gallery in those years (1949–1951), but only a very small number of us who were writing criticism at the time were aware of the real significance of scale as it pertained to the new American painting. I had become particularly sensitive to the ratio of these large canvases while working physically with Barnett Newman's paintings in my retrospective of his work at Bennington College in the spring of 1958.

century, with a few major and somewhat isolated exceptions. Since 1949 the large canvas, particularly in America, has been the rule, and the huge canvas a frequent addition.

It is surprising, considering the size of his *œuvre*, that the size of Picasso's pictures has never been exceptional. The extent of the *Guernica* (11′6″ by 25′8″) puts it in the physical category with which we are dealing, but by the nature of its style, perhaps because it is like a book illustration projected on a wall, it seems neither a painting nor a mural, and possibly this is the result of so many months of sketching and preparation. The two versions of the *Three Musicians* and, of course, *Les Demoiselles d'Avignon* and *Night Fishing at Antibes*, are certainly large pictures, the largest, in fact, Picasso has done. Considering his ambition as a painter, and the trend in general, it is somewhat surprising there are not more. In the circumstances we are led to suspect that it must have something to do with Picasso's subject matter, for in the process of the dissolution—still nostalgic—of the human figure, there seem to be limits within which the disintegrated natural object can lend itself to largeness without turning into unrecognizable areas of paint, and thus destroying whatever meaning its disintegration may have. All this further leads us to see that despite Picasso's occasional stab at what we now call "over-all" painting, as early as *Les Demoiselles* (1907) to the recent *Women of Algiers* (a small picture), he seems unable to break out of the concentration of his image around a single point. I imagine that this has something to do with the fact that Picasso has always painted with the wrist. He has one of the best wrists in the business. (A few years ago I wrote several paragraphs on the delicacy of his stroke in the analytical pictures, each one like a chip of mosaic). He is uncertain when he uses the whole arm, which is probably why he needed so many sketches for the *Guernica*, anything but spontaneous. And, elliptically,

one sees how his need to specify precisely the subject matter requires this muscular limitation. He assuredly approaches his subject matter with emotion, but it becomes aesthetic and a little congealed on the canvas. Early in his career he must have decided, among other things, to turn academicism, as regards subject matter, inside out. It did not occur to him, though a million other things did, to attack academicism on the basis of its aesthetic attitudes toward the *act* of painting.

Matisse is another matter. When he delivered his little sneer at the paintings of Braque and Picasso, speaking of "*les petits cubes*," and thus exactly naming Cubism, he was also speaking out of revulsion for the kind of attitude and act which produced them. He had already at the time been painting for several years in a manner involving the use of the whole arm, a manner carrying the emotional felicity straight from the body to the canvas. One thinks of such loose, expansive pictures as *Young Sailor with a Cap* (1905) and *Luxury, Calm and Delight* (1906). And one contrasts the apt name *Fauvism* with *Cubism*, which by some happy accident states exactly the two attitudes toward both subject matter and the so-called "problems" of painting. *Les petits cubes* were not for Matisse, nor all that they suggested. He wanted "an art of balance," of "serenity," and "to find a color that [would] fit [his] sensation," whose discovery he could make "in a purely instinctive way"; and his subject matter was to be diffused over the whole canvas with the "figures or objects, the empty spaces around them, the proportions" all playing an equal part. Of course, there is more reason operating behind this façade of "instinct" and "sensation" than the words suggest, but the essential thing was that Matisse produced pictures which *looked like* his intentions according to his statements. He was the first in this century to give free expression to the bodily act of painting, to render the sense of *expansion* which is the *literal* truth about freedom. Even his small

pictures look large; there is no fear of broad flat expanses of empty lateral space, and no sense of the cramped, green eyeshade search for proper texture, color, or contour. Compared to his contemporaries and even compared to Van Gogh, one of his obvious forebears, Matisse is a free balloon.

Matisse dared to take a brush, as broad as necessary, and hit this area or that, perform this contour or that, with careless exactitude, and as his confidence increased, the corrections grew fewer; the picture built itself as each first statement conditioned the next, and the act of painting grew more and more immediate. He dared to paint pictures with four, three, or even two colors, and to suggest that area to area was enough. That this direct painting eliminated the possible development of a spatial illusion backward and forward was less on his mind, I believe, than that whatever happened to the traditions of picture painting was worth it, provided the spontaneity, the physicality of the act of painting came across. (Picasso, on the contrary, seems always to have been dueling with the past, seeing it as an opponent rather than as simply there like a mountain you may contemplate or turn your back on.)

The result is that Matisse's early pictures do not seem dated, on the whole, because like Kandinsky's improvisations, they were ahead of their time, having avoided the circuitous, minesweeping route taken by the followers of the more conservative Cubist concern with form. If one combines the several things Matisse was after, the direct transmutation of emotion, the full sensation of color uninhibited by being linked to the vagaries of light and solids, and, indeed, the expression of his own delight in the act of painting, one can see the logicality of his painting larger pictures than his contemporaries. It is impossible to imagine *The Dance* as anything at all if reduced to a yard-high canvas. The *scale* of such a picture is in absolute adjustment to its meaning; without

simplicity there would be no "Dance," and without its largeness there would be no sense of the fullness of simplicity. The large painting has exposed many artists in their weaknesses; with Matisse it is a confirmation of his strength. How many, many paintings throughout the history of art could just as well be somewhat larger or somewhat smaller without it making the least difference, particularly when the direction of the vision is not over the canvas but into it.

Now the size of such pictures is not adjusted to the size of the kind of rooms we currently live in. It is not adjusted, so to speak, to the market, as one can say seventeenth-century Dutch painting was, and as most easel painting has been, for that matter. In this sense, the large canvas can not be said to be a fashion engendered outside its own world of art. Even museums are not in love with large pictures. Recently, however, such canvases have forced their way into rooms where they consume the entire wallspace, and in turn affect the quality of life in the room, pressing an emotional experience upon those who used to have to stand and peer.

Monet, of course, produced the largest canvases of the first twenty-five years of the century, and the installation of some of them in the Orangerie is one of the triumphs of public exhibiting. Twenty-, thirty-, forty-foot horizontals, the *Nympheas* surround you in an oval pantheon effecting exactly the right sense of radiant aloneness that emanates from the pictures. Again one is struck by the sheer physicality of the labor and of the result; the greatness of spirit which could only be expressed through greatness of size.

It is impossible to imagine that the *Nympheas* could have the same kind of emotional power if they contained human figures, or even reflections of the figures in the water. Their whole impact, their whole meaning perhaps, depends precisely on the *absence* of the figure. Having moved this far away from the representational, the

presence of the figure would defeat the underlying purpose of modern painting, which, as Joan Miró once said, is "to rediscover the sources of human feeling." The presence of the figure would define the scale of the picture from the *inside* in terms of the proportions of the human body, and the picture's scale depends upon its relation to the human body of the spectator *outside*. In the picture's actuality, in its aloneness, lies its power. Introduce an agent, an alter ego, and the result is *theatre*.

Of the large pictures painted since the war there are, of course, many which could just as well be smaller. The meaning of an aspect of style is rarely understood by, or is within reach of everyone. As I said above, the first large pictures in America during this period were done by Pollock and Newman. No two painters could have personal styles more unlike each other, yet no other painters understood so well what size means in present-day painting.

In Pollock's case the huge canvas seems to have come about primarily from the physical liberation it afforded in the act of painting, and the record of this muscularity is abundantly expressed (and part of the expression) in his pictures. Unlike Mathieu, whose large canvases began to appear at about the same time, Pollock worked in a very small studio with the canvas on the floor, often lapping the baseboards. Without repeating what is already a well documented subject, that is, Pollock's technique, it is necessary to note one or two aspects of it which are pertinent here. Pollock felt that painting today to be valid had to be *direct*, that is, to use Miró's insight, in order to rediscover the sources of human emotion one could not strain the act of painting through an aesthetic formula. Part of the purpose of the paint dripped onto the canvas from above was to get rid of the hand and wrist trained to the brush, and instead to involve the whole body as an agent for the whole man. And if the whole body is to be involved, it needs a field of action

large enough to admit it. And again, unlike Mathieu's concentrated vignettes, his records of symbolic action, Pollock's pictures seem, when righted and on the wall, to be possessed of a continuous emanation which can never be completed, and thus historically frozen, in the visual memory.

The size is manifestly important (the canvases I am thinking of range from ten to twenty feet in the horizontal direction). There is no other way the *real* record of this kind of creation could be made. In fact, these pictures are the *actuality*, the coalescence of act, form, and content.

Newman's approach has been quite the opposite from Pollock's. His large pictures (similar in size) are simple expanses of one color, usually made precise in its scale by another color painted narrowly across the field. He plans the canvas, either horizontally or vertically, so carefully that every ounce of the emotional value of a particular resonance of color will arise from the perfect adjustment of the color to the size and shape of its extent. It is easy to see that the canvases *must* be large in order that the response be emotional rather than physiological.

Since these last two artists produced their first large canvases, the average size of the easel painting has increased once again, and all the major artists here and abroad have found the larger field of action difficult to avoid. It has proved dangerous for some because it demands of the modern artist the kind of bigness of character which is exhibited in the great centuries of painting. Its appearance at the end of the first phase of modern art confirms our sense that something big has actually happened in art in our time, that an expansive phase is on the threshold. What good would the freedom won in the past fifty years be if it were not so?

The picture itself is now a *thing*, and as such refers less to extraneous "subject matter" and illusions of the

same. Almost as much as the Pyramids, it speaks of itself and itself alone. It is no longer a window to a world, but *the* world, immanent and autonomous. It has size, and thus dignity, a dignity no longer intruded upon by fictitious agents in human attire. The human figure was forced out of the picture to rejoin its alter egos, the artist and the spectator. Meanwhile, the large canvas contains inherently within it a theory of human proportions which grows out of its scale in relation to the artist or observer, endowing him with the grander size it has taken unto itself.

(1958)

NEW DIRECTIONS IN
AMERICAN PAINTING*

by Sam Hunter

Sam Hunter's "New Directions in American Painting" delineates the vital role of Abstract Expressionism in determining the contemporary aesthetic. Mr. Hunter is author of works on Pollock, Miró, Mondrian, Picasso, and the sculptor David Smith, and has taught art history at Barnard College and The University of California at Los Angeles. He is now director of the Jewish Museum in New York.

FOR TWO DECADES advanced American painting, and especially the movement known as Abstract Expressionism, has been drawn by its unsympathetic critics in violent colors as a passing episode of rebellion, parochial in style, self-indulgent in its disregard for communicable values, and charged with the other crimes of commission and omission that have been traditionally leveled at artistic avant-gardes in this century. The most persistent criticism is that of the narrowness and parochialism of abstract idioms. Such adverse criticism assumes that an art identified with specialized forms of abstraction must soon wear out its impulse, decay from within, and give way to humanistic modes that take in more of common reality and recognizable subject matter. When a certain kind of improvisatory figuration did emerge in Abstract Expressionism (its prototypes were de Kooning's

* Reprinted from the catalog of the exhibition "New Directions in American Painting," the Poses Institute of Fine Arts, Brandeis University.

Women and Pollock's intermittent anatomical fantasies), a vast sigh of relief was audible on all sides. But then the return to the figure miscarried, as a general tendency, or was assimilated without any noticeable abatement of the energies or momentum of Abstract Expressionism, and the unfavorable critics were left nursing a forlorn hope.

Over the past few years, however, far more fundamental and challenging changes have appeared in the styles of the avant-garde, and the issue of the exhaustion or supercession of Abstract Expressionism has been joined again. The fact that the gap between innovation and appreciation (on levels of public and private collecting) has been swiftly closed in our time, and that the "new" in art is conspicuously acquired and articulately presented in public almost as soon as it emerges, has proved distressing to the older generation of pioneer Abstractionists, for there seems to be an implied criticism of their achievement in the preoccupation with change. Quite apart from the restlessness of their audience in matters of taste, the older artists sense quite another, more substantial, threat in the new art. Its bland formality, anonymity, factualism, and traffic with mass culture— depending on which of a number of recent tendencies are considered—must seem to them the facile esthetic equivalent of all the conformist, mechanical, and anti-individualistic tendencies in American life and culture to which their own art proposed a loud dissent. The dramatic individualism and idealism of the de Kooning generation is, on the face of it, contradicted by the subservience of "pop art" to the mass media, and by the cool impersonality of hard-edge and other recent forms of Abstraction. Whether, in fact, this is actually a fair or appropriate criticism, we shall try to determine subsequently. In any case, there has been an unmistakable shift in sensibility and style in advanced art, and dire predictions have already been made that such changes repudiate the main premises of Abstract Expressionism,

and are to be read as a sign of cultural failure. For those who have never been moved to understand the work of the older generation, the new expressive language that has been emerging was welcomed, somewhat ironically it is true, and used to downgrade the dominating, previous advanced styles. The implication of much of the controversy surrounding these undoubtedly radical changes in contemporary painting is that Abstract Expressionism has outlived its usefulness and become past history, and that its main exponents have ceased to invent.

The exhibition of "New Directions in American Painting" at the Poses Institute of Fine Arts, Brandeis University, in 1963 was an experiment in testing this argument, and while it reflects the drastic changes in idiom and intellectual content that have taken place, it also explores the important points of contact, influence, and continuity between older and younger generations. The new and vital painting of today raises issues that cannot be evaded, but it can also be understood in depth only within the main traditions of the modern movement to which Abstract Expressionism has contributed so much. By extracting and extending certain implications that were always present in Abstract Expressionism, the new painting illuminates that movement, shows itself an integral part of it, and extends its definition. The point to be made, then, is that there are certain main lines of development in American art over the past two decades that have been modified rather than violated or breached by the current flurry of innovation, and by the excited public reactions to them. And as an added point of fact, the pioneer Abstractionists show no signs of recanting their original ideals or principles, nor do they show any visible diminution of energies. Hofmann, Guston, Brooks, Motherwell, and others are painting the finest works of their careers. Abstract Expressionism is still a force of primary importance, and in one of its phases a deep and acknowledged influence on the new painting.

In the constellation of artists generally identified with
Pollock, de Kooning, and Kline, Abstract Expressionism,
or "action" painting, as it has also been called, presented
itself as an art of passionate gesture, extreme mobility
and freedom. The registration of the act of creation as a
unique and dramatic event, and as an episode in a proc-
ess of personality, was its main subject matter, or con-
cern. All the exhibited marks of freedom, in handling
and execution, were left in visible evidence in the finished
work to document the artist's dilemmas of choice and
decision: whipped lines, torn shapes, emendations and
erasures, and smeared color. The artist's subjective self-
involvement in the creative process also expressed itself
through a fragmented visceral or mythic imagery, and
references to tradition and the grand manner (especially
in the case of de Kooning). The early Rothko in this
exhibition is a typical example of an art that in its first
phase stood poised between the preoccupying myths and
dream imagery of the Surrealists (whose automatism
and taste for fantasy deeply influenced the development
of American action painting) and a rigorous formality.
The charged, expressive brushwork of the more orthodox
action painters, with its residual traces of imagery and
its vehement emotionalism, had by the late forties given
way to refinement and objectivity. Pollock's open, drip
paintings (and the painting in this show is an excellent
example in small scale) absorbed individualized incident
and active details to a field of uniform accents. As the
stressful and disrupting fragments receded, by repetition,
and were purged of their fantasy, the over-all effect of the
painting gained importance; the painting achieved a
single, absorptive effect, or totality, and arranged itself
in the eye of the observer as one palpitant, shimmering
whole. With this development came, too, an increase in
scale, and thereby in impressiveness, with the effect that
in addition to operating as an absorbing spectacle of
gesture, the painting expanded out into free space as a

continuous autonomous structure; dualisms of intimacy and monumentality, evocative fragment and a generalized thematic synthesis, motion and stillness were encouraged.

The attainment of order and a simpler unity was taking another route at the same time, in the case of Still, Newman, and Rothko. Pictorial incident in their work was controlled, and suppressed by conscious reductions rather than by repetition. What Pollock and de Kooning achieved by the acceleration, decomposition, and milling down fine of their fragments of form and mythic memory these artists attained by the deceleration and the magnification of small, variegated forms and shapes into dominant islands, zones, and fields of color. An active linearity, or the opulent, negligent, and free brush stroke was exchanged for a more deliberated and purified structure of balanced color areas. The rigorous formality of Rothko and Newman associates them superficially with Mondrian and the purists, but they almost immediately part company by reason of their constant qualification and contradiction of purity through sensation, and the multievocative qualities of their frankly sensuous surfaces. Their use of closely valued color oppositions puts the spectator's perceptions under a strain, for these color oscillations have an unstable kind of complexity and baffling overtones that continually break down the rather rigid formality they contrive to establish. The idea of the painting as some sort of sacred paradigm of order is under constant assault by the compulsion to show it, no matter how disguised, as a working problem in individual choice and decision. By introducing illusion and ambiguity, and raising problems of visual communication and how, in fact, we see, this impressive trio of artists declare an essentially human order rather than some impeccable ideal, an order that is flawed and imperfect, inseparable from problems of vision and perception. On the level of organized perception, their work seems to indicate that the simplest comprehension of a systematic visual order

requires an act of free choice among multiple and often conflicting alternatives.

Out of these two main constellations of style in Abstract Expressionism have sprung the principal new directions of contemporary advanced art, although these have obviously required other stylistic and social sources of stimulation as well, and depended upon the emergence of new artistic personalities of sufficient creative force to make their own particular points of view influential. Generally, and at great risk of oversimplification, the variety of new styles can be classified under the new realism, which includes assemblage and pop-art, and new orders of abstraction. The latter demonstrate varying degrees of concern with imagery, optical and perceptual problems, alternately free or meticulously engineered forms, and pure color expression.

From de Kooning's "impurity," from his inspired raid on the urban environment for hints of subject matter, and from the nervous, digressive quality of his vision, with its rapidly shifting foci, derive in different ways the manners, and content of Larry Rivers and Robert Rauschenberg. Rivers pioneered in introducing recognizable subject matter at a time when such adulterations of abstraction were considered close to treasonable by the avant-garde. He fixed on a commonplace imagery taken from insignia, signs, artifacts, and photographic reproductions (in this exhibition a Webster's cigar box cover). The visual cliché, alternately comical, elegant, and noncommittal, recalled him to contemporary urban reality, but also became an occasion for virtuoso handling and fluent brushwork. Rauschenberg radically deepened the alliance with the image-world of popular culture, and with the object, incorporating Coke bottles, stuffed animals, and anonymous refuse in his constructions, but retaining the painterly qualities, and the fluid formal organization of Abstract Expressionism. To his freedom of handling, objects, reproductions, and "ready-made" forms serve as

an effective foil, invoking the mechanical, the fabricated, and the standardized elements of collective, anonymous urban life.

Unlike Dada, which was ironical and impertinent, his art does not criticize the mechanical and mass produced, but simply makes room for it, and underlines the contrast with the free shape and mark. Rauschenberg's sentiment for the disreputable, expendable, disenfranchised object fragments of the contemporary junk heap is comparable to Schwitters', and comes through as a very personal poetic note in his work. The variations on such thematic material, and their apparently inexhaustible possibilities of elaboration, are apparent in the constructions of Louise Nevelson which scrupulously regroom found and shaped forms of utter banality, and build out of them a rigorous architecture of extraordinary refinement. Her collection of treasured trophies repeats itself rhythmically in small units so that, like Pollock's paint spatters or Rothko's enveloping absorptive color fields, it extends into spectator space and becomes both presence and environment. The invasion of art by raw reality is matched, then, by the way in which contemporary art involves us directly, and close up, in its illusions, dilemmas, and poetic paradoxes.

Perhaps the most important single figure in the new generation, in terms of pointing a fresh direction, has been Jasper Johns, whose historic paintings of targets, flags, and maps identified the entire surface of the painting with a pre-existing image, sign, or known symbol taken from our common fund of daily visual experience. Apart from his painterly gifts and poetic refinement, Johns has been important in creating radical new forms of representation which made the anonymous visual language of the urban environment viable in art, not simply as evocative fragments, however, but as controlling elements and vital constituents of a deeply meditated visual order. His art not only raises questions about the paradoxical nature

of artistic representation and communication, contrasting fact and fiction, the imaged and actual world of things, but invests the world of things and signs with an extraordinary gravity and expressive power. Jim Dine extends the play of paradox between formality and spontaneity, object and image in an art of great force and inventiveness. His bathroom cabinets and household appurtenances may be enjoyed for their expressive function in the formal scheme of his constructions, and are not underscored for their incongruity or scandalous potential. In fact, whatever their role in life, they take on qualities both of intimacy and monumentality. In using objects so forthrightly, Dine manages an admirable, elementary candor, the kind of purposeful unsubtlety that has been characteristic of the mode of realism in all periods of art history, whenever a preceding empty mannerism or a vacant idealism tended to vitiate creativity. Quite mysteriously, the parity of his objects as fact and as form intensifies both their functions; whereas Matthew Arnold described art as a criticism of life, Dine now forces us to consider whether life does not also criticize, and thus revitalize, art.

"Pop art" carries the references to reality a stage further to embrace the subject matter, the presentational techniques and forms of the mass media; it is an art of anecdotal and formal quotations drawn from comic strips, billboards, magazine advertisements, and lettered signs. Somewhere in its background is lodged the pervasive sense that mass-production techniques and the ubiquitous modes of the communication media have compromised our idea of the "original," which has in our culture taken on an esoteric or technical status as mere prototype, the matrix from which copies can be reproduced. (The living-room reproduction, for example, of Van Gogh's *Sunflowers* has a warmer reality and intimacy for the mass public than its scarcely known original.) As Lawrence Alloway suggested in his excellent introduction

to the exhibition "Six Painters and the Object," the printing revolution and the subsequent flood of pictorial reproductions dispelled the notion that uniqueness was indispensable to art, and created, along with other elements of urban mass culture, an alternate "low," venacular tradition to "high" art. The important point to keep in mind, however, is that such artists as Lichtenstein or Indiana do not merely enlarge and monumentalize existing caricatures and lettered signs, but modify and transform them. There is, indeed, a dissociation of form and content, or at least an ambiguity of identification. The art of neither would be possible without the expanding color fields, the perceptual ambiguities and play with spatial illusion of such artists as Still, Rothko, and most particularly Newman. Another fascinating precedent also has existed in American art for some time, anticipating the incorporation of visual clichés and lettering in an emblematic subject matter of standardization: the lively, brash, vernacular style of Stuart Davis.

The reaction to the "action" painters' Expressionist handling, their lavish accents of freedom, and subjective idealism has also taken the form of a more anonymous and impersonal abstraction. In the painting of Morris Louis, the stains, drips, and color diffusions of Pollock were both concentrated and expanded into a complete formal system; Kenneth Noland carries the process of codification, reduction, and regularization further in his color circles. He has created a vital new expressive language which, metaphorically, tests current ideas of order by contrasting the free and the rigid, the focused and diffuse, geometric clarity and indistinctness. The dogmas and doctrinaire character of purism are under constant revision by a visible process of trial and error as the artist finds and clarifies his image. A new ordering impulse is seen, too, in the disappearing, ruled color stripes of Stella, and the immense, flat, heraldic shapes of Kelly. What seems at first an obvious and comprehensible order

becomes multievocative, and imposes a problem of selection, and hence an act of free choice, among conflicting visual alternatives. In Ortman and Miriam Schapiro, and in the new work of Marca-Relli, formality takes on overtones and shades of psychological meaning; the formal scheme may function as an architecture of the mind, a shrine for amorphous dream fragments, or establish a pattern of frustration, like a set of traffic signals that have been illogically programmed, and whose directions are unclear.

It would seem, finally, that when the contemporary artist moves toward the object, the world of packaged mass culture, or even toward formal purification, critical problems of artistic choice and decision remain, and compromise his most apparently anonymous productions. The idea of the work of art as an uncertain and problematic act of continual creation, filtered through a temperament, and retaining evidence in its final form of that subjective passage, was one of the central contributions of Abstract Expressionism. Even the new appeals to order, and the challenging investigations of the imagery of mass media, underscore the general lesson of Abstract Expressionism. While many features of Abstract Expressionism have been smoothed out, radically revised and challenged, it still constitutes the main trunk from which these new branches of vital contemporary American art proliferate, and to which they are organically connected.

THE NEW ART*

by Alan Solomon

This is one of the first critiques defining the "Pop" trend in the new art. Originally written in January 1963 as a catalog introduction to an exhibition at the Washington Gallery of Modern Art, it has appeared in Art International *and was reprinted by the Stable Gallery.*

Educated at Harvard, Professor Solomon was responsible for the reorganization of The Jewish Museum in New York in 1962 and for the inception of its present contemporary art exhibit program, which is one of the most ambitious in the country. In 1964 he served as U. S. Commissioner to the Venice Biennale, where Robert Rauschenberg won the first International Painting Prize ever given to an American artist. He is the author of monographs on Robert Rauschenberg and Jasper Johns and is at present Visiting Professor of Art at Cornell University. Like so many of those involved in the new art, Mr. Solomon does not restrict his interest to one field. With Steve Paxton he organized the first New York Theater Rally (Happenings) at an abandoned CBS television studio on Broadway.

FROM THE MOMENT when it became plain in the late forties that the first significant American style had crys-

* Reprinted from the catalog of "The Popular Image" exhibition, Washington Gallery of Modern Art.

tallized in Abstract Expressionism, a certain unhappy majority began to look forward to the day when its discomfort at the absence from art of references to external reality would be mollified by a return to figuration in painting and sculpture. For this group the abandonment of the human figure and its environment reflected a failure with respect to "humanism," and they were unwilling to acknowledge the opportunity presented by the new attitude for the artist to create a new world of form and space, existing apart from all previous experience of the tangible external world, and creating its own special logic as well as its own unique excitement.

The appeal to humanism had built into it an implied moral hierarchy of ideas deriving from the whole classical tradition which has been a model for our society and which takes as its point of departure the anthropomorphism of the Greeks.

From time to time, those who take comfort in the presence of humans in art have found momentary hope in the prospect of the emergence of new images of man. However, contemporary man sees himself in his art, not as an idealized godlike figure, in the manner of the classical tradition, but as a disrupted, contorted victim of the modern cataclysm, torn by forces of a magnitude beyond his comprehension, a grim figure, full of despair and anguish, entirely without hope. The "new image" is a monster, the product of irradiated esthetic genes. The basis of classical humanism was the spirit of man and its accommodation to the world, not the simple physical presence of his "human" person; figuration alone has not succeeded in restoring to art a meaningful sense of the value of man's existence and of his unique personality. Those of us who have looked for a way out of what we have regarded as the dilemma of abstraction through a new figurative art have therefore been faced with frustration heaped upon frustration.

Those of us for whom abstract art had not presented

a dilemma, but for whom Abstract Expressionism seemed to have run its course, now find ourselves confronted by an ironic turn of events. In the first place, a vigorous new kind of geometric abstraction has quietly gathered force during the past few years. In the second place, and much less quietly, a new figurative art has come to public attention during the past few months. Unfortunately, the new art offers no solace at all to the advocates of figuration, who had something quite different in mind.

While the public has received the new abstraction with relative indifference so far, the new figurative art, or, as it is called, "New Realism," "Pop Art," "Neo-Dada," and so on, and so on, has provoked a response of extraordinary intensity, stimulating extremes of unabashed delight or renewed anguish. Like all vital new movements in the modern period (Impressionism, Cubism, Fauvism) it has quickly been assigned a pejorative title—or string of titles, in this case—by the unsympathetic critics, who add to the confusion by emphasizing the wrong attributes of the style. On the other hand, among the "advanced" observers and collectors of contemporary art, the new artists have enjoyed a spectacular success in a relatively short period of time, and their work has been sought out even before it reached the uptown galleries during the last two seasons.

The new art stirs such polar responses because it seems to make an active frontal assault on all of our established esthetic conventions at every level of form and subject matter. Yet the problem is really ours and not the artists'; they have no aggressive or doctrinaire intention, and, in fact, they present their new faces to us with a certain blandness and indirection. At the same time, their work is pitched at a high emotive level (for reasons which will be explained later) without any accretion of reference to complex abstract ideas; they appeal directly to the senses in which one might describe as a visceral rather than an intellectual way. In other words, these artists

speak to our feelings rather than to our minds, and they have no *programmatic* philosophical intent. Still, they speak so clearly from the contemporary spirit that their art, as much as it varies from individual to individual, shows a remarkable degree of philosophical consistency.

It is not difficult to understand the extremes of feeling stirred by the new art. In the past, with few exceptions we have attached a special importance to art, separating it clearly from the rest of the world and the rest of experience, viewing it as an activity of man comparable in importance to his most highly regarded institutions, in a distinct moral sense.

This habit of separating one kind of activity *and its attributes* from others which are demeaned by the wear and tear of the practical details of human existence had brought us to a position in which we attached "moral value" to objects, depending on their uses as well as their properties. For a long time (until the sixteenth century) objects of utility or common familiarity did not enjoy sufficient moral value to justify their use as subjects for art by themselves, and it was really not until the nineteenth century that artists actually enjoyed the freedom to make such choices without reference to external considerations of hierarchy (an historical painting was "better" than a portrait which was "better" than a landscape, which was "better" than a still life, and so on). Even so, as free as the artist may have seemed in such matters even up to the mid-twentieth century, his repertory of objects included, for example, food and culinary implements, but not tools or plumbing, books and musical instruments, but not comic strips and radios. Even within acceptable categories like food, definite distinctions were made, so that bread, meat, game, fruit, vegetables, fish, or wine as they come from the market might be used, but not hamburgers, hot dogs, candy bars, pies or Seven-Up. It does not suffice to answer that the latter were not available fifty years ago or that their contem-

porary equivalents appeared in art. In 1913 the Cubists exercised a precise, self-conscious restraint in their choice of still-life objects not only in continuing acknowledgment of the traditional attitude toward such choices but also because they wished to avoid the introduction into the Cubist still life of associations which would detract from the emphasis on formal issues. They chose objects from the studio-café environment, but only those which connote pleasurable, unexacting activities like eating, drinking, smoking, playing cards, music, painting, and so on. The Bass bottle or the bunch of grapes in a Braque still life have a very different function from the Coke bottle or chocolate cream pie in the work of the new artists, where the latter have become highly charged emotive devices. The Cubists selected things which were familiar, intimate, and comfortable, so that they could set a diffuse iconographical tone for the painting. The new artists select things which are familiar, public, and often disquieting.

Why is this so? To put it as simply as possible, because the new artists have brought their own sensibilities and their deepest feelings to bear on a range of distasteful, stupid, vulgar, assertive, and ugly manifestations of the worst side of our society. Instead of rejecting the deplorable and grotesque products of the modern commercial industrial world—the world of the hard sell and all it implies, the world of bright color and loud noise too brash for nuance, of cheap and tawdry sentiment aimed at fourteen-year-old intelligences, of images so generalized for the mass audience of millions that they have lost all real human identity—instead of rejecting the incredible proliferation of *Kitsch* which provides the visual environment and probably most of the esthetic experience for 99 percent of Americans, these new artists have turned with relish and excitement to what those of us who know better regard as the wasteland of television commercials, comic strips, hot-dog stands, billboards,

junkyards, hamburger joints, used-car lots, jukeboxes, slot machines, and supermarkets. They have done so not in a spirit of contempt or social criticism or self-conscious snobbery, but out of an affirmative and unqualified commitment to the present circumstance and to a fantastic new wonderland, or, more properly, Disneyland, which asserts the conscious triumph of man's inner resources of feeling over the material rational world, to a degree perhaps not possible since the Middle Ages.

We cannot help but be anxious or cynical about the activities of these artists in the face of what we know to be "true" about Disneyland as a source of esthetic meaning. We suspect them of deliberate provocation in the manner of the Dadaists, that is to say, of political intention, so that they might seem to be nihilists at the very least, or subversives at best; or even worse, we fear that they might be "putting us on," asking us to take seriously activities which we know to be frivolous and valueless. Yet in retrospect the way in which the present group emerged has not only an air of undeniable consistency but also a distinct flavor of historical inevitability. This new style could neither have been encouraged nor prevented, nor could it have been contrived; it has followed an organic course which makes it an absolute product of its time. Perhaps the most remarkable features of the new art are the rapidity and the spontaneity with which it developed from the assumptions of several artists at the same moment in a variety of different places. Almost all the key figures in the group gravitated to New York, where their styles were established and they had become conscious of one another long before even the informed art public was significantly aware of their activities.

Writing history always becomes a process of oversimplification, and it is extremely difficult in this case to pinpoint the precise way in which the new group arrived at its own position. We can speak of a certain prevailing climate, refer to the fact that most of these

artists were too young to serve in the war, grew up in the time of The Bomb, have inherited a set of esthetic predilections, and so on. We can certainly make a number of accurate observations about them, as artists and as the younger generation. For example, they have matured in an environment in which the path of the artist has been made smoother than it was for the generation which suffered through the depression and the war decades. They have enjoyed not only a sympathetic milieu in which art has flourished, but they have also arrived at financial security with extraordinary speed; the importance of this cannot be denied; it has spared them much of the bitterness of their predecessors.

For whatever historical reasons, the new artists are detached politically (they have not shared the political experience of the older generation), and indeed they are disengaged from all institutional associations. At the same time that they are withdrawn from causes (social manifestations), they are deeply committed to the individual experience and one's identity with the environment (by contrast with the Dada group, whose sense of estrangement led them away from participation). This involvement has an unquestionably optimistic and affirmative basis as well as a distinctly existential cast, and it has a good deal to do with the tone set in their work, as we shall see. At the same time, the new artists are not intellectuals, by and large, and they have no interest in enunciated philosophical or esthetic tendencies.

They share, then, an intense passion for direct experience, for unqualified participation in the richness of our immediate world, whatever it may have become, for better or worse. For them this means a kind of total acceptance; they reject nothing except all of our previous esthetic canons. Since we regard our institutions as rationally derived and morally valid, this makes the artist seem antirational and reprehensible. It should be understood, of course, that the issue of morality raised here is

an esthetic issue and not personal or social. Despite whatever impressions their work may stimulate, these artists are not bohemians or "beatniks"; they have not rebelled against conventional social standards or modes of behavior.

The non-sense aspect of their work results from the unfamiliarity of their juxtapositions of ideas, which depend on intuitions and associations somewhat removed from customary habits of looking and feeling. In much the same way, the new theater, which searches for a deeper psychological reality and which shares a good deal in common with the new artists, had been called "absurd"; its absurdity lies simply in its rejection of the familiar modes of reality which have governed the theater much longer than they have the plastic arts.

In referring to the unfamiliarity of the artists' associations, I come back to what is perhaps their essential quality, their unwillingness to accept anything (an object, say) at face value, in the light of its possibility for enrichment and elaboration. Such an attitude is not unique in the contemporary world; it might be regarded both as a product of modern scientific skepticism and at the same time as a reaction to the modern scientific habit of precise determination of phenomena. It may well be that the new artists could best be described as "hip" in the sense that they are incapable of outrage, in the sense that they cannot generate conventional responses to established virtues, and in this sense that they are sharply attuned to the bizarre, the grotesque and, for that matter, the splendor contained in the contemporary American scene.

I have said that these artists are not bohemians; most of them are familiar middle-class types, but their detachment from their own society becomes a necessary condition to their work. As outsiders they see us with a clarity that throws our appurtenances into proper focus. Like

Vladimir Nabokov, they are tourists from another country, with resources and a spirit of curiosity which permit them to observe Disneyland with delight and amazement.

The point of view of the new artists depends on two basic ideas which were transmitted to them by a pair of older (in a stylistic sense) members of the group, Robert Rauschenberg and Jasper Johns. A statement by Rauschenberg which has by now become quite familiar implicitly contains the first of these ideas:

Painting relates to both art and life. Neither can be made. (I try to act in the gap between the two.)

Rauschenberg, along with the sculptor Richard Stankiewicz, was one of the first artists of this generation to take up again ideas which had originated fifty years earlier in the objects made or "found" by Picasso, Duchamp, and various members of the Dada group. Rauschenberg's statement, however, suggests a much more acute consciousness of the possibility of breaking down the distinction between the artist and his life on the one hand, and the thing made on the other. Earlier I discussed the philosophical issues involved here in some detail. In Rauschenberg's view, the work of art has stopped being an illusory world, or a fragment of such a world, surrounded by a frame which cuts it off irrevocably from the real world. Now, the entrance into the picture of objects from outside—not as intruders but as integral components—breaks down the distinction between a shirt collar, say, as an article of clothing and the same thing as an emotive pictorial device. In other words, we begin to operate here in an indeterminate area somewhere between art and life, in such a way that the potential of enrichment of life as art merges inseparably with the possibility of making the work of art an experience to be enormously more directly felt than the previous nature

of paintings and sculpture had ever permitted. Rauschenberg wants the work of art to be *life*, not an esthetic encounter depending in part on an intellectual process.

Without a doubt, this is an exciting and suggestive idea, one of those concepts which may not be startlingly new, but which, stated positively in appropriate circumstances, can trigger activity in other artists.

Allan Kaprow, as much as anyone, helped to elaborate this idea. An art historian as well as an artist, Kaprow has brought to the new art a sense of its historical and philosophical contexts. It seems to me that an article written by Kaprow, ostensibly an homage to Jackson Pollock, should be regarded as the manifesto of the new art ("The Legacy of Jackson Pollock," *Art News*, October, 1958, pages 24 ff.).

Kaprow says in it that

> . . . Pollock . . . left us at the point where we must become preoccupied with and even dazzled by the space and objects of our everyday life . . . Not satisfied with the *suggestion* through paint of our other senses, we shall utilize the specific substances of sight, sound, movement, people, odors, touch. Objects of every sort are materials for the new art: paint, chairs, food, electric and neon lights, smoke, water, old socks, a dog, movies, a thousand other things which will be discovered by the present generation of artists. Not only will these bold creators show us, as if for the first time, the world we have always had about us but ignored, but they will disclose entirely unheard-of happenings and events, found in garbage cans, police files, hotel lobbies, seen in store windows and on the streets, and sensed in dreams and horrible accidents.
>
> The young artist of today need no longer say "I am a painter. . . ." He is simply an

"artist." All of life will be open to him. . . . Out of nothing he will devise the extraordinary. . . . People will be delighted or horrified, critics will be confused or amused, but these, I am sure, will be the alchemies of the 1960's.

Elaboration of the idea of interpenetration of art and the external world brought Kaprow from painting to the construction of "environments" in which he experimented with the articulation and complication of space in various ways, with lights, with three-dimensional sound, and so on. Kaprow's interest in such possibilities had also been stimulated in another way. John Cage, whom Rauschenberg had met in the early fifties, was already deeply committed to the whole range of formal innovations and unprecedented mixtures of sights and sounds, especially in his collaborations with Rauschenberg and Merce Cunningham, which have continued to the present. Cage's freshness of vision, his delight in the accidental and unpredictable, and his total avoidance of qualitative judgments have more than a little to do with Zen, and his interest in all these questions has carried over into the new movement. His friendship with both Rauschenberg and Johns has resulted in a high degree of interaction among the three, and one cannot really separate these factors clearly from the rest of the process.

Cage's "performances" were presented to assembled audiences, as Kaprow's environments were not. The new artists' desire to communicate more directly suggests closer participation with the audience; as a result, Kaprow and several other artists—most notably Red Grooms, Robert Whitman, Dine, Oldenburg and Lucas Samaras—spontaneously began to elaborate a new kind of theater unlike any seen before, but perhaps recalling certain Dada performances. The formal freedom, the fluid spatial situation, the direct involvement of the audience

(who got wet, fed, hit, overheated, caressed, fanned, berated, gassed, spangled, deafened, kicked, moved, blinded, splattered, and entangled), and the spontaneity of the situation were so remote from conventional theater that a new name was required for these performances. They were called "happenings," a name which conveys the immediacy, the intensity of the present moment, the sense of individual participation and the unpredictable accidents which keep the audience at a high pitch of involvement. These events, which usually last five or ten minutes, happen *now*. Unlike ordinary theater, where every moment is predetermined, the happenings depend for their intensity on the audience's awareness that the conditions of the performance approach those of life, heightened in a special way by the creativity of the artist, but experienced without the sense of outcome which can be anticipated within the rigid forms of comedy or tragedy. The happenings differ from theater in another important respect; they depend not on the interplay of personalities, not on human conflict or even dialog, but on "conversations" between people and objects, or between objects alone. The actors are only participants, and the objects often surpass them in scale, importance, variety of traits, and violence of behavior.

If the happenings seem preoccupied with objects, it is no accident; the artists who have been involved have worked interchangeably between making objects and devising happenings. Some, like Dine, have now abandoned the performances, which appear to have been a necessary interlude in the whole process of exploration of the relation between people and things.

This contemporary absorption in the identity of objects and their emotive potential originated not only in the work of Rauschenberg but also in the paintings of Jasper Johns. Earlier I spoke of two basic considerations in the new art, the first being the new awareness of the mutual-

ity of art and life. The second brings us back to the object and its new "personality." Without a doubt, Johns's flags and targets from the mid-fifties reopened the whole issue as much as anything else, since the subsequent preoccupation with popular images and subesthetic objects in one way or another refers to his initial assumptions (or nonassumptions).

When Johns made an American flag the subject of a painting, he invited a substantial list of questions about both the image and the way he painted it. The flag is the kind of image so frequently exposed that we have literally become blind to it. In the context of the painting, we ask ourselves whether we have really ever looked at it; a moment of hesitation follows about whether the artist is really serious or not (the banality of the new images always raises this question). We might then wonder whether it is even legal to paint a flag. Short of obscenity, it is hard to think of a situation which could be more unsettling to us than the conflicts presented by this image.

Furthermore, when we really *look* at the flag, it becomes a curious obtuse image, apart from its emotive impact. A strong, simple design of rectangles and stars produces no recessive effects, so that its flatness puts us off at the same time that the strong contrasts and vibrations make such distinct visual demands. The repetitive character of the design verges on monotony, but we simply cannot isolate such factors from our compelling identification with the image, which means so many different things to each of us.

In the face of the flatness and purity of the rectangles and stars, without any modulation of tone or softening of edge, when Johns imposes on the image his own painterly handling, a new tension results, bringing us back to the basic problem of the relation between the picture and the real object. As I have said, Johns raises quite a number of questions.

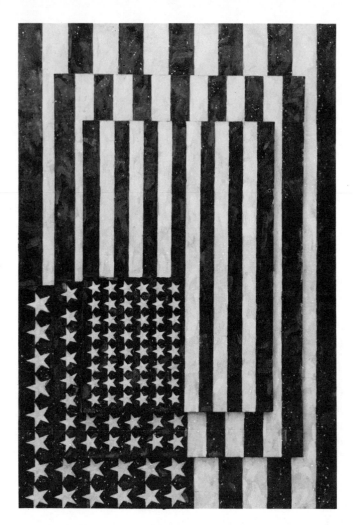

Jasper Johns: *Three Flags*. 1958. Encaustic on canvas. 30⅞" x 45½" x 5". In the collection of Mr. and Mrs. Burton Tremaine. Photograph courtesy of Leo Castelli Gallery, New York.

Once one has looked at the flag this way (there are few more familiar images), one has to look anew at everything, including the Father of Our Country, the Mona Lisa, Coke bottles, money, stamps, comic strips, and billboards. However, simply putting these objects in the painting is not the whole story for these artists, and Johns's tension between the anonymity of the execution of the real object and his own performance suggests to them exploration of the style of billboards, advertising art, comic strips, and so on. Upon examination, these too reveal unimagined mysteries of form, eccentricities of style, and a strange accumulation of images lurking where we never think to look for them. We discover that we are indeed blind and that we can be taught a new way to see.

Despite the differences in their styles, these artists share a common desire to intensify our perception of the image and to alter it in some way which complicates its effect. They may do this by augmenting the scale (Lichtenstein, Warhol, and Rosenquist) or by exaggerating or complicating the form, color, or texture of objects (Oldenburg, Dine). Since the objects chosen in one sense *must* be banal, the new artists have been accused of nostalgia for childish things, an effect which is enhanced by the simple-minded blandness with which they present their objects to us. But they purposefully appeal to our tastes for the simple things, recalling the spirit but not the facts of the child's appetite, for very much the same reasons that an earlier generation of painters turned to child art in search of the directness and intensity of the child's perceptions. The ways in which these artists have made objects function ambiguously and indeterminately recall an earlier time in man's history when spirits hid in every pot, bedeviling objects, making them move or break, even killing and curing. We are reminded here of Picasso's (from whom much of this comes) willingness to believe that paintings might one day again

perform miracles. For the new artists, objects do indeed possess mysterious powers and attributes, strange new kinds of beauty, sexuality even.

The grounds on which these new artists come to us could not be simpler, stronger, or offered in better faith. They want us to share with them their pleasure and excitement at feeling and being, in an unquestioning and optimistic way. Their concern for the quality of experience and for the human condition reflects an optimism absolutely at odds with that distrust which any appeal to our intuition and to our deeper currents of feeling seems always to provoke in us. Are we perhaps afraid to let down our guard, to let life become art? The problem seems to touch upon the security of our most cherished values. The contemporary artist is leading us through an esthetic revolution with enormous ramifications in the post-Freudian world, in which our fundamental ideas of art, beauty, the nature of experience, and the function of objects all must be reconsidered on substantially new terms. This is not a minor aberration, an interlude which will pass with a change in taste. These new artists may only be pointing the way to us, but we are entering a new world where the old art can no longer function any more than the old technology can. The new art may not provide the answers, but it is surely asking questions the consequences of which we cannot evade.

NOTES ON OP ART*

by Lawrence Alloway

In 1965 the Museum of Modern Art presented an exhibition of recent paintings that were labeled "Op Art." This exhibition, "The Responsive Eye," proved to be as controversial in art circles as it was popular with the museum-going public. In this article Mr. Alloway examines the fast public acceptance of "Op Art" and the wide publicity given to it in newspapers and magazines of all types.

Mr. Alloway was born in London in 1926. He has been Deputy Director of the Institute of Contemporary Arts in London and an instructor in the art department at Bennington College. At the present time he is Curator at the Guggenheim Museum in New York City and contributing editor of Art International.

OP ART HAS A HISTORY and, in the mid-1960's, was a fashion. The two kinds of time, the historical past converging on the present to give it continuity and echoes, and the present as a wonderful party, never met. An explanation of this double focus, of the effect of two simultaneous worlds inaccessible to one another owing to different time rates, involves a problem of mid-century culture. William Seitz, whose exhibition "The Responsive Eye" at the Museum of Modern Art popularized Op Art, postponed an historical study to a later date and

* Expanded version of a lecture "A Response to 'The Responsive Eye'" given at The Solomon R. Guggenheim Museum, April 11, 1965.

submitted, without much apparent pleasure, to what he called "the demands of the present."[1] Not only was he oppressed by the number of artists stylistically eligible, but also by the public interest: "It is a question whether any new movement, tendency, or style can withstand the public onslaught for long."[2] As this was written in a "preview" of his exhibition in *Vogue*, it can hardly be said that Mr. Seitz did much to cool it. What happened is that an inhabitant of one time-stream had become distractingly aware of the other and deplored the overlap.

The currency of the term Op Art, first printed in *Time*,[3] was extraordinary. Through 1965 it was in common use in art, fashion, and humor magazines, and in the newspapers. For example, paintings with zigzags or concentric circles appeared in a New York store's ads as appropriate furniture for the young life. *Harper's Bazaar*[4], under the heading of "Op Scene," had dress descriptions like: "Black and brown dots getting the bends on white pique (it's all in the way you look at it.)" *Vogue* returned to Op Art with a cover girl's head overprinted with a moiré pattern: "Pow! Op goes the Art. Op goes the fashion."[5]

Op Art did not stay with the slick magazines but appeared promptly in teen magazines. Here are quotations from two British journals: "Here's how the In Birds will play the Pop Art Game *gearwise* . . . crazy circles, ill-assorted diamonds, zany zigzags" and "Remember—Black and White is THE colour."[6] A little more detail on gear: "Cotton Op Art bag with lots of room" and "Op Art bag from Top Gear boutique."[7] The linking of Pop Art and

[1] *The Responsive Eye.* Text by William C. Seitz. Museum of Modern Art, New York, 1965.

[2] William C. Seitz, "The New Perceptual Art." *Vogue*, Vol. 145, No. 4, New York, 1965.

[3] *Time*, October 23, 1964.

[4] *Harper's Bazaar*, No. 3041, New York, 1965.

[5] *Vogue*, Vol. 145, No. 10, New York, 1965.

[6] *Music Parade*, No. 5, London, 1965.

[7] *Rave*, No. 19, London, 1965.

Op Art, incidentally, was widespread: *Scientific American* observed that "Op (for optical) has topped Pop (for popular) as the fashionable gallery art of 1965."[8] The most elaborate of the references to Op Art in the humor comic books was on a cover of *Sick* in which narrow bars of jumping color cut up a character like an egg slicer; it was described as an "Op-tickle Ill-usion issue."[9]

Bridget Riley, one of the artists called Op, became celebrated but, like Mr. Seitz, was embarrassed at the unexpected interpretations and unanticipated usage to which her work was subjected. Shortly after her success she wrote that "my work has been . . . vulgarized in the rag trade" (she sued the man who did it) and went on that real "qualities were obscured by an explosion of commercialism, bandwagoning and hysterical sensationalism." "Virtually nobody in the whole of New York was capable of the state of receptive participation which is essential to the experience of looking at paintings."[10] This reaction reveals the violation of a desire for the humanist tradition of an intelligent, sensitive, numerically small audience on whom an artist can count for understanding. In one way or another Miss Riley's complaint echoes the complaints of American art critics, most of whom disliked the show (including her work), but they shared her assumption of a small congenial audience. On this basis they resented the large-scale public attention given to the artists in "The Responsive Eye."

Thomas B. Hess echoed the fashion, teen, and humor magazines by equating Pop Art and Op Art: "the content of both . . . is advertising" (or, to put it another way, the content of neither is Action Painting). Real painting, Hess anounced, is "difficult, serious, remote, aristo-

[8] Martin Gardiner, "Mathematical Games." *Scientific American*, Vol. 213, No. 1, New York, 1965.

[9] *Sick*, No. 39, New York, 1965.

[10] Bridget Riley, "Perception Is the Medium." *Art News*, Vol. 64, No. 6, New York, 1965.

cratic."[11] Thus, Op Art is to be segregated from the real thing because it is popular. "The Responsive Eye" was dismissed as a "smash survey of the mode *à la mode*" and he noted that "the Estabilshment has reacted . . . warmly to these images." (The editor of a glossy and long-lived art magazine might himself be considered to be a member of "the Establishment," if this British term is applicable in the United States, which is doubtful; however, the Establishment, like hell, is "the others.") Dore Ashton decided that "these objects on the whole cannot qualify as works of art"[12]; she missed "that margin within which the imagination is free to wander." Barbara Rose dismissed Op Art as "mindless" because there is no "expressive content."[13] All three reviewers, it is interesting to note, not only recognize instantly that Op Art is not art, but they are also in possession of the knowledge of what art is. For Miss Rose, Op Art was not performing "the real task before painting in our time." She spelled out what is implicit in the Hess-Ashton-Rose position: "Our affluence, leisure, and rising literacy will call for more and more art of this kind, which should be colorful, decorative, and easily experienced." This is merely the revival of an archaic definition of the masses and their *kitsch*, but it makes possible a flattering drama of the one versus the many, the cultivated elite against the brute (if more affluent) crowd.

What happened with Op Art is that it was made famous by all the magazines except the art journals. It was precipitated into the public realm in the United States without the customary procedure of filtering and preparation in the specialized journals which has

[11] Thomas B. Hess, "You Can Hang It in the Hall." *Art News*, Vol. 64, No. 2, New York, 1965.

[12] Dore Ashton, "La Peinture Optique à New York." *XXe Siècle*, Vol. XXV, Paris, 1965.

[13] Barbara Rose, "Beyond Vertigo: Optical Art at the Modern." *Artforum*, Vol. III, No. 7, New York, 1965.

accompanied earlier twentieth-century art movements. Pop Art, for example, though the art magazines were slow to take it up, underwent a traditional sorting out process within an elite framework of judgment and inside knowledge. However, in the case of Op Art the only position left for art critics was to act as checks on supposed abuses originated by others, and to put down the new movement. The only American art critic to write about "The Responsive Eye" as if it actually contained art, and to assume that it could be approached by the use of literary sources, visual experience, and personal ideas was Sidney Tillim.[14] The initiating move by a museum and the hair-trigger topicality of the popular press left the art magazines (with their residue of minority humanism) nothing to do but castigate and ironize. The public entertainment that accompanied Op Art forced into the open the caution and restricted interests which are becoming characteristic of the art critic as a professional. It is perhaps time to state that the art world would be a dull and rarefied place without fashion. It is fashion that welcomes and celebrates new artists and new tendencies, whereas established critics and editors evoke standards as a barrier to curiosity and generosity.

Barnett Newman was named, in a premature press release from the Museum of Modern Art, as an Op artist, but was not represented in the exhibition. The reasons why his flat one-color paintings are not Op Art may clarify what Op Art is. His surfaces, though monochrome, are characterized by manual traces (though these are restrained); not only that, his work is imbued with an esthetic of the Sublime, as the artist himself has named it. If one compares a Newman painting with an Yves

14 Sidney Tillim, "Optical Art: Pending or Ending?" *Arts*, Vol. 39, No. 4, New York, 1965. This is essentially a footnote to an earlier article called "What Happened to Geometry?" in *Arts*, Vol. 33, New York, 1959.

Klein (not in "The Responsive Eye" oddly) one can see immediately how nuanced a work by the American painter is, how qualified in color, and tense in phasing. A Klein monochrome, on the other hand, lives by being a solid chunk of blue, as if a bit of Mallarmé's Azure had fallen on Chicken Little. His work is modulated by an all-over texture, which makes it receptive to light changes and shifts in the spectator's attention, whereas Newman creates effects of light within the painting. Klein's monochromes were painted with rollers to get an "impersonal" finish, and a part of their importance lies in their inertness as objects. Once a painting is sufficiently undiversified in its surface, variables of handling are replaced by variables in perception. In a Newman, the marks of the artist create a stable structure (despite some perceptual shifts), whereas a Klein is simple enough for the spectator to recognize his own perception in operation.

Mr. Seitz presented his exhibition in terms of an affective theory (of spectator participation) rather than a genetic theory (of the artist's creative experience); of consumption rather than of production. In this he is certainly correct, so far as it separates Op Art from the autobiographical and existentialist process-records of Abstract Expressionism and Action Painting. It is true that the spectator of checker-board inversions, moiré patterns, and after-images is made aware of the experience of perception and its corollary, that stimuli are shifting and ambiguous.[15] However, there are surely no still works of art and no passive spectators. Audience research on a movie, *Home of the Brave*, for instance, led to the conclusion that "interpretation was consistent with the degree of prejudice of the interpreters . . . Because perception is selective and because content, considered as stimulus material, is more or less ambiguous . . . dis-

[15] The best account of the effects is Gerald Oster's "Optical Art." *Applied Optics*, Vol. 4, No. II, New York, 1965.

tortion always occurs."[16] Any meaning or pattern is unstable and polyvalent, an experience not peculiar to Op Art.

Mr. Seitz linked Op Art with kinetic art on the basis of identifying apparent (optical) with real (physical) movement, thus linking it with the machine aesthetic and Constructivism. However, the pro-technology attitude of many European artists was not stressed in his exhibition, where emphasis was on individual authorship and formal compactness. This meant that collective manifestations, such as the Groupe de Recherche d'Art Visuel, Gruppo N, and Equippo 57, were inadequately represented. The study of possibilities of collaboration and anonymity, with the team operating instead of the individual artists, was not pursued. To consider Op Art fully it must be viewed in relation to pro-technology attitudes and authorship problems. Standardized forms and agreed-on systems make possible an art that is not necessarily equated with individual activity. Memory cues are blocked as far as possible by regular forms and the values of inspiration and uniqueness (so strong in post-war painting) are critically reduced. Basically, Op Art is part of a general use of more systematic forms than have previously engaged artists. Viewed like this, Op Art as such is not a style but a technique, one of the means of achieving certain effects. Isolating the optical elements, at the expense of other factors, is like discussing landscape paintings as Vanishing Point Perspective art.

Sidney Tillim has suggested that grids are a sign of European art's "traditional geometric orientation,"[17] but when a grid has become a field of points, an all-over display of equal emphasis, it ceases to be readable as geometric in his sense. Geometric art requires, obviously,

[16] Wilbur Schramm, *Mass Media and Education*. Chicago, University of Chicago Press, 1954.
[17] Tillim, *op. cit.*

diversified figures; when these are, as it were, pulverized, as in a dense compilation of small units, we see something else. There is a visual texture[18] which, though it can contain cluster intensifications, is homogenous, not differentiated. Control is achieved by clusters, density, flow, grain, and nets, that is to say, factors which affect equally the whole painting as a single system, rather than by balances of separate forms. In fact, the crucial element is, perhaps, not the grid but the point, the dot, the regular and repetitive unit. Starting with Georges Seurat, there is a history of the dot in painting. He reduced the structural unit of painting to the point; previously the skin of a painting was un-analyzable, either because of the motor variety of the visible strokes (too complex for description), or because the individual strokes were subsumed into one skin (hidden). Seurat, however, destroyed both the intricate and the continuous paint surface to make painting as systematic a process as engraving. Engravers who worked for reproduction possessed a syntax by which they could translate forms and space, originally painted, into graphic equivalents. They worked with set elements which could be varied and combined without loss of individual solidity. News of pointillism (which, in this context, is a better term than Neo-Impressionism and Divisionism) was distributed rapidly. The principle went to Seurat's personal contacts (for example, Paul Signac), then to *their* contacts (for example, Van Gogh), and so on to a legion of French, Italian, and American artists. On a longer term, his influence is traceable to Decorative Cubism and to the Bauhaus (Klee particularly was taken with systematic color, both as dots and as all-over grids of small squares). At the Bauhaus the dot was also identified as a basic design unit, an atom, in Kandinsky's point-line-plane sequence. However, such a theory gives the unit only an initiating role, soon lost; we

[18] Cesar Jannello, "Texture as a Visual Phenomenon." *Architectural Design*, Vol. 33, No. 8, London, 1963.

are faced in Op Art, however, with the point (without the line and the plane) repeated.

Information Theory is certainly present in recent uses of the small repeated unit in painting, either intentionally or inhaled with the twentieth century. Vasarely, for one, is conscious of a likeness between his ranks of regular forms and the binary code of digital computers in which there are two states—on/off, yes/no. Though large forms may lurk in some of his paintings, a systematic binary code is never far from his later work. One reason for his delay in developing a full color range was that its complexity made it intractable to binary coding; its random luxury overwhelmed the system. Instead of the Froebelesque solids which haunted early geometric art, the reference, in a lyrical or offhand way, is to the point, the dot, as in punched cards and tapes. Instead of the former comparison of abstract art with music there is an evocation of Information Theory. However, it must be stressed that the analogy, though vivid, is partial, because art and Information Theory constitute different systems. Writers on art who desire, fear, or scorn the marriage of art and science should not be misled by the images to assume a one-to-one relation of art and mathematics. At the Hochschule für Gestaltung in Ulm, Information Theory, not architecture, is the Mother of the Arts,[19] and it is on some such basis that the references to science should be understood. It is unifying theory, not a formula for work. It is to systematic art what the Unconscious was to effusive art.

[19] Almir Mavignier typifies Ulm ideas in this direction.

THE ART AUDIENCE AND
THE CRITIC*

by Henry Geldzahler

*Henry Geldzahler is a leading spokesman for
the New York avant-garde and has been
closely associated with various avant-garde
movements. His comments range over the en-
tire art scene from painting to the films of
Andy Warhol. In the following article he dis-
cusses the dilemma of the audience for con-
temporary art and the problems facing a critic.*

*Mr. Geldzahler was born in Belgium in 1935
and studied at Yale University, the Sorbonne,
the Ecole de Louvre and Harvard Graduate
School of Fine Arts, where he was a teaching
fellow for two years. He is an associate curator
in the Department of American Paintings and
Sculpture at the Metropolitan Museum of Art
and is the author of* American Painting in the
Twentieth Century *published by the Metro-
politan Museum in 1965. He has written
articles for* Art International, The New York
Herald Tribune's "Book Week," *and* Art News.

THE HISTORY OF MODERN ART is also the history of the
progressive loss of art's audience. Art has increasingly
become the concern of the artist and the bafflement of
the public. It is not a popular audience that was lost, not
an audience made up of the great mass of the people, but

* Reprinted from *The Hudson Review*, Vol. XVIII, No. 1, Spring,
1965.

an educated, enlightened, and enfranchised class of art connoisseurs, the aristocracy and church hierarchy of the pre-French revolutionary period. The artist of the Renaissance, Baroque, and eighteenth century knew for whom he was painting. His small audience was clearly defined, and there was a shared body of knowledge, literary and artistic, that patron and artist took for granted. Thus, if a myth were referred to in a work or if a work were commissioned to illustrate a personally and particularly meaningful myth or historical incident, no one for whom it was intended would find it a difficult picture; at times a complicated literary painting might be an elegant visual puzzle, but there was an answer and the problem could be solved. It was not until the false start toward the democratization of art in the nineteenth century that the professional critic became a necessary buffer between the painter and the public. A new profession, that of interpreter of art to a general public, became established.

As painting became less dependent upon a complicated and shared literary apparatus, and more involved, in the course of the nineteenth century, with common and contemporary experience, it began to look in upon itself, upon its own inner necessities and mechanics. Surely the long and complex history of landscape painting which culminated in the nineteenth century is not about the history of landscape (geology) but rather about the formal problems suggested by the rigid format of earth, horizon line and sky, and the variations possible within this framework.

It must be with the Impressionists, the culmination in a sense of this landscape development, that we date the obvious split engendered by an art advanced for its day and a public led in its ridicule by hostile critics. Courbet and Daumier, in the years immediately preceding the Impressionists, were criticized too, but within the context of art; they were never dismissed as flingers of paint

in the face of the public. It is undoubtedly true that the best audience, and in a sense the only audience, for Impressionist painting in its early years was the artist. Art had definitely begun to turn in on itself in a process that has continued for a hundred years.

The audience for art in our own time is still a specialized one. There has grown up in this generation a relatively small group as learned and knowing as the eighteenth-century connoisseurs. The ground, however, has shifted, and the specialist's knowledge today is not literary but formal. It is not the mythology and poetry, the Greek and Latin of the humanist, but the morphology of the art of the past century, the history of forms and movements in modern art, that is the necessary equipment for a full comprehension of the best in contemporary art.

The most important developments in the art of this century in their logical and inevitable sequence (inevitable, of course, only after the fact—and unpredictable before) are open and available, at first, only to the narrow but passionately interested audience for art made up largely of the painters and their immediate coterie. It has been the increasing concern with the basic elements of painting, the painter's vocabulary, with no concessions to a hypothetical audience out there that seemed unable or prepared to care anyway, that has slimmed and attenuated the public for art to an alert and interested few attuned to the closest scrutiny of formal variations and adjustments that seem slight or nonexistent to the inexperienced, but are deeply meaningful and rich to those who have done the work of looking.

The critic speaks to the audience out front and points to the paintings behind him. He is an unfortunately necessary link in the communication between the artist and the public. The good critics of the past hundred years have been the audience for art, the artists themselves and their writer friends. This coterie aspect of art

criticism smacks of cabal but has proved necessary. The Impressionists, Cubists, and Abstract Expressionists all had their critics, intimate with the artists from the early years of the movements. The public in most cases first heard sympathetically about the artists and paintings from the coterie, the artists' friends. The critics wrote and lectured, often persuasively, about art the public found difficult to accept. It was probably the early verbal formulation of much of the esthetic theory, formal analysis, and conceptual programs of modern movements by critics who were so intimately acquainted with the work that gave the removed, private, and even esoteric air to the early years of each movement in the best art of our century.

The problem of audience is a crucial one to the critic: Whom exactly is he addressing? Is he an interpreter of difficult, recondite, or shocking art to an already interested audience or to a wider general audience? Or is he talking only to the most interested audience of all, the most deeply concerned and committed, the artists themselves? The critic who conceives of the artist as his audience is rare. But even here, his effectiveness is limited by the very fact of the medium in which he expresses himself, words. Paintings lead to paintings; words never do. For this reason exposure to the art of the past, both historical and recent, is essential to the intelligent comprehension of painting today. Words can point, direct the attention of the audience to certain painting of the past or very recent past, but they can never be the substitutes for looking at works of art. Words, unaided pictorially, can summarize and organize visual information, and in this the critic is helpful. But painting is not verbal; it escapes words, and words cannot evoke with sufficient accuracy the effect or look or style which is the complexity of a successful painting or sculpture. The creation of a work of art has required far too many complex and manifold decisions, has referred to far too

many works already in existence, to be covered adequately by words. In short the critical task is an impossible one, but none the less worth doing for that.

In the past four decades the best artists have limited themselves in format so that an entire career, an entire productive life, consists in ringing changes on a single theme. In this, Mondrian, with the example of Monet's cathedrals and haystacks before him, was the pioneer. From 1920 to his death in 1944 Piet Mondrian stayed in his work with the right angle, the three primary colors and black and white. Within these strictures his work changed and became more complex; essentially it was a difficult art to viewers unprepared to look hard, comfortingly dismissable to those hostile or indifferent as nothing but the same picture painted over and over again.

There is something messianic in Mondrian's career and work. The implication is that he has got hold of the truth —not one truth among many, but the single eternal truth. It is necessary to the psychology of the obsessed artist, the artist who stays with a single theme over a great many years, to be exclusive and single-tracked in his thinking. This is in no way surprising, for it would be impossible to stay with an objective personal vision for more than a single painting if the stance from which the artist was working weren't held firmly and consistently.

What happens to the audience in this development? The artist who is tough on himself is that much tougher on his audience. But then there is no easy public art; there is only private, difficult art that is accessible to the public willing to make the effort. With Mondrian we have the first example of an artist who has stripped his work and who spends a major portion of his career working out and adjusting, arranging, and changing his basic simple image, and never feeling that it is quite right for the next picture, or that he wants to repeat it. That is the greatness of his art and of that of our most ad-

vanced recent painters: Clyfford Still, Barnett Newman, Mark Rothko, Morris Louis, Kenneth Noland, Frank Stella. They never feel they know how to make a Still, Newman, or Noland. Each rethinks his problem each time he starts a painting. And while they learn from their own experience, it must always be a renewed experience, never a remembered one. A painter who repeats himself meaninglessly, emptily, is remembering or trying to remember what it felt like to paint a picture last year. That doesn't work. The great men stay in touch with the wellsprings of their own creativity and are constantly recreating the impulse and energy that must inform their work. It is not surprising that this work is not instantly available to the public or easily absorbed. It is an artist's art; a critical examination of painting by painters, not necessarily for painters, but for experienced viewers. The problem of creative fecundity and excitement and a maintained level of inspiration and execution is much more acute in the stripped and repeated images of today's painting. For the painter limiting himself to a self-imposed and invented vocabulary, simple shapes and their relationships, there is literally no place to hide. This is the strength of the art and its emptiness when it goes bad. All is out in the open for everyone to see. That doesn't make it easier to see, but, paradoxically, more difficult. There is no anecdote, no allusion except to other art, nothing outside art itself that might make the viewer more comfortable or give him something to talk about.

Actually, the effort toward making differences from picture to picture is not art; it is "artiness," exactly that which is extraneous to the picture making. The attempt to make it look different can have nothing to do with the generative processes that produce the painting. Such an attempt can only be socially ordained, as for instance, in the effort toward a more interesting or varied show. If the picture is painted in exactly the way it has to be, it will look different enough from the last picture, which

had to be painted in the way it was, to satisfy anyone who is interested in looking long and hard at paintings; and that finally is the only audience the pictures will have anyway.

In the past eighty years or so the artist has been influenced not only by the advanced art of his own day and that immediately preceding, but by a new critical awareness of the entire history of art. If pictures lead to pictures, then the new availability of a much wider range of images and symbols from the art of all the world and all of history must have its effect. In past centuries artists were aware of the traditions of their own community; and, occasionally, owing to trade caravans or pilgrimage routes, or to the portability of small religious objects, the easy dissemination of prints, or travels by the artists themselves, an influence foreign to the home tradition would be felt and immediately absorbed. Now we no longer have trade routes; we have *Art News*, Harry Abrams, Phaidon, André Malraux, and jet travel—instant international communication. Between them nothing is unavailable. This in addition to widening enormously the possible influences on an artist multiplies incalculably the amount of visual material that can, and in many cases must, be brought to bear in the intelligent appreciation of contemporary art. The artist as art historian, as scholar of the history of art, makes the professional art historian his logical audience, and in the past decade it has been in this professional group that much of the early appreciation of new and difficult art has taken place.

The potentially interested viewer need not feel left out or hostile. The paintings exist and are in public collections; the very same paintings that influenced the artists and led to the important changes and breakthroughs in style of the past decades can be seen; for instance, in the permanent exhibitions of the Museum of Modern Art and in the Guggenheim Collection. The Kandinskys, Kupkas, and Delaunays, the Picassos and Matisses, the

Malevitchs and Mondrians of the first two decades of this century have entered public collections, although not perhaps as rapidly or generally (that is, outside New York) as one might wish. Just as the painters have seen them, so can the public. The Museum of Modern Art and the college art-history courses have helped create this new and aware audience for advanced painting. But all they can really do is to expose the audience to the art. The critic, curator, or historian of modern art can only point.

There is something unpleasant in the realization that the true audience for new art is so small and so specialized. The unpleasantness comes from an idea about an ideal audience or an ideal art, or rather an ideal relationship between the great democratic public and the artist performing his social function; self-revelation made generally available. In truth, despite all the education available through our art museums, periodicals, and college art-history departments, the process remains slow, the converts few, and true understanding rare. Whether this situation is ideal or necessary is a matter for speculation. It is and has been the situation for several decades, and is not likely soon to change.

MODERNIST PAINTING

by Clement Greenberg

Clement Greenberg is one of the most distinguished contemporary critics of painting and sculpture. A particularly valuable contribution has been his exploration of the essential and inherent qualities of each medium. He says in his book Art and Culture *"The easel painting, the movable picture hung on a wall, is a unique product of the West, with no real counterpart elsewhere." In the essay that follows, originally published by the Voice of America and now definitively revised by the author, Mr. Greenberg shows how an increasing emphasis on flatness and two-dimensionality played an essential part in developing self-identification of modernist painting in the nineteenth and twentieth centuries. This process of identification of painting as painting, ever further divorced from sculptural, narrative, and figurative elements, culminated in the work of the Abstract Expressionists, and was a necessary prerequisite for the literal imagery and integration of hitherto separate artistic media employed by the artist today.*

Mr. Greenberg was born in New York City in 1909 and was educated at Syracuse University and at the Art Students League of New York. He is the author of books on Miró and Matisse and of numerous critical essays for The Nation, Partisan Review, Art News, Arts *and* Art and Literature.

MODERNISM INCLUDES more than just art and literature. By now it includes almost the whole of what is truly alive in our culture. It happens, also, to be very much of a historical novelty. Western civilization is not the first to turn around and question its own foundations, but it is the civilization that has gone furthest in doing so. I identify Modernism with the intensification, almost the exacerbation, of this self-critical tendency that began with the philosopher Kant. Because he was the first to criticize the means itself of criticism, I conceive of Kant as the first real Modernist.

The essence of Modernism lies, as I see it, in the use of the characteristic methods of a discipline to criticize the discipline itself—not in order to subvert it, but to entrench it more firmly in its area of competence. Kant used logic to establish the limits of logic, and while he withdrew much from its old jurisdiction, logic was left in all the more secure possession of what remained to it.

The self-criticism of Modernism grows out of but is not the same thing as the criticism of the Enlightenment. The Enlightenment criticized from the outside, the way criticism in its more accepted sense does; Modernism criticizes from the inside, through the procedures themselves of that which is being criticized. It seems natural that this new kind of criticism should have appeared first in philosophy, which is critical by definition; but as the nineteenth century wore on, it made itself felt in many other fields. A more rational justification had begun to be demanded of every formal social activity, and "Kantian" self-criticism was called on eventually to meet and interpret this demand in areas that lay far from philosophy.

We know what has happened to an activity like religion that has not been able to avail itself of "Kantian" immanent criticism in order to justify itself. At first glance the arts might seem to have been in a situation like religion's. Having been denied by the Enlightenment

all tasks they could take seriously, they looked as though they were going to be assimilated to entertainment pure and simple, and entertainment itself looked as though it were going to be assimilated, like religion, to therapy. The arts could save themselves from this leveling down only by demonstrating that the kind of experience they provided was valuable in its own right and not to be obtained from any other kind of activity.

Each art, it turned out, had to effect this demonstration on its own account. What had to be exhibited and made explicit was that which was unique and irreducible not only in art in general but also in each particular art. Each art had to determine, through the operations peculiar to itself, the effects peculiar and exclusive to itself. By doing this, each art would, to be sure, narrow its area of competence, but at the same time it would make its possession of this area all the more secure.

It quickly emerged that the unique and proper area of competence of each art coincided with all that was unique to the nature of its medium. The task of self-criticism became to eliminate from the effects of each art any and every effect that might conceivably be borrowed from or by the medium of any other art. Thereby each art would be rendred "pure," and in its "purity" find the guarantee of its standards of quality as well as of its independence. "Purity" meant self-definition, and the enterprise of self-criticism in the arts became one of self-definition with a vengeance.

Realistic, illusionist art had dissembled the medium, using art to conceal art. Modernism used art to call attention to art. The limitations that constitute the medium of painting—the flat surface, the shape of the support, the properties of pigment—were treated by the Old Masters as negative factors that could be acknowledged only implicitly or indirectly. Modernist painting has come to regard these same limitations as positive factors that are

to be acknowledged openly. Manet's paintings became the first Modernist ones by virtue of the frankness with which they declared the surfaces on which they were painted. The Impressionists, in Manet's wake, abjured underpainting and glazing, to leave the eye under no doubt as to the fact that the colors used were made of real paint that came from pots or tubes. Cézanne sacrificed verisimilitude, or correctness, in order to fit drawing and design more explicitly to the rectangular shape of the canvas.

It was the stressing, however, of the ineluctable flatness of the support that remained most fundamental in the processes by which pictorial art criticized and defined itself under Modernism. Flatness alone was unique and exclusive to that art. The enclosing shape of the support was a limiting condition, or norm, that was shared with the art of the theater; color was a norm or means shared with sculpture as well as with the theater. Flatness, two-dimensionality, was the only condition painting shared with no other art, and so Modernist painting oriented itself to flatness as it did to nothing else.

The Old Masters had sensed that it was necessary to preserve what is called the integrity of the picture plane: that is, to signify the enduring presence of flatness under the most vivid illusion of three-dimensional space. The apparent contradiction involved—the dialectical tension, to use a fashionable but apt phrase—was essential to the success of their art, as it is indeed to the success of all pictorial art. The Modernists have neither avoided nor resolved this contradiction; rather, they have reversed its terms. One is made aware of the flatness of their pictures before, instead of after, being made aware of what the flatness contains. Whereas one tends to see what is *in* an Old Master before seeing it as a picture, one sees a Modernist painting as a picture first. This is, of course, the best way of seeing any kind of picture, Old Master

or Modernist, but Modernism imposes it as the only and necessary way, and Modernism's success in doing so is a success of self-criticism.

It is not in principle that Modernist painting in its latest phase has abandoned the representation of recognizable objects. What it has abandoned in principle is the representation of the kind of space that recognizable, three-dimensional objects can inhabit. Abstractness, or the nonfigurative, has in itself still not proved to be an altogether necessary moment in the self-criticism of pictorial art, even though artists as eminent as Kandinsky and Mondrian have thought so. Representation, or illustration, as such does not abate the uniqueness of pictorial art; what does do so are the associations of the things represented. All recognizable entities (including pictures themselves) exist in three-dimensional space, and the barest suggestion of a recognizable entity suffices to call up associations of that kind of space. The fragmentary silhouette of a human figure, or of a teacup, will do so, and by doing so alienate pictorial space from the two-dimensionality which is the guarantee of painting's independence as an art. Three-dimensionality is the province of sculpture, and for the sake of its own autonomy painting has had above all to divest itself of everything it might share with sculpture. And it is in the course of its effort to do this, and not so much—I repeat—to exclude the representational or the "literary," that painting has made itself abstract.

At the same time Modernist painting demonstrates, precisely in its resistance to the sculptural, that it continues tradition and the themes of tradition, despite all appearances to the contrary. For the resistance to the sculptural begins long before the advent of Modernism. Western painting, insofar as it strives for realistic illusion, owes an enormous debt to sculpture, which taught it in the beginning how to shade and model toward an illusion of relief, and even how to dispose that illusion

in a complementary illusion of deep space. Yet some of
the greatest feats of Western painting came as part of the
effort it has made in the last four centuries to suppress
and dispel the sculptural. Starting in Venice in the six-
teenth century and continuing in Spain, Belgium, and
Holland in the seventeenth, that effort was carried on at
first in the name of color. When David, in the eighteenth
century, sought to revive sculptural painting, it was in
part to save pictorial art from the decorative flattening
out that the emphasis on color seemed to induce. Never-
theless, the strength of David's own best pictures (which
are predominantly portraits) often lies as much in their
color as in anything else. And Ingres, his pupil, though
subordinating color far more consistently, executed pic-
tures that were among the flattest, least sculptural, done
in the West by a sophisticated artist since the fourteenth
century. Thus by the middle of the nineteenth century
all ambitious tendencies in painting were converging
(beneath their differences) in an antisculptural direction.

Modernism, in continuing this direction, made it more
conscious of itself. With Manet and the Impressionists,
the question ceased to be defined as one of color versus
drawing, and became instead a question of purely optical
experience as against optical experience modified or
revised by tactile associations. It was in the name of the
purely and literally optical, not in that of color, that the
Impressionists set themselves to undermining shading
and modeling and everything else that seemed to connote
the sculptural. And in a way like that in which David had
reacted against Fragonard in the name of the sculptural,
Cézanne, and the Cubists after him, reacted against Im-
pressionism. But once again, just as David's and Ingres's
reaction had culminated in a kind of painting even less
sculptural than before, so the Cubist counter-revolution
eventuated in a kind of painting flatter than anything
Western art had seen since before Cimabue—so flat, in-
deed, that it could hardly contain recognizable images.

In the meantime the other cardinal norms of the art of painting were undergoing an equally searching inquiry, though the results may not have been equally conspicuous. It would take me more space than is at my disposal to tell how the norm of the picture's enclosing shape or frame was loosened, then tightened, then loosened once again, and then isolated and tightened once more by successive generations of Modernist painters; or how the norms of finish, of paint texture, and of value and color contrast were tested and retested. Risks have been taken with all these not only for the sake of new expression but also in order to exhibit them more clearly as norms. By being exhibited and made explicit they are tested for their indispensability. This testing is by no means finished, and the fact that it becomes more searching as it proceeds accounts for the radical simplifications, as well as radical complications, in which the very latest abstract art abounds.

Neither the simplifications nor the complications are matters of license. On the contrary, the more closely and essentially the norms of a discipline become defined the less apt they are to permit liberties. ("Liberation" has become a much abused word in connection with avant-garde and Modernist art.) The essential norms or conventions of painting are also the limiting conditions with which a marked-up surface must comply in order to be experienced as a picture. Modernism has found that these limiting conditions can be pushed back indefinitely before a picture stops being a picture and turns into an arbitrary object; but it has also found that the further back these limits are pushed the more explicitly they have to be observed. The intersecting black lines and colored rectangles of a Mondrian may seem hardly enough to make a picture out of, yet by echoing the picture's enclosing shape so self-evidently they impose that shape as a regulating norm with a new force and a new completeness. Far from incurring the danger of arbitrariness in

the absence of a model in nature, Mondrian's art proves, with the passing of time, almost too disciplined, too convention-bound in certain respects; once we have got used to its utter abstractness we realize that it is more traditional in its color, as well as in its subservience to the frame, than the last paintings of Monet are.

It is understood, I hope, that in plotting the rationale of Modernist art I have had to simplify and exaggerate. The flatness toward which Modernist painting orients itself can never be an utter flatness. The heightened sensitivity of the picture plane may no longer permit sculptural illusion, or *trompe-l'œil*, but it does and must permit optical illusion. The first mark made on a surface destroys its virtual flatness, and the configurations of a Mondrian still suggest a kind of illusion of a kind of third dimension. Only now it is a strictly pictorial, strictly optical third dimension. Where the Old Masters created an illusion of space into which one could imagine onself walking, the illusion created by a Modernist is one into which one can look, can travel through, only with the eye.

One begins to realize that the Neo-Impressionists were not altogether misguided when they flirted with science. Kantian self-criticism finds its perfect expression in science rather than in philosophy, and when this kind of self-criticism was applied in art the latter was brought closer in spirit to scientific method than ever before— closer than in the early Renaissance. That visual art should confine itself exclusively to what is given in visual experience, and make no reference to anything given in other orders of experience, is a notion whose only justification lies, notionally, in scientific consistency. Scientific method alone asks that a situation be resolved in exactly the same kind of terms as that in which it is presented— a problem in physiology is solved in terms of physiology, not in those of psychology; to be solved in terms of psychology it has to be presented in, or translated into,

these terms first. Analogously, Modernist painting asks that a literary theme be translated into strictly optical, two-dimensional terms before becoming the subject of pictorial art—which means its being translated in such a way that it entirely loses its literary character. Actually, such consistency promises nothing in the way of aesthetic quality or aesthetic results, and the fact that the best art of the past seventy or eighty years increasingly approaches such consistency does not change this; now as before, the only consistency which counts in art is aesthetic consistency, which shows itself only in results and never in methods or means. From the point of view of art itself, its convergence of spirit with science happens to be a mere accident, and neither art nor science gives or assures the other of anything more than it ever did. What their convergence does show, however, is the degree to which Modernist art belongs to the same historical and cultural tendency as modern science.

It should also be understood that the self-criticism of Modernist art has never been carried on in any but a spontaneous and subliminal way. It has been altogether a question of practice, immanent to practice and never a topic of theory. Much has been heard about programs in connection with Modernist art, but there has really been far less of the programmatic in Modernist art than in Renaissance or Academic art. With a few untypical exceptions, the masters of Modernism have betrayed no more of an appetite for fixed ideas about art than Corot did. Certain inclinations and emphases, certain refusals and abstinences seem to become necessary simply because the way to stronger, more expressive art seems to lie through them. The immediate aims of Modernist artists remain individual before anything else, and the truth or success of their work is individual before it is anything else. To the extent that it succeeds as art, Modernist art partakes in no way of the character of a demonstration. It has needed the accumulation over decades of a good deal of

individual achievement to reveal the self-critical tendency of Modernist painting. No one artist was, or is yet, consciously aware of this tendency, nor could any artist work successfully in conscious awareness of it. To this extent—which is by far the largest—art gets carried on under Modernism in the same way as before.

And I cannot insist enough that Modernism has never meant anything like a break with the past. It may mean a devolution, an unraveling of anterior tradition, but it also means its continuation. Modernist art develops out of the past without gap or break, and wherever it ends up it will never stop being intelligible in terms of the continuity of art. The making of pictures has been governed, since pictures first began to be made, by all the norms I have mentioned. The Paleolithic painter or engraver could disregard the norm of the frame and treat the surface in both a literally and a virtually sculptural way because he made images rather than pictures, and worked on a support whose limits could be disregarded because (except in the case of small objects like a bone or horn) nature gave them to the artist in an unmanageable way. But the making of pictures, as against images in the flat, means the deliberate choice and creation of limits. This deliberateness is what Modernism harps on: that is, it spells out the fact that the limiting conditions of art have to be made altogether human limits.

I repeat that Modernist art does not offer theoretical demonstrations. It could be said, rather, that it converts all theoretical possibilities into empirical ones, and in doing so tests, inadvertently, all theories about art for their relevance to the actual practice and experience of art. Modernism is subversive in this respect alone. Ever so many factors thought to be essential to the making and experiencing of art have been shown not to be so by the fact that Modernist art has been able to dispense with them and yet continue to provide the experience of art in all its essentials. That this "demonstration" has left

most of our old *value* judgments intact makes it only the more conclusive. Modernism may have had something to do with the revival of the reputations of Uccello, Piero, El Greco, Georges de la Tour, and even Vermeer, and it certainly confirmed if it did not start other revivals like that of Giotto; but Modernism has not lowered thereby the standing of Leonardo, Raphael, Titian, Rubens, Rembrandt, or Watteau. What Modernism has made clear is that, though the past did appreciate masters like these justly, it often gave wrong or irrelevant reasons for doing so.

Still, in some ways this situation has hardly changed. Art criticism lags behind Modernist as it lagged behind pre-Modernist art. Most of the things that get written about contemporary art belong to journalism rather than criticism properly speaking. It belongs to journalism— and to the millennial complex from which so many journalists suffer in our day—that each new phase of Modernism should be hailed as the start of a whole new epoch of art making a decisive break with all the customs and conventions of the past. Each time, a kind of art is expected that will be so unlike previous kinds of art, and so "liberated" from norms of practice or taste, that everybody, regardless of how informed or uninformed, will be able to have his say about it. And each time, this expectation is disappointed, as the phase of Modernism in question takes its place, finally, in the intelligible continuity of taste and tradition, and as it becomes clear that the same demands as before are made on artist and spectator.

Nothing could be further from the authentic art of our time than the idea of a rupture of continuity. Art is, among many other things, continuity. Without the past of art, and without the need and compulsion to maintain past standards of excellence, such a thing as Modernist art would be impossible.

IN PRAISE OF ILLUSION*

by Dore Ashton

*Dore Ashton is among the most distinguished
of the younger critics. In this article she ex-
plores the role of the imagination in art, and
comes to the conclusion that its primacy re-
mains undisputed, despite the present popu-
larity of mechanistic and supposedly factual
approaches to art. As she remarks in her
monograph on Philip Guston: the artist "Like
the poet . . . confronts the great abstractions
of the mind and seeks to find corporeal ana-
logues to illustrate them."*

*Miss Ashton was born in Newark, New
Jersey, in 1928 and received her education at
the University of Wisconsin and Harvard. She
is staff art critic for* Studio International, Arts
and Architecture, Cimaise, *and* XXe Siècle,
*and teaches philosophy of art and contem-
porary art history. Her latest book,* The Un-
known Shore: A View of Contemporary Art,
was published in 1962.

AS THE VISUAL ARTS move toward arcane utterance, the
urge to explain art, to root out a scientific rationale for
its existence becomes intense.

Out of weariness, exasperation, and frustration, the
critic often resorts to evidence or data in what he im-
agines is a scientific usage. Years of the vagueness of
"psychological" interpretation in both literature and vis-

° A substantial part of this article was published in the March,
1965, issue of *Arts and Architecture.*

ual art have worn away at the spirit and have left a wake of irritability that can be salved only by facts. Literal, matter-of-fact approaches to the arts become more and more frequent, the most obvious being the influence of information theory on art criticism.

If information theory has little direct impact on the thoughts of those writing art criticism, it has nevertheless crept in as an influence. Many younger critics devote themselves to describing the "facts" before them. Many assume that the "messages" on the canvas are processed as sense data and nothing more. Many seek a consciously objective, and therefore scientifically justifiable, stance. In some ways, they echo the excesses of literary critics some years ago who, influenced by logical positivism and by the "new criticism" which concentrated on textual analysis, reacted against the psychological criticism which had predominated before them.

The critics who concentrate on the facts (and they do so at great length) are given to a kind of fragmented, pedantic, and rigid style. Take for instance the literature on Kenneth Noland: It commences with Clement Greenberg's essay in which he defines Noland as a "conceptual" painter. It is taken up by Michael Fried who bows in deference to Greenberg and then undertakes a tedious recital of the "facts," devoting himself *only* to the "structural aspects of Noland's painting." This entails considerable discussion of both format and edge. Jane Harrison, respectfully noting the two previous essays, continues this factual cataloguing by announcing in her own essay "I shall write about Noland's use of color with an emphasis on this aspect."

Certainly it could be argued that the style of the new painters under discussion calls forth an apposite critical style. Barbara Rose has defined the new "post painterly painters" (Greenberg's definition) as "uningratiating, unsentimental, unbiographical and not open to interpretation." She adds that "order, coherence, system, repetition,

internal necessity and perhaps what one might term a Calvinistic sense of conceptual pre-destination are common to the new abstract painting."

If the new painters are "not open to interpretation," they are certainly sitting ducks for academic minds that like to organize themselves systematically and in terms of the facts. The precision available in scientific methods of discourse is dear to them and they try strenuously to mimic it.

Not all critical temperaments, however, respond to this method of precise analysis of given facts. I, for instance, have always clung to the conviction that the imagination, as Baudelaire said, is the queen of the faculties. It is by its very nature expansive, unpredictable and not accessible to such neat schema as input-processing-output analysis. It seems to me that the imagination never allows a perception to remain in its raw direct state, if indeed there is such a thing. It is plastic, infinitely mobile, and its tendency is to allegorize.

If this is so, and if works of art are synonymous with works of the imagination, how can such rigid schematizations as cited above apply?

Yet, like other criticis, I have been tempted—partly out of curiosity, partly out of a natural desire for reassurance—to seek evidence in support of my intuitive conviction. In a conversation with Dr. Bernard Bihari, a brain physiologist and psychiatrist, I mentioned my romantic conception of the nature of the imagination. To my surprise, he was keenly interested. He went to his files and selected a number of papers in which the trend of speculation, and some tangible proofs, tend to confirm that the imagination is still the inscrutable queen of the faculties.

Perhaps the most dramatic evidence occurs in numerous recent accounts dealing with experiments in sensory deprivation. In these experiments, the subject was placed in situations of minimum sensory stimulus. For instance, he was masked and submerged in a darkened tank of

slowly flowing, warm water. Or he was extended on a bed in a dark, soundproof chamber, in what one writer called "monotonous solitude." In all the experiments, the aim was to reduce sensory input to an absolute minimum. In other words, to check the barrage of "information."

What happens to an individual isolated from the usual rapid succession of external stimuli? If one were to accept the mechanistic theories, he would soon cease to have any mental or imaginative activity. But these experiments indicate that his imagination functions with increased intensity. Nearly all subjects experienced unusual mental imagery—imagery not dependent on external sensory stimuli, obviously. I quote from Drs. Jack Mendelson and Philip Solomon:

> Why do hallucinations occur in sensory deprivation? Here we can only speculate. Presumably the maintenance of optimum conscious awareness and accurate reality testing depends on a necessary state of alertness, which in turn is dependent on a constant stream of *changing* stimuli from the external world, mediated through the reticular activating system. In the absence or impairment of such a stream, as occurs in sensory deprivation (or sensory monotony) alertness falls away, direct contract with the outside world diminishes and the balance of integrated activity tilts in the direction of increased relative prominence of impulses from the *inner body and central nervous system itself.* . . . The result is an increased tendency to the rehearsal of memory, meditative thought, revery and body image awareness."[1]

In other words, you can take everything away; but the mind, or imagination, continues its travail. Even in the

[1] "Hallucinations in Sensory Deprivation," reprinted from *Hallucinations*, Grune & Stratton, Inc., 1962.

face of works of art which do not purport to be more than pure visible fact, works such as Larry Poons's optically activated paintings, Noland's chevron paintings, or the mechanically aggressive paintings of Richard Anuszkiewicz, the imagination will not remain static. The specified denial of interpretation does not hold up because of the very nature of the imagination. To assume, as more and more critics seem to, that the visible data on the canvas surface—the colors or structural evidence—is all there is, and works only in terms of sensory perception, is to impoverish the reception of works of art unduly. The observation that there is an increased tendency to "rehearsal of memory, reverie and body-image awareness" in states of sensory deprivation suggests a great deal to anyone conversant with the visual arts. Sensations of weightlessness, commonly reported by the subjects in these experiments, are often encountered in abstract paintings, where gravity seems to play no role. Reverie is essential to the creative artist, and certain poets (Poe, for instance) suggested that the hypnogogic state—that moment between waking and slumber—is the optimal condition for imagining. Rehearsal of memory, which in the terms described by the scientists in these experiments strongly resembles the idea of stream-of-consciousness in literature, is a regular experience for the visual artist who has reported on many occasions that his mind wanders, and suddenly dredges up new forms.

Even so rigorously logical a painter as Victor Vasarely has described his process in terms which could easily be the terms of the more romantic Abstract Expressionist whose statements abound with imaginative revelations. Vasarely told his old friend, the painter Jean Dewasne:

> I see, I imagine, I sense a mounting in me,
> I desire or impose upon myself a color—an
> obsessing and tenacious color. This color must
> present itself in a form. I search, I fumble in
> myself until I can define it clearly, more or less

round here, pointed there, open at left, bal-
anced in this sense around an ideal center of
plastic gravity. . . . Waiting, I carry that form
around in me like a baby.

An interesting conundrum faces the scientists involved
in these explorations of sensory deprivation, and it has
to do with the definition of illusion. The hallucinations
described in the reports rather cautiously are similar to
illusions in that they are controlled in the centers of the
brain. The dictionary says that illusion is "an unreal or
misleading image presented to the vision; a deceptive
appearance." The scientists have discovered the awk-
wardness of this definition:

Although we define illusion as the distortion
of an external sensory cue, and hallucination
as a percept without external sensory cue, we
know that an individual perceives many sensa-
tions that emanate from within himself. If we
re-define illusion as a misperception of any
internal or external cue, and re-define halluci-
nation as a false perception without internal
or external cue, our problem only becomes
more difficult for how can we determine that
a person is having internal sensations? To
complicate the issue, when a person reporting
fantasy material says "I saw" does he mean
that he actually perceived something, or does
he use this to refer to phenomena he knows he
did not "see" but thought about?[2]

For my unscientific purposes, an illusion is a percep-
tion worked upon by the imagination. Obviously, any
work of art is an illusion in the sense that its material
is not necessarily its meaning. A painting presents data—

[2] Hallucinations in Sensory Deprivation, A. J. Silverman, M.D.;
S. I. Cohen, M.D.; B. Bressler, M.D.; and B. M. Shmavonian,
Ph.D. Reprinted from *Hallucinations*, Grune & Stratton, Inc.,
1962.

it is true—which the eye relays to the brain. But the imagination works upon the data, creates an "image" of it, and even an interpretation. If a circle painted on a canvas were not transmuted by the imagination, it would register as briefly, and with as little significance as a traffic sign.

There are possible alternatives to the definitions of hallucination and illusion discussed in the above experiment. Some of the answers may lie in recent dream experiments. Dr. Bihari remarked that dream studies may eventually offer proof that creative cognitive activity can occur independently of external stimuli. He points out that everyone dreams every single night and that the brainwaves during dreaming periods are indistinguishable from the patterns when the person is aware, alert and focusing attention on something either imagined or perceived.

"This does suggest," he said, "that while dreaming, the brain, though not conscious, is nevertheless working very hard in cognitive and emotional ways. During this time the brain shuts off sensory input, yet contrives to function cognitively, and with more imaginativeness and novelty than while awake."

The ancients, the Surrealists, and many individuals throughout history (above all, Nietzsche) understood the importance of dream. The "internal sensations" the experimenters found hard to measure are strenuously at work in the dreamer. Untrammeled by scientific considerations, it is not difficult to conjecture that the dream is a fabrication of the imagination, and that the imagination alone creates the arresting images which are the source of art.

When Redon made a plea for the kinds of visions that are not stimulated directly by external experiences, he was acknowledging the mental activity called imagination—that queen of the faculties that is self-generating and expansive. Every serious draftsman, even those most

eager to represent that which they see, knows the experience of having the imagination take over: While the eye is following the line of a table or a rock or a woman's breast, and while the hand is following the eye, something often happens which short-circuits this procedure. The hand then moves out, guided by the imagination, inventing forms that are only remotely indebted to the presence of a real table, rock, or breast. This accounts for the arabesques discretely winding through Rembrandt's drawings; for the breaks in line and small strokes in the backgrounds of Raphael's drawings; for the elaborate internal structures in the clothing of Ingres's sitters, and for much of the detail in Miró.

Studies of the imagination when undertaken by artists (the poet Coleridge, for instance) often start with observed data and then leap off into speculation. Henri Bergson's speculations moved far from his preliminary scientific data. Rather, Bergson swept forward on the crest of his brilliant intuitions to make certain observations that are just now finding scientific confirmation.

Lately there have been several bows from scholars using scientific methods. I think, for instance, of Claude Lévi-Strauss's remarks concerning the accuracy of Bergson's thoughts about totemism. The French anthropologist—a painstaking scientific worker—proves Bergson right in exhaustive studies of primitive societies in Australia and Africa.

Unexpectedly, I find among the papers Dr. Bihari offered me, an arresting reference to Bergson in Sir Wilfred Le Gros Clark's "Sensory Experience and Brain Structure." The Oxford professor of anatomy begins his lecture by stating that certain of Bergson's ideas deserve renewed attention:

> I refer more especially to Bergson's contrast of those two aspects of conscious experience which he terms intellect and intuition. Intellect, he argues, is the product of a gradual

evolutionary process which enables the individual with increasing efficiency to select and abstract just those several features of surrounding objects which are directly relevant to the problem of evolutionary survival. In so far as it selects and abstracts, the intellect by itself can provide only a partial view of reality. "To conquer matter" Bergson says, "consciousness has had to exhaust the best part of its power"—it has had to "adapt itself to the habits of matter and concentrate all its attention on them, in fact, determine itself more especially as intellect." But there remains "around our conceptual and logical thought a vague nebulosity, made of the very substance out of which has been formed the luminous nucleus which we call the intellect." Therein reside certain powers that are complementary to the understanding—powers of intuitive recognition.[3]

Sir Wilfred continues, saying that as an anatomist he is particularly interested in Bergson's conception of a duality of conscious experience: "The fact is that the idea of a duality in modes of sensory perception is ever and again presenting itself in one form or another to the neurological investigator." In a discussion of various anatomical studies, beyond my competence to synopsize, Sir Wilfred points to evidence that a "primitive foundation still persists in large measure in the adult brain; in fact, it is this which comprises the basis of the whole reticular system." It now seems certain, he continues, that

at every level in every sensory pathway, as far up as the cerebral cortex itself, the pattern of input from peripheral receptors may be continually controlled and modified by the

[3] The Thirty-second Maudsley Lecture, "Sensory Experience and Brain Structure," by Wilfred Le Gros Clark. *The Journal of Mental Science*, Vol. 104, No. 434, January, 1958.

activity of central regulative mechanisms. This general principle of the nervous organization is obviously of the greatest importance for the study of perceptual phenomena, for it determines that what we ultimately experience as a conscious sensation is not solely dependent on external stimuli alone; the effects of the latter may be variably conditioned by intrinsic activities emanating from the brain itself.

Obliquely, and with characteristic scientific caution, Sir Wilfred offers his confirmation of Bergson's theory:

If it is the function of lower centers of the specific sensory pathways to select and sort into categories impulses which have been initiated at the periphery by a continuously graded range of stimuli, if, that is to say, the effect of their selective activity is the abstraction of isolates from a continuum, clearly the higher centers (including the cerebral cortex) are likely to be presented with only an incomplete and patchy replica of external reality by these particular pathways. It is as though we were presented with a series of arbitrary points in a continuous curve, with the result that we interpret the abrupt contrasts between such discontinuous points as if an even curve did not exist. Such a conclusion makes an interesting comparison with one of the main themes of Bergson's philosophy—that purely intellectual processes inevitably involve selection and abstraction to the extent that they can only provide a partial view of external reality.

This is precisely what many artists have sensed. The vision of the "whole" is given by the imagination. Baudelaire and Coleridge both characterized the imagination as the synthesizer of intellect and intuition. These poetic constructions find considerable support in Sir

Wilfred's paper. Bergson thought that intuition completes a vision of whole experience which intellect cannot provide, and was followed in this by Proust. Sir Wilfred suggests that there may be a specific system of activity in the brain equivalent to Bergson's "luminous nuclei" to provide a general background, an intuitive grasp of a whole. Possibly, it is this same system which receives and creates the plastic, wide-ranging experience which the illusions in art provide.

All these discussions repeatedly give support to the ideas of Gaston Bachelard, who wrote so often that the function of the real cannot stand alone. The function of the irreal is just as important to us. In other words, illusion: Illusion is characteristic of imaginative activity.

This is demonstrated in the sensory-deprivation experiments where the imagination functions ceaselessly. It is demonstrated in the dream experiments where it is seen that physiological activity is the same whether a person is dreaming or consciously thinking in a waking state. It is suggested by anatomical studies which point increasingly to the dual system Sir Wilfred discusses, and strongly hints that it is in this "reticular" system that much originating material is contrived (in other words, the signal creative inventions found only in high arts and sciences).

Illusion, then, is a real—or should I say authentic?—part of experience, and a necessary one. (Dreamers not permitted to dream during experiments show marked anxiety, quite similar to the irritability and anxiety experienced by the artist who is prevented from working.)

One further observation stemming from physiological research on the brain: The originating status of the imagination which we have assumed to exist, but could never prove, now seems to have its scientific evidence. A visual image may be evoked by a surgeon by stimulating the cortex electrically during an operation. Since there is no "external reality" to cue the imagination or

mind, it would seem that "external reality" is not the sole reality. The internal experiences of the mind, and the kind of imagery it invents and casts into works of art, are clearly self-generating, at least to some degree. The simple feedback principle which works so well in computing machines, and for certain art and literary critics when they apply it, is highly inadequate to the understanding of the originating quality of the imagination.

CRITICAL SCHIZOPHRENIA
AND THE INTENTIONALIST METHOD*

by Max Kozloff

". . . the important relation in a work of art
is not between two or more forms on a surface,
but between itself as a complex event and the
spectator." Max Kozloff is concerned here with
a new critical awareness which has arisen with
the appearance of the new art, and the conflict
between the emotional and intellectual con-
siderations in criticism.

Max Kozloff was born in Chicago in 1933.
He was trained as an art historian at the In-
stitute of Fine Arts and, in addition to having
published widely in such periodicals as Arts,
Art International, and Partisan Review, is the
regular art critic for The Nation and New
York Editor for Artforum. He is the author of
a monograph on Jasper Johns to appear in
1966 and is presently at work on research
concerning the history of criticism of modern
art.

THIS MORNING, I want to talk about the experience of the
critic, and to offer a kind of introspection, almost a
reverie, on some of his problems in connection with the
phenomena of avant-garde art. The subject of older art,
or art of a more conservative persuasion, is properly the
subject of another paper or another talk. First, let me

* Presented at the 52nd biennial Convention of The American
Federation of Arts at the symposium "The Critic and the Visual
Arts" in Boston, in April, 1965.

begin by giving you three quotations: First by Susan Sontag:

> To interpret is to impoverish, to deplete the world—in order to set up a shadow world of "meanings," . . . In most modern instances, interpretation amounts to the philistine refusal to leave the work of art alone. Real art has the capacity to make us nervous. By reducing the work of art to its content and then interpreting that, one tames the work of art. Interpretation makes art manageable, comfortable.

Here is the second quotation, by Leo Steinberg:

> Contemporary art is constantly inviting us to applaud the destruction of values which we still cherish, while the positive cause, for the sake of which the sacrifices are made, is rarely made clear. So that the sacrifices appear as acts of demolition, or of dismantling, without any motive.

And finally, the third quotation, by Paul Valéry:

> All the arts live by words. Each work of art demands its response; and the urge that drives man to create—like the creations that result from this strange instinct—is inseparable from a form of "literature," whether written or not, whether immediate or premeditated. May not the prime motive of any work be the wish to give rise to discussion, if only between the mind and itself?

Now, if I address you this morning as a critic, it is not through any exclusiveness on my part, for in our relations to works of art, I think most of us can hardly avoid being critical, either by the amount of time we give to art, or by our lack of time, what we trouble to learn about it, or forget about it, what we choose to value or to ignore.

Well, a writer shares this natural critical behavior with all spectators. But when he starts to write, the normalcy of the critical spirit transforms itself, I think, into the perversity of the critical act. For it is only in writing about his artistic experiences that a man realizes how unrecoverable they are and, worse still, that he is a professional handler or at least observer of his own feelings. He must tamper in some manner with his reactions in order to externalize them. It is a very nervous-making proposition.

He becomes a man alone, isolated by the necessity to transform and give an account of a nondiscursive, if common, experience, in the medium of words. As the authors I have quoted suggest, he has, at this point, three alternatives. He may abdicate "interpretation," despair of achieving it, or embrace it as the only means of fulfilling himself.

In early 1962, March to be exact, there began to appear a spate of articles by critics about criticism. One remembers Clement Greenberg's "Why Art Writing Earns its Bad Name," Leo Steinberg's "Contemporary Art and the Plight of Its Public," and Hilton Kramer's article a little later on in his preface to *Arts Yearbook*. In addition, there appeared two pieces that I had written, one in general rebuttal of the Greenberg position, the other in *The Nation*. Also, there came forth Harold Rosenberg's comments on criticism much later in *Artforum*, and more recently, Michael Fried's article on formal criticism, in the *American Scholar* (Autumn, 1964).

One was aware that a dam had burst, and one knew where and when, but one wants very much to know why—why at that particular moment? Well, I think certain reasons can be adduced for this sudden interest in criticism by critics.

For one thing, there seems to have been a tremendous dissatisfaction and self-consciousness, in which the critics seeking to find their own identity had to surmount the

obstacle of their own lack of self-criticism. For another, connected, but I think much more important reason, 1962 was the year in which a discomfort with new art—pop, and its colleague in abstraction, figuratively detonated. The realization was upon us that a younger generation had obviously succeeded the Abstract Expressionists and was challenging the spectator with a critique which was very unsettling, and within a field of inquiry which was opaque and alien. Nothing was clearer than the inadequacy of the then going critical apparatus in judging these pictorial phenomena.

In addition, there was a breakdown of idiomatic cohesiveness, a wide-ranging differentiation among the artists themselves, so that no simplistic critical attack appeared sufficient. Finally, the diffusion of art in society and the greatly accelerated interest in art by laymen only emphasized by contrast the evasion of responsibility by most critics. Nothing less than their leadership was at stake. But this in turn could not be affirmed without an awareness and shoring up of the past discipline of criticism, such as it then was.

Today I have no time to go into an involved discussion of the intellectual currents of American art criticism. Generally, however, there seem to have been two streams: on one hand, faithfulness to the optical data, a fidelity both descriptive and analytic, and on the other, of evocative or poetic judgment, chafing to find "content," sometimes cued by visual fact, but not necessarily. Both vantages, by the way, were moralistically based, inasmuch as each assumed value to be revealed only through its own perspective, while the other was stigmatized as frivolous or incidental.

What they had in common, however, was their inability to see the "otherness" of the work, that is, its distinctness as a product separate from their own systems or ideologies. Unfortunately, Abstract Expressionism did not succeed in eliciting any common bond between the two

critical ideologies, nor in strengthening the accuracy of either one vis-à-vis individual works of art.

In the radically changed situation today, this has become a rather crucial deficiency. Let's consider for a moment the tenets of formalist criticism, as they would apply to one of the new works done by a young and rather influential, if unsettling, representative of new art. Look at a painting by Frank Stella, *Die Fahne Hoch*.

Now, it seems reasonable to assume, when we look at this work, that it is an abstract painting and, therefore, approachable in terms of the reputable tenets of abstract art—how abstract art had been looked upon in the twentieth century. Let me quote two statements which have contributed to the basis of vision regarding abstract art. The first is by Albert Gleizes and Jean Metzinger in their book *On Cubism* (1913):

> The science of design consists in instituting relations between straight lines and curves. A picture which contained only straight lines or curves would not express existence. It would be the same with a painting in which curves and straight lines exactly compensated each other, for exact equivalence is equal to zero.

Or let's take another statement:

> Sensations are not transmissible, or rather their purely qualitative properties are not transmissible. The same, however, does not apply for relations between sensations. From this point of view, everything objective is devoid of all quality: it is purely relative. . . . Consequently, only relations between sensations can have an objective value. It is only in these relationships that objectivity must be sought.

This last may sound like Mondrian, but was written by Henri Poincaré in 1906. Now, looking at this painting

by Stella, has one seen any greater betrayal of the idea that forms must work together in some organic and re-creative way, or of necessary relational explorations, than this painting? What we in fact see is a closed system in which the geographic location of every element is fixed by no agency more significant than the choice of format, and placed in a set sequence that almost seems an illus-tration of the "zero" to which Gleizes and Metzinger previously referred. Given Stella's initial decisions, the whole façade is frozen into a predictable framework which becomes essentially an anti-relationship frame-work, consumed, from the constructional point of view, almost immediately. I presume you have seen there is a four-part image, or rather emblem, here, four parts sym-metrically reversing each other as if they were mutual carbons, upon the whole surface of this painting.

I choose this picture not merely because it encourages, only to reject, a certain kind of analysis, but also because it shows that the important relation in a work of art is not between two or more forms on a surface, but between itself as a complex event, and the spectator. A paradox of abstractionist theory is that it imposes "apartness" on the work of art, rather than allowing us to discover it personally for ourselves. And if one of the major notions of formalist criticism has been that iconography or any associative references are literary matters only, that pure forms are what constitute "expression," then the Stella painting indicates that formal analysis itself is a kind of literature, a new subject matter, if you will, and a way of talking *around* rather than *about* what is there.

May not Stella in effect be saying that the problem of abstract art makes what is "expressed," as opposed to what is put together, unavoidable, and that the two, as so obvious here, are not the same? He forces one to reconsider the tools of apprehension. Suddenly, one realizes that a cycle is completed and that the point of such an ostensibly non-representational autonomous

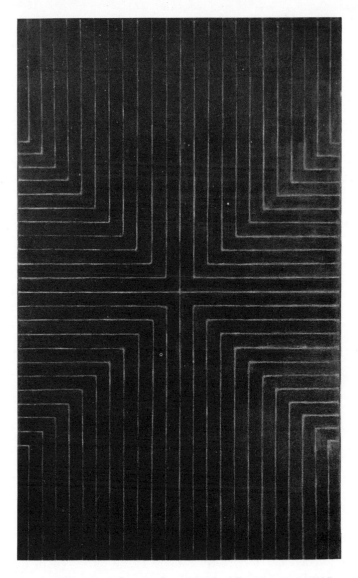

Frank Stella: *Die Fahne Hoch*. 1959. Enamel on canvas. 121½″ x 72″. Photograph courtesy of Leo Castelli Gallery, New York.

work can be appreciated only through an informed out-
side knowledge of the context of abstract painting, as it
is redefined by Stella's radical gesture.

The variables in the aesthetic experience, therefore,
are the work, the spectator's physiological and emotional
response, and whatever appropriate information he can
bring to bear—all of which will affect the mutual shaping
of object and subject. Contrary to the theory of abstract
art, these will vary greatly in significance. Incidentally,
one further obstacle in that theory is its fond belief that
modern art is out to reduce itself to some essential pres-
ence or to refine itself to an exalted animal or kinesthetic
sensation. But Stella demonstrates, I think, that the more
reductionist the visual material, the more conceptual is
its nature. Far from becoming physically provocative it
becomes rhetorically provocative. And this is a principle
that is decidedly Dada in character. Actually, it is not
accidental that Stella and Jasper Johns's work in the same
milieu, just as it was not coincidental that Malevitch's
white-on-white paintings and Duchamp's "Bicycle Wheel
Mounted on a Stool" were roughly contemporary fifty
years ago. On both occasions, a coexistence of forces has
expanded the notion of the *artistic*, beyond the capacities
of conventional relational painting.

Now, this impression that there is a point of diminish-
ing returns in purism promotes a disproportionately
heterogeneous response in order to comprehend it. This
conclusion is intellectually derived, and it obliges us to
process forms in an effort to deal with the ideas con-
cealed, or alluded to, by those forms. Unfortunately, a
constant factor in American art life has been anti-
intellectualism, whether it comes from the one (with
its contempt for interpretation) or the other (with its
disdain for analysis), or both of the two currents I men-
tioned earlier.

After accommodating itself with great difficulty to the
fact that art was "sensuous," "creative," "emotional," and

"personal," art commentary wallowed in an irrationality which almost became a reverse Puritanism. If there was once a discomfort before all the immeasurable, intangible aspects of art, there is now an equal displeasure or reluctance to deal with an artistic dialectic that demands logical examination. Not for nothing are we in the midst, at the moment, of an accelerating cult of enthusiasm, a movement of the sensibility which might be called "Warholism," in which nothing has to be proved or justified, and which is designed to invalidate, as one writer put it, "the critic, with his baggage of lunatic distinctions, judgments, significant and insignificant forms, 'second guesses,' killing doubts, museum mentality—pack him off to look for 'motifs' in comic strips and half the battle is won." (Philip Leider, *Artforum*, December, 1964)

But this is an aggression by artists which can be understood and given any significance as the anti-humanist development it is only from the vantage of a new methodology in criticism. As so often happens, only the brain can appreciate and be affected by the attempt of another brain to deny itself. New art, however, constantly makes that attempt, and, to quote Miss Sontag again:

> The flight from interpretation seems particularly a feature of modern painting. Abstract painting is the attempt to have, in the ordinary sense, no content, and since there is no content, there can be no interpretation. Pop art works by the opposite means to the same result, using a content so blatant, so "what it is," it, too, ends by being uninterpretable.

For myself, this statement, far from solving, only poses the problem. One of the chief difficulties in judging art of the last seven years is the pervasive habit of painters and sculptors of suppressing moral values inherent in objects and sensations. The absence of any comment on even the most vulgar motifs in pop art is a well-known

phenomenon, but it applies in a subtler, yet still disconcerting manner, to aspects of current abstraction, as I hope the Stella painting indicates.

Curiously enough, this neutrality of art has not yet affected criticism with a proper skepticism of its own. (If we were honest with ourselves, we should be far more ambivalent about the avant-garde than we have revealed.) Modern art has traditionally obscurred the distinctions between the beautiful and the ugly, but rarely so systematically as now has it blurred the categories of good and bad, the indifferent and the committed. Even the affectivity of pleasure and pain, once such reliable cues to meaning, can, as the Stella once again shows, be anesthetized to insignificance.

This may account for the situation in which I, at least, frequently find myself of respecting a work of art, or its position, but not responding to it, or vice versa. Under the circumstances, what we are able to say about the processes and intentions of that work as they affect our experience or change our world is more relevant, perhaps in the end more important, than our judgment of that work. Not so much is this the only adequate; it is the only natural, or inevitable, defense of the critic against the relatively amoral strategy of the artist.

But there is a practical morality all its own in criticism. I am against such expressions as "exquisite" or "disgusting," "exciting" or "mediocre," not only because they are inarticulate and unsubtle, but because they are abstract. Criticism should be hard verbal cash on the line. If a reader attains no idea of how I evaluate a work by my analytic observation and description, then no expletive tacked on at the end will help him. Conversely, if that's all the idea he gains, then my critical elucidation has failed. One must remain faithful to this idea of elucidation, leaving evaluation to the choice of what is elucidated, and how it is subsequently modified by the critical piece per se.

We are back again, therefore, at the responsibility of interpretation, or shall we say, "of the mind, provoked into a dialogue with itself."

I, at least, consider that responsibility to be an exploration of the intention of the artist, and as a result, should like to see a scrupulously "intentionalist" criticism come into being, as a means of dealing with problematical aspects of new art.

What can this possibly mean? We know that the literary critics have long since forsaken the intentionalist approach as a fallacy, saying that knowledge of intention can only illuminate a fragment of the over-all entity and can never account for the emotion produced or measure the statement achieved. I agree with the majority of these points, but the truth of the matter is, the literary critics do not have an intransigent avant-garde, and are not faced with a new kind of anti-humanism in their field. Besides, I want to employ this term "intention" very distinctly, very individually.

"Artistic intention" is different from the unconscious desires or fantasies of the artist which may not have any relation to his art. It is different too from his public statements, because these may be wishful or retrospective; and it is distinct from the "effect" of his work because this has been already more or less indiscriminately received. Yet, all this can be data from which a notion of artistic intention can be constructed. Essentially though, what one does is to examine the physical execution of a work, and all its complexities, as they lead to some awareness of the organizing concept. And this in turn is based upon a visual response which constantly tests itself. The most useful way of seeing how this operates is by observing or examining perennial oppositions within works of art. How, for instance, does one determine whether what one sees are contrasts, deliberate oppositions, dramatic tensions, clever paradoxes, or just plain inconsistencies and contradictions? To ask this question—and

I do not see how it can be avoided—is to inquire of intention. And to answer it for oneself, and hopefully for others, is to have performed a critical act.

Let's go back to the Stella painting just very briefly. I have no intention of discussing all its intricacies at this time, but I would like to point out just a few things. One can notice, for instance, in the original that its totally non-referential, abstract character is contrasted with its concrete actuality. The thickness of the stretcher is a good three inches and comes out from the wall, is intrusive, has a presence. Similarly, the paint itself, which looks so dead and undifferentiated, is opposed with its soft edges to the totally bland textile channels of unprimed canvas, which make the paint matter itself look suddenly far more associated, or saturated with varying sensations than previously. One becomes aware of a curious equilibrium between the idea we have of painting and the presence we think of as an object's. Stella's discreetness in not giving in to either one or the other of these conditions, itself a valid ambiguity, constitutes our first signpost to his artistic intention.

Does it become clearer, I wonder, how intentionalist supersedes formalist and evocative criticism, while feeling free to take advantage of both? In fact, becoming a compound of both? I study intention because there is no other way of determining the nature of the object and, more important still, no other way of ascertaining the terms of the dialogue between myself and that object.

Ruskin once said that a man of strong feeling will be a poor judge of art because he may see a thunderstorm in a paint smudge. Conversely, he might have said that a man of weak feeling would also be a poor judge of art because he will lack the openness of mind to see what works of art so often suggest, rather than state.

To attain the psychological balance between credulity and incredulity, I have decided to take some peculiar measures: to be, on one hand, philosophically and intel-

lectually as sympathetic and as attuned as I can be, but on the other, emotionally as resistant and as tough-minded as I know how to be. Or for the fun of it, I can reverse this, if it is at all possible. Whenever I can transcend or at least coherently state the results of this schizophrenic conflict, I am able to write a piece of criticism and so, in the end, I affirm what Paul Valéry affirmed, although, ideally, stopping far short of "taming" the work of art. Here I am also reminded of what Leo Steinberg stated in that remarkable article I quoted earlier:

> It is quite wrong to say that the bewilderment people feel over a new style is of no great account since it doesn't last long. Indeed it does; it has been with us for a century. And the thrill of pain caused by modern art is like an addiction—so much of a necessity to us, that societies like Soviet Russia, without any outrageous modern art of their own, seem to us to be only half alive. They do not suffer that perpetual anxiety, or periodic frustration, or unease, which is our normal condition.

And art, I may add, is a haunting paradigm of that condition.

ANTI-ART AND CRITICISM*

by Allen Leepa

The following article presents an analysis of the existential aesthetic required for meaningful criticism of today's art. By way of introduction it is enough to quote from Sir Herbert Read's preface to Professor Leepa's book The Challenge of Modern Art: *"It is because the modern artist is faced by an existential situation of unparalleled complexity that his art, in attempting to resolve that situation, assumes those unfamiliar forms which Mr. Leepa has so persuasively explained."*

Allen Leepa was born in New York in 1919. He studied at the Art Students League, New Bauhaus, Hans Hofmann School, and Columbia University. He was a Fulbright student at the Sorbonne. He has lectured at the Brooklyn and Metropolitan Museums and is now Associate Professor of Art in the Department of Graduate Painting at Michigan State University. A retrospective exhibition of his paintings was held at Hofstra University in 1965, and he was included in the "Young American Artists" show at the Museum of Modern Art in 1953.

* Excerpts from Professor Leepa's forthcoming book *Problems in Contemporary Painting.*

I

ART FORMS BASED on the major ideas, feelings, and events of a cultural period emerge, live, fight for survival. They may help broaden the humanistic basis of society, as in the Renaissance, revolutionize the concepts of pictorial space, as in the work of Cézanne, or attack the very culture that harbors them, as in some of the art forms today. One of the major characteristics of pop art, for instance, is its sardonic reaction to the banality that surrounds us, though the bitterness is expressed by parody rather than by such traditional means as a critical subject matter or a violence of form. The means employed are depersonalized, the artist eliminating his own feelings in paintings of repetitious images and comic-book cartoons. Objects are no longer imbued with traditional animistic or romantic associations. Why? The theories advanced, in what follows, are that the meaning of art, no less than the meaning of man, is under attack; that inherited contradictions in Romanticism enter into existential directions today, and that traditional definitions and meanings in art must be re-examined and a new criticism developed.

Despite the apparent novelty and obvious impersonality of some contemporary art forms, the vitality of these new movements persists. They are manifestations of twentieth-century thinking in a world under pressure, when processes of social growth all over the globe are being telescoped with incredible urgency, at a time when the possibility of nuclear annihilation is as close as a push button. The gray flannel suit and the organization man are being mocked, defrocked, criticized, declared absurd—by a means that is often as absurd (a carefully designed and disguised absurdity) as the thing ridiculed. However, as with all new directions in art, time alone must be the final judge as to which forms will survive as the fittest

spokesmen of our epoch—as the most precise, catholic, and profound expression of our unprecedented age.

The definitions of "art" and of "criticism" vary widely. It is important, therefore, to define these terms. This is particularly necessary today when various contemporary movements all but reverse accepted art meanings.

One definition of art is that it is the expression of emotional meanings in the organized patterns of a medium. It is a definition that emphasizes emotion rather than idea. While one does not exist without the other— thought is accompanied by a physical, visceral reaction— some contemporary artists disdain such a definition as being suitable for Abstract Expressionism and the Romantic tradition but inadequate for today.

Art is a form of knowledge. Knowledge is usually interpreted to mean intellectual understanding by verbal or rational means—information, learning, scholarship. Yet there is emotional understanding which, while not independent of intellectual responses, does not primarily depend on them. A work of art communicates itself through both idea and feeling, not idea alone. Since the human act of cognition is thought to depend on man's ability to use a written and spoken language, i.e., to employ and store verbal symbols, all forms of knowledge can, presumably, be traced back to verbal skills. But the act of cognition does not preclude its use in forms of knowledge that are not primarily verbal, as in the case of art. The pragmatic test, of course, is that a visual work of art cannot be translated into words. The assumption that it can, as when someone asks that a painting be explained to him, attests to Western man's over-reliance on rational thought as the primary, if not the only, way to understand the world. In art, the primary instrument of knowing is the experience itself, for which only the work itself is the vehicle of communication without the intermediary of words.

Art is a metaphorical statement that is defined by those

meanings and human equivalents which man feels most directly, truthfully, and comprehensively represent him at any particular time. It is particularly necessary to approach art this way if we are to understand something of what is happening at the present time.

What is criticism? It is the employment of discrimination in the judgment of something. As such, it is an elemental factor in experience. We judge ourselves, others, and knowledge itself. To judge is to employ standards. A thing is right or wrong, good or bad, valid or invalid according to the criteria employed. One of the major problems faced by art criticism, it would seem, is the establishment of such standards. But can standards be determined? What is being judged? What are the criteria used? The problems these questions raise are more easily asked than answered.

Art is the communication of human experience and is, therefore, subjective: what the artist expresses cannot be evaluated objectively. The spectator, or critic's, experience of the work is also subjective. In short, both the work of art and its criticism make for a continuous, reciprocally dependent vicious circle in which one is defined by the other.

At first glance, it would seem possible to employ in art a procedure similar to that used in philosophy—to define premises so that consequences can be drawn from them. The artist begins his work employing various premises and assumptions, states a point of view, and aims at goals. But this method does not work in art as it does in philosophy because the experiencing of art is both emotional and intellectual and not, like philosophy, primarily intellectual. Subjective criticism can be, and is, easily abused: "educated" opinions, proferred by persons with an ability to write or with previous literary experience—though in a totally unrelated field, are accepted as art criticism.

There is another way of approaching the problem of

criticism, and that is to view it as a means of describing, identifying, and analyzing those characteristics that uniquely mark a particular work of art. This is attempted in as precise and as objective a way as possible without immediately applying subjective judgments and with a minimum reference to a priori standards. It is impossible, of course, not to use any standards whatever, since there is some point of reference, some philosophic or psychological overtone to all perceptions. The emphasis in this form of criticism, however, is on the internal Gestalt of a work and not on its relationship to standardized aesthetic systems of values. The functions of the critic, then, are to observe, describe, and reveal—as accurately and objectively as possible—what the artist is trying to say and to show how he does or does not succeed in accomplishing his goals.

While the critic's ability to be objective is dependent on his knowledge and training as an art historian, art philosopher, aesthetician, artist, he does not function exclusively as any of these. The primary role of the critic is concerned with the work of art itself. Otherwise, the work becomes weakened or lost if the critic functions as a prisoner of fixed viewpoints. In other words, if art is viewed as the expression of a static set of ideas, experiences, aesthetic values, or even humanistic positions, the critic will impose on the works that he sees, the concepts, principles, and attitudes inherent in the system of appraisal he is employing. This type of approach—the belief in an absolute set of fundamentals applicable to all arts, of all times—has led to innumerable aesthetic miscalculations. Often, partial truths have been taken for the whole truth. Roger Fry, for example, so strictly insisted on significant form as the basis of art that, instead of form being viewed as part of the total creative statement, it became *the* criterion.

The problem that the serious critic faces is how to *identify* a work of art—its particular content, unique

structure, and special meaning. His dilemma is how to recognize that element of uniqueness in a work of art that requires subjective reaction while not allowing himself to be unduly prejudiced by such reactions. Likes and dislikes of the critic are less important than what the work itself communicates. While the ability to perceive various kinds of content in a work of art is not always predicated on the emotional preferences of the critic, too often such preferences preclude a sympathetic analysis of the work. A more serious shortcoming is an inability to react in kind to various qualities in the work, such as the sensitive integration of form and content or the expression of a feeling-content through form alone, because of a lack of perceptual awareness. Equally inept is a critic who fails to see an art movement in terms of, and against the background of, the forces that give birth to it. Since there is no completely objective way to view a work of art, the critic must seek to be as catholic and as profound as he can. He must attempt to be as aware as possible of the experiential factors on which he bases his personal reactions in order to see more objectively the work in its own singleness of purpose. While the artist recognizes these changes by revealing them creatively, the critic acknowledges them descriptively and analytically.

Significant creative work is new. The great art is contemporary art. As such, it is "subversive"—shaking up traditional criteria of art and criticism. It challenges both past and present as it discovers the new. This challenge confronts the critic today no less than it did in the past. What changes are taking place? What are the characteristics of the new directions? How significant are they?

II

To understand the present, it is helpful to know its roots in the past. One of the principal characteristics of various

contemporary avant-garde movements is their break with the tradition of romanticism. The romantic ideal has been one of the dominating factors in art. At its core is emotional expression and personal interpretation. This is as true of Abstract Expressionism as of Fauvism or Impressionism. The emphasis in the romantic movement is on the personal vision of the artist, his sentiments, his viewpoint, his reactions, his dreams, and his ideals. To find the basis of the Romanticism we know today, we must go back to the last century.

The nineteenth-century romantic created his own world, out of his feelings, beliefs, ideas, and ideals. He rebelled against the idea, exemplified in the philosophic world of Descartes and the mechanical world of Newton, that personal experience and personality were secondary, and counted for little, that only the mind really mattered and could, in cold calculation, analyze and understand all there was to know about the world and human experience. Why should the past—Plato, for instance—be looked to for the answers to the problems of contemporary life or for a definition of man's role in the universe? Why should other authorities—the Church, for example—have exclusive monopoly on final answers in matters so personal that the individual could hardly come to grips with them, their complexities and implications. Man began to look to himself rather than to external authority.

But the vitality of the Romantic, heroic as it was, bordered on the irresponsible. Complete personal independence led to nihilism. While Romanticism insisted on the importance of the individual, it also argued for the political liberty of all. Freedom was an inherent right of every human being. The Romantic, who initially insisted on the inner freedom and importance of the individual, embraced the concepts of universal freedom for everyone. This created a dilemma. A person could not be completely free without infringing on the rights of others. Romanticism therefore lost something of its initial vitality,

and freedom became institutionalized. The idealized self, the rallying cry for the romantic rebellion, changed. What was first the personal protest of the Romantic became a part of the social protest of the masses, and soon dominated the nineteenth century—in government, trade, economics, and politics. The ideal of the rugged individualist, who operated primarily for himself under a laissez-faire philosophy, gave way to that government control for the benefit of all.

Romanticism supported concepts, created dilemmas, and influenced ideas that are part of the fabric of our thinking today. Ideas of individual freedom versus mass liberty, *id.*, versus superego, laissez-faire versus federal control, obligation to self versus responsibility to others are very much a part of our lives today. In art, similar dilemmas are evident. There are problems concerning the relationship between the expressional act and various kinds of control; between external limitations (object, media, technique) and internal ones (idea, feeling, method); between Expressionist directions and Neoclassic aims; between the theories and allegiances of hard-edge painting and those of soft edge Expressionism; and most recently, between anti-Romantic pop and new Realist artists and the form-conscious Abstract Expressionists.

A movement in rebellion is dedicated at the same time to its own goals and ideals—the line of demarcation between rebellion and dedication is not always easy to discern. An act of rebellion against an idea external to itself must also be an act of rebellion against something within the person. The self of the Romantic, in other words, is in rebellion, and as a result, the Romantic movement in art is characterized by a struggle for the hidden within the self, a search for the intangible and mysterious in nature, the unattainable in experience. The deepest within the self is to be sought, but it cannot be released without a fierce personal struggle and intensive search.

When Romanticism gradually lost its momentum, the aesthetic pendulum swung to an opposite pole, to Existentialism. Existentialism, one of the most vital philosophies of the twentieth century and particularly of the postwar world, holds that man's position on earth is absurd—he is unable to understand the reason for his existence. Rather than continuing to look to Romantic, imaginary, subjective interpretations of the world, the Existentialists prefer to face existence phenomenologically. The Existentialist's position is obviously in strenuous opposition to the Romantic's. Existentialism challenges many of the most cherished values, assumptions, theories, and beliefs of the nineteenth and twentieth centuries.

Art is caught up in this shift in man's evaluation of himself and his role in the world. Some of the new movements no longer take seriously the idea that art is the embodiment of a subjective, intangible, imaginary world, one that must somehow be re-experienced by the spectator. Instead, he is free to experience his own world in relation to the picture—if this is what is most meaningful to him. A work of art is an extra- or super-phenomenal object unto itself, to be examined without prior conceptual commitments, without thinking of it as a surreptitious representation of something else other than an image in a painting. A house drawn on canvas, for instance, has a different Existential existence than an actual house and should not, therefore, be compared to it. The house on the canvas forms a new Gestalt in relation to the medium and material of which it is a part and in relationship to the spectator who views it. It is to be experienced in terms of its own unique situation, its own set of relationships, with no prior, generalized, imaginary transference of any kind expected or assumed. This is quite different from the Romantic's expectation

that the spectator identify with the artist's vision and attempt to possess the same kind of reality that he experienced when he played off his personality against the world. What has happened in the newer art directions is anti-art when viewed against the traditional sacrosanct meanings and definitions of art.

The anti-art movements today are based on the idea that experience changes to abstractions and existence to constructions in logic, when idea, unadulterated by sentiment, is given its fullest recognition. Individual personality ceases to be of primary importance since it is based on Romantic associations. In the new art, or anti-art, reason functions in the service of the will, first to attempt to go beyond logic, and then to go beyond individual personality in order to escape from the contradictions of Romantic freedom.

The absurdity of man's position in the world has become the guiding idea of many contemporary artists. The most meaningful act that can be performed, they insist, is to emphasize the meaninglessness of life. In the anti-novels of Beckett, a typical hero finds that nothing is more real than nothing—he withdraws and dies without realizing any conclusions. Robbe-Grillet states about his novels, "A new form always seems to be more or less an absence of any form at all, since it is unconsciously judged by reference to consecrated forms."

The anti-art position of the painter and sculptor parallels that of artists in other fields. The following is a typical composite of their positions:

> I do not want to project myself into my work; to identify myself in my painting is to mistake me for it. . . . I cannot perceive the universe in the same black-and-white way that the Abstractionists did. Black-and-white ideas mean clichés to me. I was nourished on them as a child. They meant commercials, falsity, duplicity, slickness, Madison Avenue. Now, all of

this must be reversed. White becomes black.
. . . Heros are nauseating. They are cardboard
mannikins. The world is not exclusively com-
posed of stereotype good persons and bad per-
sons. There are other paths to explore. . . . A
new image can be created, one that does not
differentiate what is and what is not, what
exists and what does not. This can be created
powerfully by means of the very contradic-
tions that produce them. Why should right
and wrong, existence and non-existence, be
the proper categories and only alternatives?
. . . Concepts, feelings, theories, ideologies,
goals can mislead; they have no bearing on my
work. The work exists as art solely within
itself.

Anti-art can be viewed as a crisis in Romanticism, with
Existentialism as one of the dominating influences. Anti-
art thinking has focused on the idea that art, when
romantically employed, is simply the duplication of the
experiences of everyday life. Art, then, is subordinate to
such experiences. It ceases to exist in its own right. In
watching a drama, the audience reacts by identifying its
own experiences with those of the characters and the
situations presented in the play. But we already know
about such experiences and situations from non-art
sources. Why use art this way?

Art, the anti-Romantic believes, must have a more
significant function to serve. What is needed, he feels,
is a new approach, one that is no less than a complete
redefinition of art itself. If it is to cease to be a hand-
maiden to everyday emotional experiences, art must first
be considered as an idea, a concept, a symbol apart from
such experiences. In other words, it must somehow be
viewed first as a thing apart from the duplication of
feelings or the expression of personality. These already
exist within their own contexts; they have a life of their
own. But what of the life of a work of art? What is its

context, its *unique* context? Is it simply to communicate the experiences already occurring in the human being, to copy or duplicate them, so that the spectator, when viewing a work of art, relives the sensation of sorrow, happiness, exhilaration, piety, and pity that he already experiences daily? Instead, are there perceptions that relate to a Gestalt unique to the idea of a work of art itself? It is within this framework of thinking that new art concepts and forms are developing.

We can think back to movements in the past that appear similar to some that are occuring today, to Dadaism, for instance. But where Dada was primarily an act of rebellion, and a romantic one at that, pop art is primarily parody. It is anti-Romantic, anti-emotional, anti-intellectual, and anti-art.

Another way to view the effort to break from the Romantic tradition is to remember that Romanticism refers primarily to a state of experience within the individual rather than to his relationship to a work of art. When he fantasizes about emotionalized ideals, personal dreams, and far away places, he is engaged in imaginative experiences. As such, his is a behavioral activity, not an artistic one. To rebel against society, to fight against tyrannical aspects of science, to argue against fixed and arbitrary standards for human behavior—these are not the same types of activity as that which deals with problems of art. Concern with them or their employment in art does not, according to the anti-Romantic, clarify, develop, encourage, or reassert the integral, independent nature of art.

Existentialism states that it is impossible to establish the necessary truth of any knowledge acquired by experience. Man's sensory investigations do not yield the necessary information that would make it possible to come to certain or necessary conclusions about the nature of life—its ultimate purpose, structure, or meaning. We can, for instance, touch something and not know that it is

made up of millions of electrons in movement. Science does not reveal the ultimate truth about an object. Neither do instruments or techniques. All that man can be sure of is that certain consequences will follow from particular concepts, once he has defined them. The concepts, however, are limited by the theory on which they are based. Theories are not absolutes. The attitude that man exists in a state of total ignorance can lead to a position of complete skepticism: man is unable to know anything about the world which is absolutely necessary or true.

Existential problems become uppermost when authenticity rather than Romantic freedom becomes the critical issue at stake. At the core of the Romantic effort is the aim to transcend all—media, techniques, methods—to reveal through personal sensibility, the authoritative act, the "agony" of creation, the unattainable and unrevealable. He pushes for that which cannot be stated. The effort of the nineteenth century was to make the world an implicit part of consciousness; but once this position became untenable, changes developed—social as well as philosophic—that brought the Existentialism of Kierkegaard, Sartre, and Camus to the fore and the I-thou concept of Buber into prominence. Buber felt, for instance, that the individual "I" discovers authentic being only through responses—agreeing or disagreeing—to the "thou" of others. The crisis of modern man, according to Buber, is his "loss of community . . . individualism sees man only in relation to himself, but collectivism does not see man at all, it only sees society."

For man to have authenticity, he must have the capacity for dissatisfaction and self-criticism. Otherwise, self-satisfaction, smugness, and appetites circumscribe and bind him. Culture means the capacity to criticize—criticism based on analysis and evaluation. Democracy offers the opportunity for creative self-development but

is not its guarantee. Democratic man is without culture until he attempts to live authentically.

The Existentialist denies the classic idea of tragedy, and resorts to parody; contemporary man can be dealt with only derisively, since his position in the world is nonsensical, not simply tragic. Parody is more desperate than tragedy, for it ridicules hope as well as despair: the heart of comedy is incongruity. Today, the scientist, Existential philosopher, and artist all agree that the universe is no longer understandable:

> We are now approaching a bound beyond which we are forever stopped from pushing our inquiries, not by the construction of the world, but by the construction of ourselves. The world fades out and eludes us because it becomes meaningless. We cannot even express this in the way we would like. We cannot say that there exists a world beyond any knowledge possible to us because of the nature of knowledge. The very concept of existence becomes meaningless. It is literally true that the only way of reacting to this is to shut up. We are confronted with something truly ineffable. We have reached the limit of the vision of the great pioneers of science, the vision, namely, that we live in a sympathetic world, in that it is comprehensible by our minds."[1]

The parody of the human situation in art is purposely demonstrated by such obvious devices as reproducing advertising art of the kind that dominates and standardizes thought in America. Satirization of aesthetic intellectualism is expressed by the stretching of pants on a canvas, with pockets bulging, to ridicule the theory of

[1] P. W. Bridgman, "Philosophical Implications of Physics," in American Academy of Arts and Science *Bulletin*, Vol. III, No. 5 (February, 1950).

the picture plane. The myth of freedom and individualism in America is stressed by repeating ad infinitum on a canvas surface the same photographic image. Are these anti-art manifestations truly works of art? The contemporary artist replies by asking another question, "Was painting of the past art?" The artist does not attempt to define art. He feels that as he defines himself, his art defines itself.

To be alive, art must create. To do so is to explore fearlessly and profoundly the meaning of existence. This exploration is not scientific or simply analytical. But why exploration? Art, as we said, is a form of knowledge and as such can help man understand the world—as can all forms of knowledge. Anything of importance to man is significant in the degree that it touches on his meanings. By expanding his understanding and experiences, he provides new insights, and life renews itself. Art offers this possibility to an extraordinary degree since it can employ more of man's faculties in an integrated and concentrated way than perhaps any other instrument of knowing that he employs. The fact that the knowledge offered by art is experienced at the same moment that it reveals its meaning gives it the distinction of being at one and the same time a living counterpart to life and also an activator of it.

Art criticism can also function as an activator of experience. While it does so by revealing insights about a field other than itself—it discusses art and not the art of criticism—it nevertheless can play an important role. By discussing the content of what the artist does within the context of how he does it, the critic can help clarify how, why, and what the artist is saying about the times in which man lives. Man is helped to see himself. But criticism that does not help to reveal the meanings the artist is creating fails in its responsibilities.

The critic constructively contributes to aesthetic meanings when he speaks of the inner structure of a work,

of the relationship of its parts, and of the way they interact with each other to construct and create that particular work. The intentions of the artist must be examined in terms of the way in which they are fulfilled in his work. The nature of the particular work will then be discussed in terms of its uniqueness and the universals to which they relate. The most significant directions in cirticism are those that help reveal the content of art as it comments on and reveals the present condition of man.

NON-WRITING AND THE ART SCENE*

by Susan Sontag

The new art has been extensively publicized and has met with relatively widespread superficial acceptance. It has never encountered the almost totally negative reaction that greeted Cubism at its first appearance. But, as Susan Sontag points out, much of its popularity is with the wrong people for the wrong reasons: a manifestation of cultural chauvinism in one form or another.

Miss Sontag, born in New York in 1933, was educated at the University of Chicago and Harvard Graduate School. She is author of The Benefactor, *a novel, and of numerous critical essays, some of which are collected in her most recent book,* Against Interpretation.

IN CERTAIN CIRCLES the international stature of contemporary American painting and sculpture is the cause of a shameless gloating virtually identical with what is felt, in other circles, about America's imperialist foreign policy ventures and America's nuclear supremacy. The New York art world is engaged in an endless litany of nationalist self-congratulation. People never seem to get tired of telling each other that Paris is "dead," nothing going on there, though London is "getting a little more interesting" (the way English literary critics might refer

* This article first appeared in a somewhat different version in *Book Week*, published by *The New York Herald Tribune*, July 25, 1965.

to the progress of poetry in New Zealand). And it is not simply the fact that American art, so long in tutelage to European art, has come into its own, that New York, so long a provincial outpost in the art world, has replaced Paris as the art capital, which is being outrageously and tirelessly relished. It is the feeling that the ascendancy of American art represents a vindication of the most philistine values of American culture, of, not to put too fine a point on it, The American Way of Life. The art world in the last ten years has become the unexpected home for an incredible set of attitudes, a kind of cultural Goldwaterism.

The interest of Mr. Rublowsky's hair-raising book[1] is the innocent lack of reserve with which it serves up the new chauvinism. We are told that the great merit of certain recent American painters and sculptors is to have created an art which is "accessible and acceptable," an art which is "no longer an escape from reality." These artists have shown us how "cliché and banality" can "inspire reverence." They celebrate reality (the afore-mentioned cliché and banality) "and dismiss pretension." They are a happy expression of "the mirth and joy of today's scene," of a happy American well rid of the gloomy strivings for quality attributed to Europe and the moribund past. For, we are told, ours is a society in "which movie stars, not scholars, are the heroes" (when have scholars been the heroes of European society?), a society "that considers the latest Hollywood extrav-aganza a relief from the pretentious monotony of the ubiquitous 'art' movie." We are now lucky enough to have an art "inspired by the joys of the assembly-line" (joys to whom?), an art which reflects "this peculiar civiliza-tion in its acceptance of the mechanized and mass-produced." Our America ("this is an 'other-directed' realm") is "a unique and wonderful reality," and our

[1] *Pop Art* by John Rublowsky, photography by Ken Heyman. New York: Basic Books, 1965.

artists have discovered how to be happy and prosper financially, too, by discovering "acceptance of oneself and of our mechanized and impersonal world." Down with criticism, alienation, "severe introspection," elites, Europe, all that nonsense about art being edifying or improving the quality of one's heart, soul, consciousness.

I have been quoting from the introduction to the book by Samuel Adams Green, Director of the Philadelphia Institute for Contemporary Art, but his brief text concisely anticipates the spirit of what follows. The book has nine chapters: two introductory ones on "the new movement" and its all-American "sources"; an encomium apiece on five artists—Roy Lichtenstein, Claes Oldenburg, James Rosenquist, Andy Warhol, and Tom Wesselman; another angle on this American success story by means of brief sketches of some businessmen-collectors (Scull, Brown-Baker, Krauschar, Manuchin) and galleries; a concluding chapter on "the new wave" of artists (D'Arcalangelo, Artschwager, Ramos, Foyster, Watts, and several others); plus a generous number of photographs, many in color, of the artists uninhibitedly at home and at work, and of their work. Throughout, there is a complete innocence of any consideration that pertains to the discussion of works of art as works of art. Art is one of the more successful commodities produced by our affluent society. But even viewed, more charitably, as advertising copy rather than as history or assessment, Mr. Rublowsky's model is the Rotary Club or American Legion rhetoric of small-town America rather than the sophisticated businessman's ethic of Madison Avenue. Two random examples of his style and critical judgment:

> A careful craftsman, Lichtenstein approaches his paintings in a workmanlike manner. He generally sets up a series of related paintings at the same time. The production-line method saves time and effort.

Wesselman respects honesty and work, and this respect is reflected in his art. Such simple wholesome virtues have become unfashionable topics of discussion. Yet they are part of the man, and neither the artist nor his work can be adequately understood without considering them. They represent the epitome of the middle-class American ethic—a tradition in which Tom Wesselman grew up.

Writing on this level would scarcely be deserving of notice, were it not that it expresses—more nakedly—a collection of sinister attitudes that are becoming increasingly widespread among relatively cultivated and sensitive people. One hears all too many versions of Mr. Rublowsky's repeated denigration of the most brilliant American artists of the 1940's and early 1950's because they "represent the aristocratic ideal in art, an ideal that has dominated Western art since the end of the Middle Ages"—as opposed to the new artists who reflect "a democratic ideal." Measured alongside this, the philistine condemnation of abstract art in the name of "Socialist Realism" seems positively benign. And the pity of the Rublowsky treatment is that a number of these new artists, who presumably lent themselves to the making of this book, are indeed worth taking seriously.

One of the problems is, of course, the label. Labeling is the perennial human substitute for thinking. At its least harmful, it can be the verbal token which follows a train of reflection, a process of response. When it becomes objectionable is when it precedes, and thereby cuts off, a response, because all genuine thinking, feeling, and acting is singular. One can argue that this sort of thing is ineradicable; people will always seek out the short-cut provided by the label. But not all labeling is equally vicious, or influential. Brand names like, say, "post-Webernian music" or "theatre of the absurd" are probably no less silly—intellectually, aesthetically—than "Pop

Art;" in all these cases, artists whose styles, themes, and quality differ vastly are herded together. But the influence of, and damage done by, labels in the art world seem incomparably greater. It may seem late in the day to complain about the relentless verbal packaging that infects one's response to contemporary painting and sculpture in America. Yet, it can hardly be overstressed. With all the publicity about openings and art-market prices, the speed with which the painting style is converted into a gimmick (within six months one can meet a new painter's work as a New Yorker cartoon, a dress, an item of billboard graphics, a refrigerator door), and the persistence of that nativist boasting I have spoken of, it is difficult for even the most serious viewer to look properly at the work of the artists discussed in Mr. Rublowsky's book without flinching.

What makes it possible for a label like Pop Art to stick, and for much new work to be marketed wholesale, is something superficial and misleading: an apparently common "subject matter." It's possible if one thinks that Lichtenstein's paintings really are about comic strips, that Andy Warhol's Marilyn Monroe and Campbell soup cans and electric chairs really are about Marilyn Monroe, Campbell's soups, and electric chairs, or (to take a senior example) that Jasper Johns's flag paintings have anything to do with the American flag. In fact, the merit of these paintings is not as an anthology or inventory of Americana, but as a visual experience, a research, if you will, into ways of seeing more rigorously and precisely. (The banal subject-matter is simply an interesting "given" in that experience.) The detachment of the so-called Pop artists is a complex kind of irony; and their work, the best of it, does not depart from the formalist tradition which has been established in modern painting since Cézanne.

It is not hard to imagine for whom Mr. Rublowsky's book is written. George Babbitt might read it; he has a little

nest-egg which he might be talked into putting into paintings instead of A T & T or Xerox. But to whom is *American Painting in the 20th Century*[2] addressed? School libraries, perhaps. It is neither a popular book (it's not fun to read and has no color plates) nor a serious one; its method of organization—painter by painter, in chronological order, from Robert Henri to Jasper Johns—by definition precludes any serious discussion of anything. The title should have been something like *Concise Encyclopedia of American Painters in the 20th Century*. This thankless job Mr. Geldzahler performs in the standard paste-together style of contemporary encyclopedists. The writing is generally on a pedestrian level that seems prepackaged for students to plagiarize in term-papers due in their college art-history courses:

> Henri's technique was broader and looser than Eakins', his drawing less accurate.

> In 1908 Henri left the Chase School and founded the Henri School of Art. Among his students of these years were George Bellows, Rockwell Kent, Edward Hopper, Eugene Speicher, Patrick Henry Bruce, Glenn Coleman, Yasuo Kuniyoshi, Morgan Russell, and Stuart Davis—all of them men who were to figure prominently in the art of their time.

Etcetera. There are the usual vagaries and inconsistencies in emphasis, length, and approach common to encyclopedias—only worth remarking because this one is written by a single person. One does not know why Ivan Albright gets twice as much space as Pavel Tchelitshew, or why Arthur Dove gets six times as much as Robert Rauschenberg. An appendix offers short biographies of all the painters whose work is described in the body of

[2] *American Painting in the 20th Century* by Henry Geldzahler. The Metropolitan Museum of Art, New York. Distributed by the New York Graphic Society, Greenwich, Connecticut, 1965.

the book, yet some of the main entries are organized around the painters' biographies and some not. Painters of the last twenty years get particularly perfunctory handling, although Mr. Geldzahler is well known (from articles in art magazines) for his enthusiasm about some of the most recent American work. Of Sam Francis, for instance, virtually all Mr. Geldzahler tells us is that he "has continued into the sixties the richness and intelligent excitement of abstract expressionism" and that "his style is instantly recognizable." But if Mr. Geldzahler is perfunctory, at least he conducts himself with a certain sobriety. The note which is consistently struck in the Rublowsky book is confined to several paragraphs in the final chapter on post-war painting. ("New York has become the center of world art. . . . for some time now it has no longer been necessary to look to Europe for examples that would be only partially understood. The culture is now local, the context American and understandable.") On the whole Mr. Geldzahler has held off on the noxious chauvinism that his subject triggers in other writers.

Although one could undoubtedly pick up a certain amount of useful information from the book, it offers no point of view, no glimpse of any organizing sensibility. (That this could not be said of Mr. Geldzahler personally is well-known in the art world.) *American Painting in the 20th Century* is, in fact, a perfect example of its genre— the institutional publication, that seems to have been written by a machine or a committee; lifeless, tasteless; wholly uncontaminated by a human voice. It might be objected that this criticism is misplaced. After all, the book *is* published by the Metropolitan Museum of Art in New York (where the author is Associate Curator of American Paintings and Sculpture), almost all the illustrations are of paintings in the Museum's permanent collection, and it is in fact a guidebook to that collection. But there is ample precedent for museums sponsoring

much livelier and intellectually more challenging work—as, for instance, the recent volumes (associated with exhibitions) produced by the Museum of Modern Art on *Art Nouveau, Futurism, The Art of Assemblage.* It is scarcely to the advantage of even the most conservative museum to embalm and flatten out its collection by means of a book like this.

Indeed, were it not so plainly and sadly untrue, one could read the two books under review as satires or parodies. Certainly they illustrate, to the point of self-caricature—the Rublowsky book by its rank vulgarity, the Geldzahler by its insipid academicism—the range of useless writing which afflict the art scene in America today.

Of course, good writing about painting and sculpture exists. There are magazines like *Arts, Art International, Art News,* and more recently *Artforum,* which occasionally have printed, and continue to print, essays worth reading. The long-standing exchange between Clement Greenberg, for some years the art critic with the greatest influence, and the neo-Greenbergians and anti-Greenbergians, such as Max Kozloff, Michael Fried, and Barbara Rose, has produced some genuinely interesting and literate writing. The erudition, probity, and intellectual rigor of Meyer Schapiro continue as a model to a generation of critics, like Annette Michelson, and curators, like Maurice Tuchman of the new Los Angeles County Museum, who have studied with him. There are articulate and intelligent painters who write, like Robert Motherwell and Ad Reinhardt. Barring the hope of imposing total silence on everybody, one can only hope for the recruitment of more good writers, preferably from outside the official art world, to throw more in the balance against tons of print issuing from publicists, encyclopedists, and self-appointed experts in "art appreciation."

It is a matter of getting certain standards of writing

not simply accepted but taken for granted. Unfortunately for art criticism today and the contemporary art audience in America, this country has almost no men of letters, like Sir Herbert Read in England, Malraux and Sartre and Roland Barthes in France, who are also interested in the visual arts, if only in art history. American literary intellectuals with the rarest exceptions—Harold Rosenberg is practically the only one who comes to mind— are totally ignorant of, and indifferent to, painting. (Not to mention the other visual arts.) As everyone knows, the American art world today is, on the one hand, insular and esoteric, and on the other hand, commerce-ridden and terribly fashionable. It might be something else besides these two spectacularly joined extremes if the level of discourse about art were raised. And *this* seems more likely if painting and sculpture could be brought within the province of literary intellectuals, where much higher standards for critical discourse exist and are firmly established.

I am aware that the possession of a "literary" sensibility is scarcely a guarantee of any sensitivity to the visual arts, and may even be a hindrance. What I am arguing is that this gap does not exist in the nature of things, but exists mainly as the result of miseducation, snobbery, prejudice, ignorance, and laziness. As long as art is going to be *written* about, not simply seen and savored, it should be written about well. It is not a "literary" approach to painting which I am advocating for art criticism, but the standards of literacy, seriousness, knowledgeableness, and theoretical power which have been set for literary criticism.

A TALE OF TWO CITIES*
by Thomas B. Hess

In this controversial article, Thomas B. Hess reviews the history of the decline of Paris as an international art center and the rise of New York in its place. Mr. Hess celebrates the first generation of Abstract Expressionists but questions the validity of certain painters and movements within the New York School today. He warns that if some present trends continue, New York may, in turn, encounter the fate of Paris.

Thomas Hess graduated from Yale University in 1942 and is now editor of Art News. *In addition to numerous contributions to periodicals, his publications include a monograph on Willem de Kooning published in 1959.*

WE ALL KNOW what happened to International School of Paris painting at some time in between 1935 and 1945; it ceased to exist.

We know how it happened; the evidence is plain in literally thousands of pictures by hundreds of very gifted, intelligent artists.

Up to World War II, masters had succeeded masters, Isms chased Isms, in a brilliant evolution of at least a century's duration.

And by the mid-1930's, there seemed no reason to believe that Paris's continuity would not continue forever. If there had been drab moments now and then, there was

* Originally published in *Location*, Vol. 1, No. 2, Summer, 1964.

also a superb confidence in the inevitable reappearance of masters—as punctual as sunshine in Burgundy.

Furthermore there was plenty of talent around the city. Even as Surrealist painting faded into increasingly pallid artifice, connoisseurs were keeping their eyes peeled for the next season's new talent.[1]

But instead of emerging as a fresh cluster of Isms and individuals, the artists in postwar Paris seemed to stick and sink into the luscious colors, graceful lines, and cunningly interlocked forms that, a generation before, had been the local marks of excellence.

Suddenly, as it were, strengths became weaknesses. The nicely adjusted harmony of blue and roses took on a deathly look of undertaker's cosmetic. Virtuoso drawing strangled form instead of defining it. The secret recipes of the painters' cuisine, of fine cookery to Cocteau's taste, now combined to dish up cloying sauces, pastries that would never rise no matter how thoroughly the dough was teased, the creams whipped, the crusts garnished and dusted.

[1] Fautrier was prominently cited, as were Bissière, Hartung, Herbin, Bazaine, Borès, Pignon, Fougeron, Lam, Lorjou, etc.; shortly after the war this group was enlarged by scores of new names, such as Marchand, De Staël, Dubuffet, Buffet, Soulages, Mathieu, Lanskoy, Manessier, Singier, etc., etc. And, of course, museums and dealers all over the world, particularly those in New York, were predisposed to back this work. Fashionable collectors had combed Europe, Asia, and even Latin America long before they reluctantly put their noses in the few galleries that displayed postwar American painting. In 1962, for example, the prices for an Afro were higher than those of a de Kooning of the same size and date. In 1953, Dubuffet was an established best seller, and Jackson Pollock was broke. The market's preference for Paris art still persists, even though the industrialists who used to concentrate on Chagall, Soutine, and Marino Marini now are apt to put a Pollock in the library. The Museum of Modern Art in New York could not see Hans Hofmann until the 1960s, but turned over their whole sculpture garden for a demonstration by Jean Tinguely as soon as he appeared to their view. This is not a criticism of Tinguely, but an indication of the institution's obvious (even if hotly denied) bias.

The old masters of modern Paris art were still very much alive, but, by 1945, they shone with an ominous, almost hostile, indifference to other art. They had closed off their images, filled them up; there was no room left in the margins for anyone else to begin. Many younger Paris artists attempted to force the magnificent styles of the late Bonnard or the late Matisse into eclectic combinations. One toned Matisse's color to Picasso's anatomies; another tried to fill Paul Klee's diagrams with the brushmarks of Bonnard. But due to what might be called lack of "esthetic gravity," or moral pressure, the parts fell apart.

International Paris painting degenerated with a rapidity that was as astonishing as it was saddening—for, despite what the French themselves believe, nobody except a few cranky chauvinists took any pleasure from this debacle.

We know what happened; we know how it happened; but the important question is, Why did it happen? This crucial problem remains curiously overlooked. Styles and schools do not wither like simple flowers. Something has to intervene; something must change. And the search for these unknown factors is a primary responsibility for any critic who feels that there is more to his task than the simple gasp of appreciation and gush of exegesis.

About fifteen years ago, I put the question to one of the modern artists I most admire, Alberto Giacometti, mentioning at the same time that I felt "the only major new painting is being produced in New York."

Giacometti said that this did not surprise him at all because art always gravitates to the centers of world power.

But this view of art as an ally to the biggest battalions has not applied since at least 1814. French painting itself reached one of its most splendid climaxes during and after the defeat of 1870. And there were no concentra-

tions of painters around the power centers of Edwardian London or Hohenzollern Berlin ca. 1900.

Another Paris painter (he had served briefly as a private with the defeated armies of 1940) explained that French painting simply rotted away within the disillusion, cynicism, and corruption of the nation. "We act as if things were the same as ever," he said, "but inside, we remember the surrenders, the Occupation, the collaborationists, the black markets everywhere."

But even if, for the sake of argument, one conceded this dismal analysis of the European national character (these strictures would apply to Germany, Italy, and Spain, as well as France), the question remains unanswered. It ignores the contemporaneous vitality of Paris poetry, drama, the novel and, more recently, architecture. If France was so decayed after the Liberation that it could not become a place for artists, how could it have made a stage for the international theatre of Beckett, Ionesco, Audiberti, Vauthier; for the poetry of Char, Dubouchet, Emmanuel, Bonnefoy, Pleynet; the novels of Butor, Bosquet, Vian, Robbe-Grillet, Lanzmann, Simon; to say nothing of the typically French, typically energetic postwar work of Camus, Sartre, and the *Temps Modernes* team, the New Wave movies?

Even separately, such manifestations indicate life; together they demonstrate that France remains immensely rich and productive, not only as a land, but as a vital national, indeed international, spirit.

A third painter I asked to explain the demise of Paris painting restricted his answer to the artists' world and produced a half-hour rant against the whole system. The dealers, he said, with their bought critics, run everything. Artists kneel complacently in front of the manipulators of the marketplace. Everybody is so smug, he complained. "They" feel idiotically superior, and are happy to spend a lifetime buttering each others' provin-

cial backs. The Paris art set-up, he concluded, is a cozy racket; it disgusts him and all his friends.

This view, because it is from an American in Paris, must be suspect (even if Left Bank expatriates usually are more loyal to Paris than Parisians). But his remarks illuminate some facts of life that concern the few leading Paris artists who have stayed above the deplorable norm.

These men seem to agree with the American's analysis. They work almost entirely apart from the local art scene and its social and financial tangles.

"I never see any other painters," is a typical statement from such distinguished mid-century Paris masters as Giacometti and Balthus (whose styles are as solitary as their lives—as against the older generations of Paris masters, whose styles formed schools); I have heard it said many times, usually with rueful pride.

What is indicated here, I believe, is that, after a century of revolutionary activities, the vast majority of Paris painters, at some point in between 1935 and 1944, began to disappear into the milieu. Working for, instead of against, the Establishment, they became indistinguishable from it. And their sacrifices of a bit of rough-edged individuality entailed the loss of art.

In its relationship to the audience, there is a sharp contrast between Paris painting today and Paris painting from Courbet through Picasso. Vanguard Paris art, in the past, had a tough, intransigent, often overtly revolutionary attitude. The artist was a dedicated enemy of the Right People, he was not out to *épater* the bourgeois; he was apart from him and against him. He was against the government, its courts, economics, industrialization, capitalism. Usually artists sided with the political Left (it has been noted that vanguard manifesto-movements in twentieth-century painting were frequently modeled on the lines of the political-activist's cell; like van Doesburg's agitprop for de Stijl or the German Dadas). Sometimes

artists sided with the extreme, aristocratic Right (e.g., Degas's anti-Dreyfus passion, or Dali's "Catholic-Royalist-Anarchism"). Manet, old and famous, rejected the Legion of Honor. Picasso joined the Communist Party, van Gogh dreamed of a Republic of Artists governed according to the rules of Apostolic Communism. In the mid-1920s, the entire Surrealist band dedicated itself to the "Service of the Revolution." A good symbol of the modern French painter could be Courbet lending a hand to the Communard workers as they pulled down the Napoleonic column in the Place Vendôme.

The Paris artists who seemed apolitical had withdrawn in disgust, nor from apathy or ignorance. Renoir was not bored by French politicians, he avoided them because they, and what they stood for, nauseated him.

This political, social orientation was as much a part of the painters' *œuvre* as it was of their biography.

Almost as if in reaction to this attack from the artists, Capitalism developed, first in France, later internationally, what has been called its Vanguard Audience.

Unlike the heterogeneous mass public and the close-knit ruling upper middle class, which never have been interested in modern art, the vanguard audience is sympathetically involved with artists, but for its own ends. It retains its allegiance to, and roots in, the political and economic status quo. It goes to the art world for amusement, relaxation, diversion, most of all for a comfortable, colorful social milieu. Costume balls and cocktail parties are goals for the vanguard audience, which looks for the artist at his most sociable, rather than to his work. Knowledge of anecdotes, gossip about painters' foibles, glimpses at undress rehearsals become the ersatz image of the subversive content of modern painting.

Fascinated by bohemia, the vanguard audience moves along lines set by its powerful appetites for acquisitions and social climbing. It subsidizes art galleries, buys paintings, and if at first the new collector's prizes are rather

altruistic status symbols, the profit motive is never buried very deeply in the transaction. The fast buck is as attractive as the impressed friends and the entrées. The only problem for the member of the vanguard audience is how to get inside, and once with it, how to keep swinging.

Because the vanguard audience is fundamentally antagonistic to the content of modern painting, its only possibility of staying in the art world is to agitate for change. It can stay modern and superficial only when the face of modernity stays unfamiliar.

Drained of its content, the modern painting has only one significance: it is New. Thus the vanguard audience keeps pressure on the artists to switch styles and manners, to produce new looks, new shivers, new laughs. The passport to the future needs almost daily revalidation.

The faster Isms replace each other, the better. And the New is always a bit cheaper in price; profit motive reinforces an interior hysteria. The alienated *rentier* or retailer or stock-exchange speculator seeks a culture that will echo the rhythms of his own manic-depressive way of life.

Furthermore, hospitality to the new offers a glamorous disguise of enlightenment. The absentee slumlord can, without a twinge, decorate his salons with the furnishings of liberalism.

In its passive role, the vanguard audience is out for money, prestige, and kicks, in approximately that order. But it has its active side. Society as a whole assigns to the vanguard audience the duty of containing, and where possible emasculating, modern art. An illustration can be borrowed from the old-fashioned animated-anatomy diagrams in the Child's Book of Knowledge. The vanguard audience is an army of white phagocytes mobilized by the Body Politic to contain the infection of art. Like the white blood cells, it surrounds the alien elements, engulfs them, dissolves them. The vanguard audience will buy

an artist until it kills him. This may sound like a far-fetched trope, if we did not remember the poignant case of the suicide of Nicolas de Staël. Of course there is no single reason for self-destruction, especially in a man as complicated, sensitive, and intelligent as De Staël; there were many contributing factors. But one of the causes of his anguish—as he told his friends—was that his pictures kept selling faster and at higher prices while he was feeling more and more doubtful about where he was heading and what he was doing.

Most Paris painters accepted the comforts of the van-guard audience without sacrificing anything more impor-tant than those trifles which distinguish a work of art from a bit of tasty decor.

By the mid 1930s, for example, the Surrealist painters tended to behave precisely as outrageously as outrageous demands were put to them by high fashion and big dealers. The vanguard audience absorbed the movement by forming its acceptance into a negative mold of the artists' aggressions. Finally, acceptance and aggression blended into a single comforting cushion.

If Courbet's leadership in the Commune epitomizes the artists' attitudes in the days of Paris' hegemony, a recent Paris exhibition by Spoerri exemplifies the postwar approach. In this manifestation, the artist mailed out elaborate invitations to his opening at which he cooked a dinner; his art-critic friends acted as waiters, and the collectors ate and paid for the meal. Afterward, Spoerri pasted the leftovers to the tabletops and these assem-blages became his exhibition. In this parody, the artist intuited a certain truth—he has transformed himself into an obliging servant, a good cook.

No wonder artists like Balthus and Giacometti, who continue to produce major work, have opted out of the Paris art scene.

Dubuffet presents a particularly interesting case in this context. He has built himself an artificial barricade

within the Establishment itself, posing as anti-art, anti-bourgeois, anti-esthetic while manufacturing bourgeois, esthetic pictures. He runs with the herd while baying like a wolf. He works for and with the vanguard audience even as he denounces it in manifestoes that are published in deluxe editions, in forewords to elaborate catalogues of best-selling exhibitions, in private demurrers that end up in the public columns of influential magazines. He has shrewdly picked the role of pet saboteur to Paris culture. His equivocation has given Dubuffet's work of the past ten years a vivid and not altogether unsuccessful tension. But his earlier pictures, which are felt as well as apparent attacks, that is, from the position of an outsider to the Paris art world, are far more moving and profound.

No single cause can account for the collapse of a school as large, heterogeneous, and deeply rooted in tradition and convention as was International Paris painting. The predatory vanguard audience did not simply swallow it raw. There was another, converging, event which, in a sense, loosened painting from its moorings. Paris itself changed.

It had been the most modern city of the nineteenth and early twentieth centuries. Paris was the arena where a cosmopolitan, radical, international art could flourish because the city embodied the look, tempo, the texture of the historical moment. It was, in Harold Rosenberg's phrase, a "laboratory of possibilities."

It was not so much a matter of architecture or technocracy, traffic or mores. Rather it was a combination of all these elements with the open political atmosphere, the changing class structure, the character of the city and of that mixture of sun, haze, and style that painters call Light. Paris had it. Then, seemingly as quickly as its painters changed, Paris lost it.

The city of the midcentury became New York. Travelers from all over the world notice this instantly.

Europeans are apt to call New York the "City of the Future," which is merely a metaphorical way of understanding that it is the city of Now, the industrial landscape of our times.

Looking back, from the perspective of two decades, it seems inevitable that events should have moved with such dramatic haste to make New York the capital and center of a new, cosmopolitan, international bundle of styles. It had a large interlocked community of artists. Waves of Paris artists-in-exile moved through the scene during the war (an influence which I underlined in my book on U.S. abstract painting in 1951, but which today seems to be overestimated). American painters were keenly sophisticated to the historical possibilities in the air. Kandinsky, Mondrian, Klee, even Matisse, Picasso, and Bonnard, were better known to New York artists than they were to their Parisian colleagues.

And the city itself, its corruption, speed, growth, mechanization, change, Light, its stupid hostile public that looked at modern art with the uncomprehending malevolence of Balzac's capitalist gorillas and Flaubert's charlatan tycoons, became, however improbable it might have seemed at the time, the only place for painting.

A paradox is suggested by that last sentence. If modern art must be, as I have suggested, international and cosmopolitan, made up of artists from many different origins, of painters and paintings on the move, should it not, by definition, inhabit no place at all?

But in order to exist, international art has to be embedded. Styles must have location, even if they have no names. Art must have a centripetal focus, both in time and in geography. There must be a home—even if it is seldom visited. Place is a precondition for work.

Regional or provincial art, on the other hand, nurtured in its own village on local beliefs and picturesque famili-

arities, however valuable it may be in itself, actually exists no place. It pertains to no other times than its own timeless reality. It rises and declines independently of the great traditions and historical movements. By being so nicely where it is, provincial art could be anywhere at any time.

The most popular American painter today, for example, is Andrew Wyeth, a regionalist of the Maine and Pennsylvania countrysides. But he could just as well have painted his haunted evocations of lonely winter suns and bicycling teen-agers in Greece or in Finland—and in 1890 instead of in 1960. Or in 1980. Minor details of costume or property might vary; a hired hand might stand on an acanthus instead of a blueberry plant. But Wyeth's concept is essentially outside history and independent of location.

Cosmopolitan modern art, on the other hand, depends on both time and place. The city has been necessary for the continuity of Western art since Giotto. The indifference of the city, its size, its particularized anonymity, provide the medium through which the discourse essential to developing art can be maintained. And this conversation can take the form of a ten-year-long chat in a studio, a visit to a favorite bar, a glance in a gallery. (One might note in passing that Willem de Kooning, whose pictures epitomize the grandeurs and miseries of the New York School, has called the New York milieu "No-environment"—what to him was unique about the location was the openness and interchangeability of its specific details.)

Postwar Paris changed, by chance or choice, into a *gemütlich* capital—probably the French word is *cossu*. When a batch of young American painters working on the G.I. Bill, around 1948–1952, discovered that there was no Left-Bank life, no bop version of the *Vie de Bohème*, they proceeded to make one up for themselves, from scratch.

The French were aghast. They visited the studio brawls, eavesdropped on the café jabber, goggled at the beards and blue jeans, and flatly announced that this life does not exist. It was a work of pure imagination. As much as anything, the creative ambiance of the young G.I.s emphasized how deeply Paris had changed.

The content of New York School painting, like the content of its ancestral School of Paris art, was and continues to be revolutionary, subversive, radically against the Establishment and practically everything that the Powers-that-Be stand for and do.

As in Paris painting, this antagonism seldom takes the form of an overtly political subject matter. Indeed, in our period of liquidated ideologies, nothing has been liquidated quite so thoroughly as politically ideological art. The Fascist and Communist Social-Realists, after all, compromised even more drastically with their patrons, relinquished even more of their identities, than the postwar Paris artists ever did to their well-mannered dealers, critics, and collectors.

New York painting is subversive in its exaltation of art and of the artist, in the sweeping range of its claims to all-inclusiveness and exclusivity. Art assumes it can do anything, mean anything, affect anything as long as it corresponds to and is controlled by the artist's most intense experience. It sets its standards above those of the community, society, and history.

One of the most remarkable accomplishments of New York painting has been its simultaneous renewal and defiance of the past. With its radical assumption that anything can become art and that the artist can do anything, the painters proceeded to drag past art up into the present. Willem de Kooning has called this "reinventing the harpsichord." And it involves the daring step of canceling out the whole idea of an avant-garde art. Keeping the picture open became more important than

keeping in step with history. Doctrinaire ideas were discarded with curt ruthlessness. In this painting, only the hip are square.

Schwitters' Merz collages were reassembled for entirely new purposes, based on completely different concepts, by Rauschenberg and Stankiewicz. Larry Rivers could reinvent Delacroix's old-master smudge; Joan Mitchell, the Romantic inscape. Barnett Newman could insist that his pure verticals are not pure and that they have nothing at all to do with the formal esthetics of geometric abstraction, but refer only to their interior aspirations to the sublime. Robert Motherwell could redraw Picasso's happy-go-lucky dove into a private, brooding, sensitive Motherwell-bird.

The past was worshiped as it was being defied, and the synthesis of this dialectic gave to the tradition of modern painting its most remarkable and desperately won continuity.

Implanted in the city, reacting violently with and against it, the artists defined the style and atmosphere—or Light —of New York.

Their influence, of course, has been enormous, international and transmitted as fast as jet planes can carry reproductions. But, as so many surveys of the state of world art demonstrate, International New York School painting is not exportable. Its effects are fatal when used externally. An action attack, adapted to a new look, becomes just another icing on the same old cake. Abstract Expressionism cannot be put to the service of the vanguard audience's craving for novelty without a total loss of content.

A brilliant South African, let us say, can attempt to extrapolate New York painting from color plates and from an intuition of its place in history, but he is bound to miss the point. The assumptions of the style, its ethical imperatives, have to be met—in New York.

Until recently, the situation in New York developed mainly in ways that could have been predicted from the elements at hand.

A very few of the originating Abstract Expressionists have become financially successful—as might have been expected.

The New York School has developed with force and consistency, and its younger members, the scandalously neglected second generation, and a brilliant group of new sculptors, are meeting, as expected, the same hostility, misunderstanding, and neglect that first welcomed their elders to the marketplace.[2]

An American vanguard audience has come into being and it performs its historical, parasitic role. It patronizes new painting while attempting to contain and muffle its subversive content; it loses the artists' statements of despair and exaltation in bland motions of chummy acceptance. I heard a new collector explain a Barnett Newman painting in his living room with the words, "Oh, Barney, he's really a swell guy; he came to dinner here with us last week."

[2] The Museum of Modern Art is a useful indicator of the fluctuations in official, big-money taste (which it leads). By the early 1950s, when the Museum had welcomed de Staël, Mathieu, Dubuffet, *et al.*, such Americans as Kline, Gottlieb, or Tworkov received the polite fish-eye. Ad Reinhardt, for example, was not tapped for one of the Museum's influential "15 Americans" anthologies until 1963 (when he asked them, "What are you up to now; scraping the bottom of the barrel?"). The Museum has consistently ignored such major painters of the New York School second generation as Milton Resnick, Elaine de Kooning, Robert Goodnough, Joan Mitchell, Robert de Niro, Leland Bell, Michael Goldberg, Norman Bluhm, Nell Blaine, Raymond Parker, Stephen Pace, Hubert Crehan, Al Held, Charles Cajori, John Grillo, etc. Only Larry Rivers, Grace Hartigan, and Sam Francis (who was "discovered" in Paris) were approved. By contrast, Jasper Johns sold out his first one-man show on the strength of the Museum's approval and such minor pop artists as Chryssa and Robert Indiana were celebrated in its exhibitions and acquisitions.

This frivolity, typical of the vanguard audience's craving for the

The pressure for novelty from the American vanguard audience, and the atmosphere it creates of witless frivolity and intrigue, of shallow seriousness, has added a certain adrenalin smell to the art world. In a recent article, I called this "The Phony Crisis," because the anxiety and hysteria it produces come from false dilemmas and foolish questions—"What comes AFTER pop art?" or "Isn't Philip Guston repeating himself?" or "Where can you get a good picture for $500 like you used to be able at Charlie Egan's?" or "Who are you betting on next year?" or "If Abstract Expressionism isn't dead, name six painters in their twenties who can keep it going?" or "Is it true that painterly painting is OUT?"

The only damage the Phony Crisis has done is to mask from the artist the real nature of his stake in the continuing crisis of modern art and modern life, which is the crucial problem of identity, possibility, continuity, and existence.

The exfoliation of styles in New York painting has not been in response to coaxings from the vanguard audi-

New and of a Museum's nostalgia for its bad Dada days, has carried over to the new sculptors. The Museum, to its credit, has backed Nakian, Hague, and Mallary, but it has also gone in for the most trivial sorts of nonsense while ignoring sculptors like Peter Agostini, George Spaventa, Philip Pavia, David Slivka, James Rosati, Dorothy Dehner, Mary Frank. Typical of the times is the immediate success of a Jasper Johns and the corresponding difficulties of an Esteban Vicente; the acceptance of the fashion-plate assemblages of an Armand and the blank rejection of the highly original contributions of a Jean Follett; the easy road for an Andy Warhol and the impossible one for a Miles Forst.

A comparison with the acceptance of *Art Officiel* in end-of-the-century Paris while the Post-Impressionists were being hooted from the halls throws a strange light on the contemporary situation. The Paris bourgeois of seventy-five years ago liked only bad art. Today there are no rules. Works of real merit (Larry Rivers, Jasper Johns) are accepted, while pictures of similar quality are ignored. The market operates out of an hysterical chaos—the mirror image of the vanguard audience.

ence. The school was wildly heterogeneous from its beginnings, including in its community such disparate idioms as:

Franz Kline's violent black-and-white insignia activated by, and expressing, precisely delicate balance,

Rothko's intricate passages of color between flat bright expanses of hue, which make the hues throb with passionate languor,

Newman's vertical stripe, repeated for fifteen years, and in the repetition becoming a new presence (to father such popular children as Johns's flags and Noland's chevrons),

Willem de Kooning's *Women* with their allusions to the billboard image and the studio environment; his "landscapes" with their thrusts of exactly interlocking colored turmoil,

Vicente's collages of painted paper arranged according to an idea that sprouted somewhere in between the space of painting and the space of collage,

Reinhardt's square blacks which anxiously offer the dimmest flicker of light as the highest consummation of two thousand years of history,

Clyfford Still's flayed surfaces with their implications of an autobiography as deep as the artist's life,

Motherwell's inflated, soft declaration of *"Je t'aime"* in which flabbiness begins to turn into something else, which carries intimations of the universal,

Pollock's one-man shows which sucked the spectator into a swirled landscape of thrown paint,

Gottlieb's apocalyptic black suns leaking tangles of calligraphy to a mineralized beach . . .

Pop art, Hard Edge painting, optical abstractions, neo-Dada assemblages and constructions, the dramatics of Happenings and Environments and Nothings, are all in direct, lineal descent from the assumptions of the New York School.

Recent changes in the situation, however, are dangerous and unforeseen.

There is the tendency to break down the esthetic distance, the crystalline barrier that separates the work of art from the spectator. "Anti-style" has been a New York slogan in modern paintings since the mid-1940s, but it was informed by a hardboiled, aristocratic, intellectual attitude. Something new appears in pictures which are programmatically ingratiating, which cuddle the audience in the name of Anti-art. Certain neo-Dada constructions, for example, invite the in-group to play with them, to join in the romp. They charm the spectator, beguile and tease him. Art tends to be a courtship dance between seller and buyer.

Equally nonpictorial are some abstractions that rely on optical effects—colors which apparently flash on and off; lines appear and disappear in moiré patterns; after-images mill about like a crowd dispersed into the streets. The action of the painting takes place in the eye of the beholder. A new sort of anecdotal naturalism, based on the viewer's retinal nerves, is evolving in which the artist depends on his audience to finish the art.

And in some examples of pop art, acceptance of the environment has changed into a campy game about it. The vulgar, instead of being taken for granted, admired and transformed, becomes a cult object or fetish or inside joke for esthetes. An epicene simper is sensed behind some of these works that go all out to seem daring or risky.

Related in temper, if not in appearance, to this sub-pop group are the new, cutey-pie nihilists who make abstract objects that are meant to function as concrete demonstrations of night-school phenomenology: what is "art," what is "illusion," what is really "real," etc.

And, logically enough, all four nonpictorial manifestations invoke the old-fashioned idea of an avant-garde

to justify their essentially reactionary positions. (The phenomenon of "New Conservatives" claiming the glamour of historical avant-garde prerogatives is by now familiar from politics.)

A final portent is the emergence of the art critic who wants to be a force in sales, and of the art dealer who wants to create styles, and of the blending of both into one lumpy entrepreneur (who is, of course, the loudest drum-beater for the revival of an avant-garde).

New York art mediates a delicate balance between location and dislocation, continuity and revolution. A jump on either side of the equation will annul it.

It won't take anything so big as a world war to ruin the New York School.

The fact that at least two generations of artists are now at work in masterful independence can be as little help to the younger artists as Picasso and Miró were to the lost generations of Parisians in the 1940's.

The Phony Crisis can merge into the real one, just as two forest fires can join to destroy a landscape.

Part of our commitment to modern art, and adherence to the radical solutions it found in New York, is the realization that art can cease to exist.

AND NOW THE SPHINX

by Nicolas Calas

Most critics find the roots of the new art in Abstract Expressionism and Dada. In this article, Nicolas Calas explores the relationship between Pop Art and Surrealism. He notes similarities between the two styles despite their fundamental difference in approach.

Mr. Calas is on the faculty of Fairleigh Dickinson University and writes art criticism for The Village Voice. *His publications include a collection of surrealist essays entitled* Foyers d'Incendie *(Paris, 1938) and essays in* Kulchur *and* Art and Literature.

WHEN ASKED "Is Pop Art a postwar form of Surrealism?" I beg my interrogator to bear in mind that Surrealism is deeply involved in moral issues, while Pop Art is not. Surrealism is passionate and romantic, while Pop Art is cool and pragmatic. Surrealism developed in the intellectual climate of dialectical interpretations of both society and the psyche. Pop Art grew in an age of logical positivism and empiricism. Surrealism relies on symbolism, Pop Art on literalness.

Instead of Max Ernst's wonderland peopled by fabulous women metamorphosed into hybrid birds, what we are shown today is Lichtenstein's stenographer as a heroine of comic-strip melodrama; Delvaux's somnambulistic sirens are replaced by Wesselmann's bland call-girl with the eyeless gaze. Dali wants painting to be appetizing, and Oldenburg offers oversized drugstore hamburgers.

Between Surrealism and Pop Art the avant-garde went

179

through a phase of Existentialism that had a profound influence on some of today's best writers and artists.

1. SURREALISM

Surrealism challenges reality in the name of freedom of the individual. Like Pascal, the Surrealists interpret this freedom in terms of intentions rather than actions, as do the Jesuits and other adherents to the doctrine of "the end justifies the means." Since the Surrealists are involved with passion, and not with salvation, they interpret intentions in terms of desire rather than in terms of freedom of will.

The ambition of Surrealism was to reinterpret on the poetic level Marx's famous aphorism, "We have sufficiently explained the world; it is time to transform it." To the Surrealists this involved overcoming the contradiction reality-dream by creating a super-reality.

To achieve these political and literary goals sacrifices must be borne. The poet must realize that not all desires are desirable, for the most desirable of all desires is love. Through love, and love only, can we overcome the boundaries of the self and achieve that ecstasy, that state beyond bounds in which the I and the Thou are one. To understand what love is, the Surrealist will refer to the letters of Héloïse and Abélard, to Shakespeare's *Antony and Cleopatra*, to the poetry of Saint John of the Cross, to Rousseau's *Nouvelle Héloïse*, to the letters of Napoleon Bonaparte to Josephine. Breton's contribution to the exposition of love is *Nadja*, a novel in which insanity becomes an asset of the poet's beloved. Nadja possesses "la beauté du diable."

Since the insane reject reality—for whatever reason— those who believe in the reality of God justifiably recall David's verse, "The fool hath said in his heart there is no God." When therefore André Breton hails insanity as

purity, it is as if he were proclaiming that the poet has the right to be irresponsible. Negation of reality in the name of a poetic dream or a political utopia becomes ludicrous in the age of anxiety. "Forget your dreams and hold your breath" advise Kierkegaard's disciples. To Solomon's passionate *Song of Songs* the humility of Job is opposed by Sartre; to Rimbaud, Dostoyevsky; to Lautréamont, Kafka; to *Nadja, La Nausée*; to love, death. Freedom from bondage is reinterpreted in terms of freedom in bondage. Sartre believes man can be saved through self-realization, through the "pour soi." What this means is obscure, since the term implies both the collective "we" and the individual "I."[1]

With their "cri du cœur" in praise of love and folly, revolt and irresponsibility, the Surrealists enter the domain of lyricism. The Existentialists, with their attention focused on extreme situations, espouse tragedy.

2. POP ART

Unlike the Surrealists, who plunge into their souls and the Existentialists who explore extreme situations, Pop artists "look out upon the world" (Lichtenstein), boasting of their detachment. The Pop artists' approach poses a serious question: If new art is no longer the reflection of the unconscious or an expression of emotion, can it claim to be a manifestation of modern art? Is it not modern art's great glory to have substituted "inner truth" for Truth (of perspective or reality)—and the uniqueness of an individual's experience to "knowing how to see?" From Turner to Monet, from Van Gogh to Picasso and after, modern art stands or falls according to the answer we give to this question. After Picasso come

[1] Herbert Marcuse: Existentialism; remarks on J-P. Sartre's *L'Être et le Néant*; in *Philosophy and Phenomenological Research*, VIII, 3; March, 1948.

Pollock and de Kooning, who opened our eyes to the enchantment of indeterminate patterns. (The composer John Cage translated Pollock's findings to indeterminate sequences, opposing thereby the stillness-in-movement to Pollock's motion-in-stillness.) Rauschenberg formed indeterminate sequences of dissociated images into a patternless setting. "Something new (spontaneous, 'specific') is always a language game," says Wittgenstein. This dictum certainly applies to Jasper Johns, as is made clear by an excerpt from the latter's *Sketch Book Notes*: "Make neg. of part of figure and chair. Fill with these layers—encaustic (flesh?), linen Celastic. One thing made of another. One thing used as another. *An arrogant object.* Something to be folded, or bent, or stretched (SKIN?). Beware of the body and the mind. Avoid a polar situation. Think of the edge of the city and the traffic there" (*Art and Literature*, 4, Paris, 1965).

Thus handled, painting could become but a game. The true artist, however, has a spectator in mind—as Sartre has so convincingly demonstrated—and he seeks to engage this viewer, make him look again and again. Back of the game, or beyond it, a dialogue is perused.

Emotional detachment, as interpreted by John Cage and Allan Kaprow, reflects the contention that artistic activity is natural to man, and consequently should not be differentiated from any other form of activity. One and all can be comprehended in terms of Happenings. Thus Kaprow writing on Spoerri lists, together with the artist's productions, the cooking of lasagna, lovemaking, sleeping, defecating. By stressing the chance character of Happenings at the expense of a meaningful sequence of events, the present is more easily detached from a historical order, and appreciated for its pure actuality. This in turn prompts a dissociation of conduct from any moral consideration. When before the 1964 Venice Biennale Rauschenberg was asked if he had considered at all refusing a prize he remarked in mild surprise "Who

am I to say no?" A remark such as this makes explicit the difference in attitude from that of the orthodox Surrealist who is eager for an opportunity to defy the Establishment. Perhaps the most vivid illustration of difference between the two approaches is exemplified on the one hand by the Surrealist poet Jean-Pierre Duprey urinating in Paris over the tomb of the Unknown Soldier and, on the other, by Robert Whitman whose defecation is registered by a movie camera set within the toilet bowl for the benefit of the public in one of Alan Solomon's Happenings. Duprey's act is a desecration symbolic of revolt, while Robert Whitman's relies on the public's acceptance of: "Why not?"

The "Why not?" attitude helps develop a sympathetic state of mind toward the gathering of information through the most unusual forms of investigation and experimentation. In so far as art gathers and transmits information, the "Why not?" attitude toward art is healthy. Why not depict the dream? and introduce ready-mades and *objets trouvés* into an art exhibition? Why not imitate reproductions?

But art is not reducible to a means of conveying information. The statement has to be made with elegance. This is what Paul Valéry meant when he noted, "I stop saying in order to make." The object made by the poet or painter is one that the artist offers to the world. He is giving something useless as a compensation for not having worked at making something useful. The recipient will accept the gift if he finds it interesting and attractive. According to Sartre, the reader fills in the writer's statements with his own feelings, and Paul Eluard remarked, "Le poète est celui qui inspire." We do not just read a work of art; we read into it. Yet this is only possible when the artist has left something unsaid. He has to "stop saying" in order to withhold information.

By withholding, control is maintained. Without control there could be no civilization. It's prerequisite may be

sphincter control, but the Sphinx is the symbol of its achievement. Gifts are compensations made for wealth or knowledge withheld. There is no reason, however, for us to accept all offered gifts. To extend permissiveness to the point where producing a sculpture or defecation is not qualitatively differentiated reduces the human being to the level of those dumb animals for which all functions—copulating, eating, sleeping, and defecating—are equal events or happenings.

In the world of happenings, love is nothing more than an encounter and an acquiescence. Striking in John Cage's book *Silence* is the total absence of any reference to love, despite its wide range of topics. This might be due to the influence of the monastic discipline of Zen upon the author. Since Cage's upbringing is Christian, of significance is the very fact that he is attracted by a doctrine which, in contradistinction to Christianism, ignores love.

Pop artists and their intellectual guides take as little interest in freedom as they do in love. But one form of freedom they are concerned in maintaining and expanding is a by-product of the freedom of the press. In the first place, it is the press that feeds them with slogans and images. Viewed as a source of information, journalism's function is to transmit news as accurately and as precisely as possible. We may suspect that absolute precision in non-technical language is not feasible. For myself, I had not realized the extent of the difficulty of giving precise technical information concerning such things as the color of a material until I read an article on universal color language, in which we are told that thanks to the Munsell tables the color of a "yellowish brown rug can be specified with the greatest accuracy as $x = 0.395$, $y = 0.382$ and $Y = 35.6\%$."[2] Since no writer would be likely to describe the rug in a room in this

[2] Kenneth Kelly, "A Universal Color Language," in *Color Engineering*, III, 2 M-A, 1965.

manner and no painter would match the color of that rug with such a degree of accuracy, one's belief is confirmed that art may well be a source of misinformation. Any semantic attempt to account for the work of men like Cage, Rauschenberg, or Warhol in terms of communication of information is beyond the point. Accuracy is demanded as a consequence of competition, whether in play or work, or to establish truth in the realm of justice or to discover it in the field of science. To the extent that a work of art is original, it cannot be measured accurately, for it does not fit existent standards.

The artist cannot but misinform about shape and color of depicted objects for insofar as he is a poet he is a being who associates what he sees with what he remembers. Through association of the present to his past the poet remains himself and avoids becoming just a worker or a machine. Because of death, the poet can never reconcile himself to a world in which man becomes the sex organ of the machine (Marshall McLuhan). Fear of death caused man to seek means of postponing the inevitable. In the age of mechanical speed, the poet's function is to invent delaying techniques. Historically, delay was elaborated in relation to rituals performed around the altar, for the function of ceremony was to delay the end, symbolized by the sacrifice. In art, both repetition of rhythm and lack of clarity delay the end.

Yet Andy Warhol declares how desirable it would be to resemble the machine. But of course! for then there could be no misunderstandings. Nor can there be any misunderstanding about the literal meaning of Whitman's defecation film. It seems that some of the organizers of the Happening at which this movie was shown disapproved of it, but felt it was unacceptable to act as censors. Likewise certain critics refrained from adverse comment on the movie least they be accused of narrowmindedness. It recalls the mother who does not scold her child when he defecates in her lap because she learned

from her psychiatrist that the infant's act must be seen in terms of a gift to her.

The child needs to learn not to make the gift. But how should the critic respond to the artist who says why not film defecation? Or write a poem to the process as does Felix Pollak?[3] Or mold excrements as does Sam Goodman? In the name of the attitude of "Why not?" the critic's role would be likened to writing copy for the artist's publicity agent. Has not the time come when the critic should earnestly ask himself, not only how permissive must he be, but how demanding? My answer, as demanding as was the Sphinx when Oedipus was questioned.

[3] See *Kulchur* 18, Summer, 1965.

NEW YORK LETTER 1965
REINHARDT, DUCHAMP, MORRIS*
by Lucy R. Lippard

*The following essay discusses three artists who
are representative of some of the principal
trends in the New York art scene today. Two
of these have long been established as major
artists—Ad Reinhardt for twenty years and
Marcel Duchamp for half a century. The
third, Robert Morris, is a relative newcomer,
but, as Miss Lippard points out, his work is
markedly related to the older artists, espe-
cially Duchamp. Once again we see how
firmly today's most avant-garde art is rooted
in Abstract Expressionism and Dada.*

*Miss Lippard was born in New York in
1937 and attended Smith College and the
New York University Institute of Fine Arts.
She is New York editor for* Art International
*and is currently preparing a book on Max
Ernst.*

AD REINHARDT was born on Christmas Eve in a properly
messianic manner. His "Twelve Rules for a New Acad-
emy," published in 1957, were indeed prophetic of the
new academism of 1965. ("No texture, no accidents or
automatism, no brushwork or calligraphy, no sketching
or drawing, no forms, no design, no color.") Reinhardt
is now recognized as a rebel and a prophet, and is widely
admired; but he has been a precedent for, rather than

* Selected reviews, slightly revised, from "New York Letters"
published in *Art International*, Vol. 9, Nos. 3 and 4, 1965.

an influence on, recent trends. After all, Reinhardt had been working in a sternly reductive vein since 1951, yet it was Barnett Newman who provided the key for the emerging formalism. Reinhardt's attitude is diametrically opposed to Newman's diffuse inclinations to the "sublime" as well as to those of the intellectually oriented "cool" persuasion. Despite his iconoclasm, he is an idealist; despite his conceptualism, the uncompromising spirit of his writings is closer to the Abstract Expressionist crisis-and-sacrifice esthetic, with a touch of Dada, than to the determinedly non-emotional stance of the younger generation. Only an idealist could have written: "The one standard in art is oneness and fineness, rightness and purity, abstraction and evanescence" (1962).

It is the duty of a museum to assemble a Reinhardt retrospective, and an overdue task at that. Since none has so far taken up the challenge, it has been left to his dealer of nearly twenty years, Betty Parsons, to organize small panoramic views of his work from time to time.[1] In March of 1965, the Stable, Graham, and Parsons galleries showed, respectively, the blue paintings, the red paintings, and the notorious black paintings. The two first named date from 1951–1954 and mark the beginnings of the Reinhardt we know; they represent the break from his equally individual and equally purist Abstract Expressionist period. The black paintings date from 1960 to the present. Chronology means little to Reinhardt; he considers all his work "timeless," yet the spectacle of undeviating distillation and refinement through the years is one of the most interesting aspects of these three exhibitions. In 1951, the choice was made of a relatively conventional geometric style and a muted palette as the best vehicles for a goal already clear in 1948 when he wrote: "Perhaps pure painting is a direct experience and an honest communication. Perhaps it is a creative complete-

[1] One has. The Jewish Museum has scheduled a Reinhardt retrospective for Spring 1966.

ness and total sensitivity related to personal wholeness and social order because it is so clear and without extra-esthetic elements." Reinhardt refined rather than inno-vated this form of abstraction, still rooted in Cubism. His innovation was his use of color (and later the unchanging framework)—non-complementary, then close-valued, and finally "invisible"—and his attitude, his insistence upon the monotony, detachment, inaction, and dignity that he once enumerated as the great qualities of Asian art. The brilliant red paintings at Graham—from an early piece including maroon and ochre to the late pink and cadmium "monochrome" canvases—made a dazzling show; they firmly establish Reinhardt as the originator of American color primacy, and of optical painting as it is used in the non-illusionistic context of the new abstraction. The red paintings are as light-filled and glowing as the black paintings are darkness-filled and glowing. The blue paintings have more chromatic variety. Only a few (from 1953) are as richly luminous as the red, and some are very dark, heralding the "black" con-cept. One particularly handsome vertical has an elec-trically tactile, dark royal blue on red and green tones that approach no-color. In a few cases, in both blue and red paintings, a distinctly "human touch" is evident in the visible brush strokes, the not quite straight or clean edges; and I suspect this is true of the black ones as well, although there such touches are lost in the over-all gloom.

It is too bad that Reinhardt's 1955–1960 works—varia-tions on the darker blue theme and the beautiful red, blue, and green paintings that the artist called "black" even then—could not have been included in this three-gallery show. Red, blue, and green have been Reinhardt's colors all along. The blacks represent a synthesis, and the 1958 near-black paintings might have reconciled some of the timid to the more radical ones, made up of the same colors, but darkened and close-valued until they are a

unity instead of a combination of hues. The Parsons show is extremely moving. What seems a final reduction (barring solid black out of the tube) to the identically square trisected canvas is not so rigid a framework as one would suppose. The initial visual experience is of the persistently matte surface, a paint quality that seems velvety, producing an inward-turning depth instead of asserting the surface. This is achieved by draining all of the oil from the paint in some special process, and makes the canvases extraordinarily susceptible to fingerprints or to the touch of oily substances. The mortality rate in exhibitions is high, bearing out the artist's opinion that "the less exposed a painting is to a chance audience, the better." (They are not only touched but ridiculed; the touching is because people can't *see* anything, and are irresistibly constrained to touch instead, like the blind.) After some paintings were damaged at the Museum of Modern Art, Reinhardt was ready to replace them with "a picture here that's more like the one you've got than the one you've got." At Parsons, rectangular white platforms were put in front of each picture, which heightened the religious aura of silence and darkness, also augmented by organ strains from the sound studio next door.

The fact that it takes so long to perceive the forms and colors in the black paintings forces the viewer into an appropriate mood, if he doesn't just shrug and move on. Once in the mood, it is difficult to escape. An intimacy is established, a kind of secret bond between the patient, concentrating viewer, whose mind and eye are slowly opening to nuance and undertone, and the impassive but "self-conscious object" waiting to be penetrated, implying that there is something there for those who will work for it. There is. Each painting is different. And because they are ostensibly "all alike," similarities are ultimately minimized, degrees of difference magnified. Reinhardt's will toward sameness is contradicted in the process. The more everything is alike and the more his pictures

resemble each other, the greater the significance of the slightest diversity. Each imperceptible move off the straight and narrow path takes on the momentousness of an event. The intensity is fortified by mystery. Reinhardt insists, of course, that metaphysics, mysticism, symbols have nothing to do with his art. Nevertheless, the cross, with all its implications, is the hermetic skeleton of every painting. And they are all human in scale. The norm Reinhardt has fixed upon—5′ by 5′, or "high as a man, as wide as a man's outstretched arms"— reinforces the impression of universality, and refers again to the crucifix, as did his earlier vertical figurations. It is important to remember that the cross long predates Christian symbolism and existed as a significant form in all cultures. The totally non-specific reference—actually an abstract mood rather than a sign—in Reinhardt's canvases is to magic rather than to religion—not black magic or white, but the magic of creativity as a life force and a universal phenomenon. Since the black paintings serve to stimulate meditation, and Reinhardt is himself a scholar of Oriental art, references have also been sensed to Ch'an Buddhism, and these are supported by the constant emphasis on oneness and freedom through discipline in his writings. In fact, the source of his double negative critical style might well be the sage who said: "No thought, no reflection, no analysis, no cultivation, no intention."

The question inevitably raised by work as radically reductive as Reinhardt's is "How far can it go?" or "Where will it all end?" No one knows but the artists who will someday, maybe tomorrow, go further. Much the same thing was said about Malevich's *White on White*, which turned out to be the *beginning* rather than the end of a new art. Another Oriental ancient said: "When everyone recognizes beauty as beautiful, there is already ugliness." It is artists like Reinhardt who extend our comprehension of the nature of beauty. Martin

James and Priscilla Colt have written perceptive articles treating the major issues in Reinhardt's work (*Portfolio* No. 3, 1960; *Art International* Vol. 8, No. 8); it remains for someone to write a book on Reinhardt clarifying the complex relationships between the expressionist and the purist, the editor and the theorist, the scholar and Orientalist and the cartoonist and social satirist, the idealist and the "conscience of the art world," or, as he has called himself, "The Great Demurrer in a time of Great Enthusiasms." The paradox awaits the courageous adept. The qualifications for Reinhardt's biographer are as stringent as those for the priesthood. Still another Eastern axiom: "Those who know do not speak; those who speak do not know."

* * *

"Like Louis XIV," Salvador Dali once quipped, "Marcel Duchamp can say: *'L'echec c'est moi.'* " In a large and endlessly provocative exhibition held at the Cordier & Ekstrom gallery, in February, 1965, an extensive collection of post-1912 Duchampiana was reunited with a selection of very early paintings, journalistic illustrations, drawings, and watercolors from a sketchbook of 1904–1905, manuscript notes, memorabilia, and bibliographical ephemera. The ready-mades were there in full force, often in the limited edition reproductions recently brought out by the Galleria Schwarz in Milan. These pose a new ethical problem as to "originality" after Duchamp's own heart, since the artist himself has long had the habit of making multiple versions of lost or un-available works; they differ primarily in that Schwarz has tried to stay as close as possible to the first version, whereas the artist has felt free to improvise. Duchamp has mentioned the "snapshot effect" desirable for a ready-made, which would also refer to its reproducibility, and in the catalogue of the exhibition Richard Hamilton elucidates: "Three means 'number' for Duchamp. One is unique, two is a pair, three approaches many. To make

three of a thing was to mass-produce them . . . the ready-mades symbolize an idea—the rest is sentiment."

Aside from being *the* proto-Dada, Duchamp has also been in many ways the anti-Dada par excellence. While the Dadas exhorted their audience to "Stop thinking!" and cried, *"Bas les mots!"* and *"Merde à la beauté!"* Duchamp was doing nothing but thinking, using words, and even creating new areas of beauty. While his attitude epitomized iconoclasm, his work never lost the elegance evident in his early drawings. The Dadas also said, *"Intelligenz ist Dilletantismus,"* and in looking back over Duchamp's career this is indeed the crux of the matter. In the face of much new art, academic seriousness has become somewhat ludicrous, and popular or "found" culture has in turn become esoteric and fashionably profound. What better combination than the hero who is dead serious about not being serious? Duchamp has set the tone for an entire era. The epochal Virgins, Bachelors, and Brides were actually his first fully realized creations. Whether his subsequent voluntary withdrawal from conventional painting stemmed from a knowledge of his own limitations or whether it was a sublime sacrificial act, the decision was a profoundly important one. His superior intellect spared him from the theatrical exhibitionism of many Surrealists; his wit set him apart from the naïveté of the emotional idealists, and his unique concept of art reserved for him a seat in the Pantheon's peanut gallery, where he could wryly comment on the activities on stage and, occasionally, throw things. Now the times have caught up with his ideas and there are others who can build constructively on them. It is interesting that in spite of the purely intellectual and ascetic intentions always attributed to Duchamp, the influence of his work has been as great in its formal as in its metaphysical qualities. As Richard Hamilton noted in an article last year: "The most remarkable quality that Duchamp possesses is his ability to find ex-

pression for notions which, at first sight, seem totally devoid of plastic interpretation. He finds a visual poetry for ideas which appear essentially abstract and non-visual" (*Art International*, Vol. 7, No. 10). Herein lies his real genius and his real contribution. Duchamp straddles the gap between the intellectual and the artist. There is something for everyone. His work after 1914 can be enjoyed because of its humor, wit, and irony, because of its strictly visual properties, or on the almost unapproachable plane of mental athletics. But whatever level is chosen, there is always the multidimensional prospect of other levels, anarchic hints and tentacles sent out in the direction of the unsuspecting onlooker from the agile mind of the Great Dilettante.

* * *

Robert Morris, whose architectonic structures and lead and sculpmetal reliefs were exhibited at the Green Gallery in 1965, seems to be reconciling his double tendency toward the formal and the cerebral, toward Reinhardt and Duchamp. The new reliefs are generally simpler and more rigorous than those shown in 1964, though there are still several relatively literary pieces. References to Duchamp abound, and are undoubtedly intentional. Among them: a piece of cracked plateglass, the imprint of a vulva (recalling Duchamp's *Feuille de vigne femelle*), notes for the work as a work of art in themselves (*Green Box*), two "measured" cracks (*Stoppages-étalon*), commercial brushes (*Tu m'*), "framed" ball of twine (*A bruit secret*—see illustration), not to mention the ready-mades and more esoteric homages. Although the dull gray materials that Morris has used persistently for some time were practically invented by Jasper Johns, Morris parallels Johns's debt to Duchamp rather than being third in line. He is much more conspicuously involved with ideas than Johns, who is first and foremost a painter. (The brain is precious to Morris, so much so that he covered a cast of it with dollar bills,

Marcel Duchamp: *A bruit secret (With Hidden Noise)*. 1916. Semi ready-made: ball of twine containing a small "secret" object pressed between two brass plates (12.9 x 13 cm.) joined by four screws (11.4 cm. long). Photograph courtesy of Galleria Schwarz, Milan.

and another with silver.) The interesting thing about Morris's work is that he rarely overdoes the intellectual content. Formally, he does some very interesting things that would take too long to describe; mentally, he has a good deal to say to those who care to listen. His idea of a template—a form made for the purpose of testing accuracy (mentioned in his notes)—may be at the heart of the exhibition. The fascination in tracing his devious trail lies not in the solutions arrived at (there are none), but in the labyrinthine processes of the artist's mind in action. It might well be asked whether all this is not so close to Duchamp that it simply derives or repeats. I think the answer is that Duchamp's methods of chance and highly personal metaphysics are by definition infinitely extensible, for they are different in every set of hands, or every mind.

One of Morris's present themes seems to be connection and separation, or wholeness through fragmentation. The largest piece is a horizontal with a slice out of one corner, various other apertures in the surface, several objects, and long connecting bands. There is also a lock, a knot, and a ball of twine. Two wire brushes may have been used to burnish areas of the surface, and therefore play the double role of object and implied act. It is full of allusions to regularity and irregularity, straight and "torn" edge, image and abstraction, softness and hardness. On a nail at the right hang a soft lead envelope and several "sheets" of notes which read, in part:

> Use the idea of a template—together with something which perishes/make facsimile notes on lead sheets, hang on hook against wall surface/many parts/the knot piece with angle below—this confrontation; a possible means—but as a "starting point" for a collection—or from which to begin a collection of configurations, it remains—is the prime possibility incarnate. In other words is in a sense

Robert Morris: *Untitled*. 1965. Mixed media on masonite. 30" x 8" x 3½". Photograph courtesy of The Green Gallery, New York.

closed and reflexive (not yet extended, elaborated, differentiated)/Possible mode of 2/As the presentation of a possible mode of 2 series of possibilities undeveloped it must refer (in its existence) to itself. (More so than if it were the name of the class of configurations— i.e. after extension of its possibilities.)

Three other pieces carry separation and reunion to the breaking point. The first (see illustration) consists of two small objects between two horizontal bars set just far enough apart to stretch their relationship, as though Morris were testing the possible distance of withdrawal that still commands some tension between the two elements; one of the inserted objects is a ball of twine, the other a rotary brush half concealed in a slot. The second piece on this theme has a battery suspended from the ceiling in front of the wall plaque; another battery is set on a little shelf far away on the wall, related to the relief only by the presence of its twin. The separated objects draw together by means of a magnetic optical impulse to connect; the bonds are as mental as they are physical. The third piece is made up of four wide-set mirror cubes, or visual puns, placed on the floor. The sides reflect the floor so that only the top plane "exists," providing a transparency more true than that of plexiglass or glass. There is no distracting reflection because the image is reflection.

WRITINGS*

by Ad Reinhardt

Elsewhere in this book, Lucy Lippard points out, Reinhardt's ". . . 'Twelve Rules for a New Academy' . . . were indeed prophetic of the new academism of 1965." The notes that follow comment on all aspects of the "art world" and include refreshing suggestions and blunt reminders.

Ad Reinhardt:—Painter, born New York, December 24, 1913.

—Columbia College, 1935

—25 one-man shows in New York, London, Paris, Los Angeles

—Teaches at Hunter and Brooklyn Colleges

—Represented in most major museums in America

—Travels in Asia, Europe

* Parts of this material originally appeared in *Art News*, May, 1957, and February, 1964; in *Art International*, Vol. VI, No. 10, December, 1962; and in the catalog of the "Americans 1963" exhibition at the Museum of Modern Art. The remainder is excerpted from a talk given by Mr. Reinhardt at the church of St. Marks-in-the-Bouwerie in October, 1963.

FROM "TWELVE RULES FOR A NEW ACADEMY"[1]

"THE GUARDIAN of the True Tradition in Art" is the Academy of Fine Art: "to give certain rules to our art and to render it pure." The first rule and absolute standard of fine art, and painting, which is the highest and freest art, is the purity of it. The more uses, relations, and "additions" a painting has, the less pure it is. The more stuff in it, the busier the work of art, the worse it is. "More is less."

The less an artist thinks in nonartistic terms, and the less he exploits the easy, common skills, the more of an artist he is. "The less an artist obtrudes himself in his painting, the purer and clear his aims." The less exposed a painting is to a chance public, the better. "Less is more."

The Twelve Technical Rules (or How to Achieve the Twelve Things to Avoid) to be followed are:

1. No texture. Texture is naturalistic, mechanical, and a vulgar quality, especially pigment texture or impasto. Palette knifing, canvas stabbing, paint scumbling and other action techniques are unintelligent and to be avoided. No accidents or automatism.

2. No brushwork or calligraphy. Hand writing, hand working, and hand jerking are personal and in poor taste. No signature or trademarking. "Brushwork should be invisible." "One should never let the influence of evil demons gain control of the brush."

3. No sketching or drawing. Everything, where to begin and where to end, should be worked out in the mind beforehand. "In painting the idea should exist in the mind before the brush is taken up." No line or outline. "Madmen see outlines and therefore they draw them." A line is a figure; a "square is a face." No shading or streaking.

4. No forms. "The finest has no shape." No figure or

[1] Sources of quotations from the ancients will be supplied by the author upon written request.

fore- or back-ground. No volume or mass, no cylinder, sphere, or cone, or cube or boogie-woogie. No push or pull. "No shape or substance."

5. No design. "Design is everywhere."

6. No colors. "Color blinds." "Color sticks in one's eyes like something caught in one's throat." "Colors are an aspect of appearance and so only of the surface," are "a distracting embellishment," and "manifest an indiscreet personality with shameful insistence." Colors are barbaric, physical, unstable, suggest life, "cannot be completely controlled" and "should be concealed." No white. "White is a color, and all colors." White is "not artistic, appropriate and pleasing for kitchen fixtures, and hardly the medium for expressing truth and beauty." White on white is "a transition from pigment to light" and "a screen for the projection of light" and "moving" pictures.

7. No light. No bright or direct light in or over the painting. Dim, late afternoon, nonreflecting twilight is best outside. No chiaroscuro, "the malodorant reality of craftsmen, beggars, topers with rags and wrinkles."

8. No space. Space should be empty, should not project, and should not be flat. "The painting should be behind the picture frame." The frame should isolate and protect the painting from its surroundings. Space divisions within the painting should not be seen.

9. No time. "Clock time is inconsequential." "There is no ancient or modern, no past or future in art. A work of art is always present." The present is the future of the past, and the past of the future.

10. No size or scale. Breadth and depth of thought and feeling in art have no relation to physical size. Large sizes are aggressive, positivist, intemperate, venal, and graceless.

11. No movement. "Everything is on the move. Art should be still."

12. No object, no subject, no matter. No symbols, images, visions or ready-mades. Neither pleasure nor

pain. No mindless working or mindless nonworking. No chess playing.

The department of fine art should be separate from other departments in the academy-university, and its aim the education and "correction of the artist"-as-artist, not the "enlightenment of the public" or the popularization of art. The art-college should be a cloister-ivy-hall-ivory-tower community of artists, an artists' union and congress and club, a "center of consciousness and conscience," not a success-school or service station or rest home or house of artists' ill-fame.

The museum of fine art should exclude everything but fine art, and be separate from museums of ethnology, geology, archaeology, history, decorative arts, industrial arts, military arts, and museums of other things. A museum is a treasure housē and tomb, not a countinghouse or amusement center. A museum should not be an art curator's personal monument or an art-collector-sanctifying establishment or an art-history manufacturing plant or an artists' market block.

The government bureau of fine art should keep art free from free enterprise, and when artists are unable to conduct themselves properly or are not able to govern or correct themselves, and when an art milieu becomes over-professionalized, over-amateurized, over-irrationalized, or over-managerialized, it should speak softly and carry a big stick.

THE NEXT REVOLUTION IN ART

The next revolution in Art will be the same old one Revolution.

Every revolution in art turns over Art from art-as-also-something-else into Art-as-only-itself.

The one eternal, permanent revolution in Art is always a Negation of the use of Art for some purpose other than its own.

All progress and change in Art is toward the one end of Art as Art-as-Art.

An avant-garde in Art advances Art-as-Art or it isn't an avant-garde.

Art-as-Art is as old as Art and Artists. Artists have always practiced, if not always professed, secretly or openly, Art-as-Art as Artists. Artists-as-Artists have always worked the same way and have always made the same things.

Art-as-Art is always a battle-cry, polemic, picket-sign, sit-in, sit-down, civil-disobedience, passive-resistance, crusade, fiery-cross, and non-violent-protest.

The Artist-as-Artist's first enemy is the philistine-artist, the "all-too-human" or subhuman or superhuman artist inside or outside or beside himself, the socially useful and usable artist, the artist-jobber and sales-artist, the expressionist-business man and "action" artist, the artist who "has to eat," who has to "express himself," and who "lives off, on, in, for or from his art."

The Artist-as-Artist's second enemy is the art dealer who deals in art, the private collector who collects art, and the public-profiteer who profits from art.

The Artist-as-Artist's third enemy is the utilitarian, acquisitive, exploiting society in which any tendency to do anything for its own transcendental sake cannot be tolerated.

Art-as-Art has always been and always will be a trouble for philosophers, priests, politicians, professors, patriots, provincials, property-people, proud-possessors, primitives, poets, psychiatrists, petit-bourgeois-persons, pensioneers,

patrons, plutocrats, paupers, panderers, pecksniffs and pleasure-seekers, for the reason of Art's own Reason that needs no other reason or unreason.

The most barefaced, half-assed, sham battle in the marketplace in recent years was the unprincipled "Action Painters' Protest Against the Critic of the New York Times," with the artists listing themselves shamelessly with their customers, mouthpieces, devotees and agents. What was good for the actionary-artists' busy-art-business was good also for the "embattled"-reactionary-art-critic's busy-book-business, and showed how the foundations could not be shaken.

The next revolution will sound the farewell of the old favorite songs of "Art and Life" that the old favorite artist-flocks loved to sing along with the old bower-birds and the new, good, rich, swallow-audiences. What curator has not thrilled to the strains and old refrains of "Art is a style of living, so to speak" (de Kooning, 1951), "Painting is voyaging into the night, one knows not where. . . ." (Motherwell, 1959), "There is no such thing as a painting about nothing" (Rothko, Gottlieb, 1947), and "Let no man undervalue the implications of this work, or its power for life, or for death, if it is misused" (Still, 1959)?

The next revolution will see the return again of natural, brute, expressionist, folk, monster, neo-primitive, junk, collage, assemblage, combine mongrel "merz," "pop," happening, unconscious, accidental, poetic, dramatic, "song and dance" art back to the every-day-theatre and environment, to the entertainment-field and junk-yard, to the folk-places and lower-depths where it all came from in the first place.

The next revolution will see a scattering to the winds of all local and foreign New York School "pictures of the passing world" and the permanent acknowledgment of

universal "pure land school" paintings everywhere, come heller or high water.

The next revolution will see the fading away of all old, unschooled, "school of hard knocks"-artists telling young artists they need not go to school, and the casting to the dogs of all schooled artist-company-men and the techniques of their trade—brushworking, pan-handling, backscratching, palette-knifing, waxing, buncombing, texturing, wheedling, tooling, sponging, carping, blobbing, beefing, staining, straining, scheming, striping, stripping, bowing, scraping, hacking, poaching, subliming, shpritzing, soft-soaping, piddling, puddling, imaging, visioning, etc. The soft sell on the clean, hard edge by the new artists was as much of a sellout as the hard sell on the soft edge by the dirty, old artists.

The next revolution will see the emancipation of the university-academy of art from its marketplace-fantasies and its emergence as "a center of consciousness and conscience," and the formation of a government department of art as the main support of unsupportable art. Art as an art-program or art-project will be a creeping-socialist-hothouse-flower instead of the present private-enterprise-outhouse-harlotree.

The next revolution in Art will recognize the inalienable right of each art to be free from all other arts, to be free to be itself, and to be free of itself.

Art-as-Art is a concentration on Art's essential nature. The nature of art has not to do with the nature of perception or with the nature of light or with the nature of space or with the nature of time or with the nature of mankind or with the nature of society.

Art-as-Art is a creation that revolutionizes creation and judges itself by its destructions. Artists-as-Artists value themselves for what they have gotten rid of and for what they refuse to do.

Art has never ruled the world.

Art-as-Art cannot win the world without losing its soul.

Art's reward is its own virture.

Words in art are words.
Letters in art are letters.
Writing in art is writing.
Messages in art are not messages.
A work of art is not work.
Working in art is not working.
Work in art is work.
Not working in art is working.
Play in art is not play.

Knowledge in art is not knowledge.
Learning in art is not learning.
Ignorance in art is ignorance.
Art-schooling is not schooling.

Unlearning in art is learning.
The unschooled in art are unschooled.
Wisdom in art is not wisdom.
Foolishness in art is foolishness.
Consciousness in art is consciousness.
Unconciousness in art is unconsciousness.

Order in art is not order.
Chaos in art is chaos.
Symmetry in art is not symmetry.
Asymmetry in art is asymmetry.
A square in art is not a square.
A circle in art is a circle.
A triangle in art is a triangle.
A trisection in art is not a trisection.

A color in art is not a color.
Colorlessness in art is not colorlessness.
Blue in art is blue.
Red in art is red.
Yellow in art is yellow.
Dark gray in art is not dark gray.
Matt black in art is not matt black.
Gloss black in art is gloss black.
White in art is white.

A line in art is not a line.
A wiggly line in art is a wiggly line.
A shape in art is a shape.
A scumbled shape in art is a scumbled shape.
Form in art is not form.
The formlessness of art is not formlessness.
Imagelessness in art is imagelessness.

Drawing in art is drawing.
Graphic art is graphic.
A print in art is a print.
A reproduction in art is a reproduction.
Painting in art is not painting.
Plumbing in art is not plumbing.
Carpentry in art is carpentry.
Texture in art is texture.
Figures in art are figures.
Configurations in art are configurations.
Transfigurations in art are not transfigurations.

Simplicity in art is not simplicity.
Less in art is not less.
More in art is not more.
Too little in art is not too little.
Too large in art is too large.
Too much in art is too much.
Chance in art is not chance.

Accident in art is not accident.
Spontaneity in art is not spontaneity.
Pushing in art is pushing.
Pulling in art is pulling.
Heroism in art is not heroism.
Hankering in art is hankering.
Hungering in art is hungering.

A collage in art is a collage.
Paste in art is paste.
Paint in art is not paint.
Brushwork in art is brushwork.
Sand, string, plaster in art is sand, string, plaster.
Sculpture in art is sculpture.
Architecture in art is not architecture.
Literature in art is literature.
Poetry in art is poetry.
Music in art is not music.
Poetry in art is not poetry.
Sublimity in art is not sublimity.
Rusticity in art is rusticity.

Vision in art is not vision.
The visible in art is visible.
The invisible in art is invisible.
The visibility of art is visible.
The invisibility of art is visible.
The mystery of art is not a mystery.
The unfathomable in art is not unfathomable.
The unknown in art is not the unknown.
The beyond in art is not beyond.
The immediate in art is not the immediate.
The behind in art is not the behind.
The forefront of art is forefront.

The cosmology of art is not cosmology.
The psychology of art is not psychology.

The philosophy of art is not philosophy.
The history of art is not history.
Art in history is not history.
The meaning of art is not meaning.
The morality of art is not morality.
The religion of art is not religion.
The spirituality of art is not spirituality.
Humanism in art is not humanism.
Dehumanism in art is not dehumanism.
Bumpkin-Dionysianism in art is Bumpkin-Dionysianism.

Darkness in art is not darkness.
Light in art is not light.
Space in art is space.
Time in art is not time.

The beginning of art is not the beginning.
The finishing of art is not the finishing.
The furnishing of art is furnishing.
The nothingness of art is not nothingness.
Negation in art is not negation.
The absolute in art is absolute.

Art in art is art.
The end of art is art as art.
The end of art is not the end.

JASPER JOHNS: STORIES AND IDEAS*

by John Cage

In his book Silence *John Cage writes: "The novelty of our work derives from our having moved away from simply private human concerns towards the world of nature and society of which all of us are a part." Cage substantiates this idea, as do many modern artists, by his interest in bringing together several disciplines.*

John Cage, the outstanding composer of avant-garde music, was born in Los Angeles in 1912 and he studied in California with Adolf Weiss and Arnold Schoenberg. He is musical director for the Merce Cunningham Dance Company and has taught at the New School in New York. The following piece on Jasper Johns will appear in his new book to be published in 1966.

Passages in italics are quotations from Jasper Johns found in his notebooks and published statements.

ON THE porch at Edisto. Henry's records filling the air with Rock-'n-Roll. I said I couldn't understand what the singer was saying. Johns (laughing): That's because you don't listen.

* Reprinted from the catalog of the Jasper Johns exhibition, The Jewish Museum, New York, 1964.

Beginning with a flag that has no space around it, that has the same size as the painting, we see that it is not a painting *of* a flag. The roles are reversed: beginning with the flag, a painting was made. Beginning, that is, with structure, the division of the whole into parts corresponding to the parts of a flag, a painting was made which both obscures and clarifies the underlying structure. A precedent is in poetry, the sonnet: by means of language, caesurae, iambic pentameter, license and rhymes to obscure and clarify the grand division of the fourteen lines into eight and six. The sonnet and the United States flag during that period of history when there were forty-eight? These are houses, Shakespeare in one, Johns in the other, each spending some of his time living. ¶ I thought he was doing three things (five things he was doing escaped my notice).

He keeps himself informed about what's going on, particularly in the world of art. This is done by reading magazines, visiting galleries and studios, answering the telephone, conversing with friends. If a book is brought to his attention that he has reason to believe is interesting, he gets it and reads it (Wittgenstein, Nabokov, McLuhan). If it comes to his notice that someone else had one of his ideas before he did, he makes a mental or actual note not to proceed with his plan. (On the other hand, the casual remark of a friend can serve to change a painting essentially.) There are various ways to improve one's chess game. One is to take back a move when it becomes clear that is was a bad one. Another is to accept the consequences, devastating as they are. Johns chooses the latter even when the former is offered. Say he has a disagreement with others; he examines the situation and comes to a moral decision. He then proceeds, if to an impasse, to an impasse. When all else fails (and he has taken the precaution of being prepared in case it does), he makes a work of art devoid of complaint.

Sometimes I see it and then paint it. Other times I paint it and then see it. Both are impure situations, and I prefer neither.

Right conduct. He moved from objecting to not objecting. Things beneath other people to do are not that way for him. America. ¶ Walking with him in the garden of the Museum of Modern Art, she said, "Jasper, you must be from the Southern Aristocracy." He said, "No, Jean, I'm just trash." She replied, "It's hard to understand how anyone who's trash could be as nice as you are." Another lady, outraged by the beer cans that were exhibited in the gallery, said, "What are they doing here?" When Johns explained that they were not beer cans but had taken him much time and effort to make, that if she examined them closely she would notice among other things fingerprints, that moreover she might also observe that they were not the same height (i.e., had not come off an assembly line), why, he asks, was she won over? Why does the information that someone has done something affect the judgment of another? Why cannot someone who is looking at something do his own work of looking? Why is language necessary when art so to speak already has it in it? "Any fool can tell that that's a broom." The clothes (conventions) are underneath. The painting is as naked as the day it was born. ¶ What did I say in Japan? That the Mona Lisa with mustache or just anything plus a signature equals addition, that the erased de Kooning is additive subtraction, that we may be confident that someone understands multiplication, division, calculus, trigonometry? Johns.

The cigars in Los Angeles that were Duchamp-signed and then smoked. Leaning back, his chair on two legs, smiling, Johns said: My beer cans have no beer in them. Coming forward, not smiling, with mercy and no judgment he said: I had trouble too; it seemed it might be a

step backward. Whenever the telephone rings, asleep or awake he never hesitates to answer. ¶ *An object that tells of the loss, destruction, disappearance of objects. Does not speak of itself. Tells of others. Will it include them? Deluge.*

Why this palaver about structure? Particularly since he doesn't need to have any, involved as he is with process, knowing that the frame that will be put around the all that he makes will not make the environment invisible? Simply in order to make clear that these flags-numbers-letters-targets are not subjects? (That he has nothing to say about them proves that they are not subjects rather than that he as a human being is absent from them. He is present as a person who has noticed that *At every point in nature there is something to see.* And so: *My work contains similar possibilities for the changing focus of the eye.*) Structures, not subjects—if only that that will make us pause long enough in our headstrong passage through history to realize that Pop Art, if deduced from his work, represents a misunderstanding, if embarked upon as the next step after his, represents a non sequitur. He is engaged with the endlessly changing ancient task: the imitation of nature in her manner of operation. The structures he uses give the dates and places (some less confined historically and geographically than others). They are the signature of anonymity. When, dealing with operative nature he does so without structure, he sometimes introduces signs of humanity to intimate that we, not birds for instance, are part of the dialogue. Someone, that is, must have said Yes (*No*), but since we are not now informed we answer the painting affirmatively. Finally, with nothing in it to grasp, the work is weather, an atmosphere that is heavy rather than light (something he knows and regrets); in oscillation with it we tend toward our ultimate place: zero, gray disinterest.

It does not enter his mind that he lives alone in the

world. There are in fact all the others. I have seen him entering a room, head aloft, striding with determination, an extraordinary presence inappropriate to the circumstance: an ordinary dinner engagement in an upstairs restaurant. There were chairs and tables, not much room, and though he seemed to be somewhere else in a space utterly free of obstructions he bumped into nothing. Furthermore he reached the table where I was sitting and recognized me immediately. Another time he was working. He had found a printed map of the United States that represented only the boundaries between them. (It was not topographical nor were rivers or highways shown.) Over this he had ruled a geometry which he copied enlarged on a canvas. This done, freehand he copied the printed map, carefully preserving its proportions. Then with a change of tempo he began painting quickly, all at once as it were, here and there with the same brush, changing brushes and colors, and working everywhere at the same time rather than starting at one point, finishing it and going on to another. It seemed that he was going over the whole canvas accomplishing nothing, and, having done that, going over it again, and again incompletely. And so on and on. Every now and then using stencils he put in the name of a state or the abbreviation for it, but having done this represented in no sense an achievement, for as he continued working he often had to do again what he had already done. Something had happened which is to say something had not happened. And this necessitated the repetitions, Colorado, Colorado, Colorado, which were not the same being different colors in different places. I asked how many processes he was involved in. He concentrated to reply and speaking sincerely said: It is all one process.

Conversing in a room that had both painting and sculpture in it and knowing as he does that there is a difference between them, he suddenly laughed for he heard

what he had just said (I am not a sculptor). I felt suddenly lost, and then speaking to me as though I were a jury he said: But I *am* a sculptor, am I not? This remark let me find myself, but what I found myself in was an impenetrable jungle. There are evidently more persons in him than one. (A) having painted a picture gives it the title *Flag*. (B) having made a sculpture gives it the title *Painted Bronze*. (A) referring to (B)'s work says beer when to be in character he would say ale. (C) is not concerned with structure nor with sculpture (*Jubilee*). (D) (*Painting with Two Balls*) is concerned with both. (E) has a plan: *Make something, a kind of object which as it changes or falls apart (dies as it were) or increases in its parts (grows as it were) offers no clue as to what its state or form or nature was at any previous time. Physical and Metaphysical Obstinacy. Could this be a useful object?* (F) experimentally inclined, among other ways of applying paint, stood on his head to make *Skin*. (G) sees objects in poetic interpenetration (*Fool's House*). (H) stands sufficiently far away to see panoramically (*Diver*). (I) records history (*Make Shirl Hendryx's shoe in Sculpmetal with a mirror in the toe—to be used for looking up girls' dresses. High School Days. (There is no way to make this before 1955.)*). (J) is concerned with language, (K) with culture sacramentally (*Tennyson*). (L) makes plans not to be carried out. (M) asks: *Can a rubber face be stretched in such a way that some mirror will reorganize it into normal proportion?* (N) is a philosopher: "——" *differs from a* "——". (O) studies the family tree. (P) is not interested in working but only in playing games. (Q) encourages himself and others *to do more rather than less.* (R) destroys the works he finishes and is the cause of all the others. (S) made *The Critic Sees.* (T) ¶ Both Johns and we have other things to do (and in a multiplicity of directions), but that he let his work have the American flag as its structure keeps us conscious of that flag no matter what else we have in

mind. How does the flag sit with us, we who don't give a hoot for Betsy Ross, who never think of tea as a cause for parties? (If anyone speaks of patriotism, it is nowadays global: our newspapers are internationally inclined.) The flag is nothing but The Stars and Stripes Forever. The stars are placed in the upper left hand corner of the field of stripes. But even though the whole thing is all off center it gives us the impression symmetry does, that nothing is in the wrong place. The flag is a paradox in broad daylight: proof that asymmetry is symmetry. That this information was given before so to speak the work was begun is a sign, if one needed one, of generosity which, alas, passeth understanding. Looking around his thoughts, he sees them in the room where he is. The clock doesn't always tell the same time. The dining-room table in the dining room does. *We're not idiots.* Just as, answered, the telephone presents an unexpected though often recognized voice, so a table should speak, provoking, if not surprising, at least a variety of responses. Eating is only one. The dining-room table will not do. It is taken apart, stored, then sent to the south. Another, a loan not a possession, but having a history of many uses, is brought in. That it is round is its concern. It might have been square or rectangular. Its surface, however, stimulates the tendency to do something, in this case a process of bleaching and staining. And the chairs around it: the removal of varnish and the application of paint. The result is nothing special. It looks as though something had been tried and had been found to work: to have many uses, not focusing attention but letting attention focus itself.

He does not remember being born. His earliest memories concern living with his grandparents in Allendale, South Carolina. Later, in the same town, he lived with an aunt and uncle who had twins, a brother and sister. Then he went back to live with his grandparents. After the third grade in school he went to Columbia, which seemed

like a big city, to live with his mother and stepfather. A year later, school finished, he went to a community on a lake called The Corner to stay with his Aunt Gladys. He thought it was for the summer but he stayed there for six years, studying with his aunt who taught all the grades in one room, a school called Climax. The following year he finished high school, living in Sumter with his mother and stepfather, two half sisters and his half brother. He went to college for a year and a half in Columbia where he lived alone. He made two visits during that period, one to his father, one to his mother. Leaving college he came to New York, studying in an art school for a little over six months. After applying for a scholarship, he was called into an office and it was explained that he could have the scholarship but only due to his circumstances since his work didn't merit it. He replied that if his work didn't merit it he would not accept it. Later, working in a bookstore on 57th Street, he went to see an exhibition at the Stable Gallery. Leo Steinberg, seeing him, asked if he was Michael Goldberg. He said: I am Jasper Johns. Steinberg said: That's strange; you look so familiar. Johns said: I once sold you a book. Clothes do not make him. Instead, his influence at rare and unexpected moments extends to his clothes, transforming their appearance. No mask fits his face. Elegance. ¶ He went to the kitchen, later said lunch was ready. Wild rice with Boleti. Duck in a cream sauce with Chanterelles. Salad. Hazelnut cake with Coffee.

The thermostats are fixed to the radiators but lead ineffectually to two bare wires. The Jaguar repaired and ready to run sits in a garage unused. It has been there since October. An electrician came to fix the thermostats but went away before his work was finished and never returned. The application for the registration of the car has not been found. It is somewhere among the papers which are unfiled and in different places. For odd trips a car is rented. If it gets too hot, a window is opened.

The freezer is full of books. The closet in the guest room is full of furniture. There is, and anyone knows there is, a mystery, but these are not the clues. *The relationship between the object and the event. Can they 2 be separated? Is one a detail of the other? What is the meeting? Air?*

The situation must be Yes-and-No not either-or. *Avoid a polar situation.* A target is not a paradox. Ergo: when he painted it he did not use a circular canvas. ¶ How lucky to be alive the same time he is! It could have been otherwise. ¶ Conversation takes place whether the telephone rings or not and whether or not he is alone in the room. (*I'm believing painting to be language, . . .*) Once he does something, it doesn't just exist: it replies, calling from him another action. *If one takes delight in that kind of changing process one moves toward new recognitions (?), names, images.* The end is not in view; the method (the way one brush stroke follows another) is discursive. Pauses. Not in order through consideration to arrive at a conclusion. (Staying with him is astonishing: I know perfectly well that were I to say I was leaving he would have no objection, nor would he if I said I was not going.) A painting is not a record of what was said and what the replies were but the thick presence all at once of a naked self-obscuring body of history. All the time has been put in one (structured?) space. He is able, even anxious, to repair a painting once it is damaged. A change in the painting or even someone looking at it reopens the conversation. Conversation goes on faithful to time, not to the remarks that earlier occurred in it. Once when I visited him he was working on a painting called *Highway*. After looking at it I remarked that he had put the word right in the middle. When I left he painted over it so that the word, still there, is not legible. I had forgotten that this ever happened. He hasn't. ¶ *Three academic ideas which have been of interest to me are what a teacher of mine (speaking of*

Cézanne and Cubism) called *"the rotating point of view"* (*Larry Rivers recently pointed to a black rectangle, two or three feet away from where he had been looking in a painting, and said ". . . like there's something happening over there too."*); *Marcel Duchamp's suggestion "to reach the Impossibility of sufficient visual memory to transfer from one like object to another the memory imprint"; and Leonardo's idea . . . that the boundary of a body is neither a part of the enclosed body nor a part of the surrounding atmosphere.* ¶ A target needs something else. Anything in fact will do to be its opposite. Even the space in the square in which it is centrally placed. This undivided seemingly left-over area miraculously produces a duplex asymmetrical structure. Faces.

Make this and get it cast. (Painting with ruler and "gray.") Sculpt a folded flag and a stool. Make a target in bronze so that the circles can be turned to any relationship. All the numbers zero through nine. 0 through 9. Strip painting before tying it with rope (Painting with a rope). Do Not *Combine the 4 Disappearances. A through Z.* He didn't do this because it seemed like a jewel. (The individual letters disappear into a single object.) Perhaps there's a solution. *It moves. It moved. It was moved. It can, will, might move. It has been moved. It will be moved (can't have just it).*

Does he live in the same terror and confusion that we do? *The air must move in as well as out—no sadness, just disaster.* I remember the deadline they had: to put up a display, not in windows on a street but upstairs in a building for a company that was involved in sales and promotion. Needing some printing done they gave me the job to do it. Struggling with pens and india ink, arriving at nothing but failure, I gradually became hysterical. Johns rose to the occasion. Though he already had too much to do, he went to a store, found some mechanical device for facilitating lettering, used it successfully, did all the other necessary things connected with the work

and in addition returned to me my personal dignity. Where had I put it? Where did he find it? That his work is beautiful is only one of its aspects. It is, as it were, not interior to it that it is seductive. We catch ourselves looking in another direction for fear of becoming jealous, closing our eyes for fear our walls will seem to be empty. Skulduggery.

Focus. Include one's looking. Include one's seeing. Include one's using. It and its use and its action. As it is, was, might be (each as a single tense, all as one). A = B. A is B. A represents B (do what I do, do what I say).

The demand for his work exceeds the supply. The information that he has stretched a canvas, if, that is, it was not already commissioned, produces a purchase. He conceives and executes an exclusive plan: the portfolios of lithographs. Two rows of numbers, 0 1 2 3 4 above, 5 6 7 8 9 below, the two rows forming a rectangle having ten equal parts; centered below this and separated by space is a single number of greater size but in a smaller area. (The two rectangles are not equal: together they produce asymmetry.) Because there are ten different numerals, and because each single lithograph shows only one of them in the lower rectangle, there are ten different lithographs in each portfolio, one for each numeral. The edition is one of thirty sets: a third in different colors no white, ten in black on off-white, the rest in gray on natural linen. (All the papers have as watermark the artist's signature.) The working process employed two stones: a large one upon which the two structures appear, a smaller one having the inferior rectangle alone. As the work proceeded, due partly to things that happened outside his control, partly to his own acts, the stones passed through a graphic metamorphosis showing both utter and subtle changes. The smaller stone, given its own color or value (sometimes barely differentiated from the color or value given the large one), appears on only a single lithograph of a given portfolio, on in fact that

lithograph having the large number corresponding to the number of that portfolio. Beyond these three sets of ten, three portfolios exist *hors de commerce*. They alone show the total work, but each of them is unique, printed in the different inks on the different papers. The world he inhabits us in? One in which once again we must go to a particular place in order to see what there alone there is to see. The structure above is as unchanging as the thirteen stripes of our flag. The structure below changes with each number just as the number of stars changes with each change in history. (The paradox is not just in space but in time too: space-time.) The alphabets were arranged that way in a book. He derived from them his own similar arrangement of numbers. *Competition as definition of one kind of focus. Competition (?) for different kinds of focus. What prize? Price? Value? Quantity?* Given the title and date of one of his works, he sometimes can remember it only vaguely, other times not at all. ¶ He is a critic. No matter how inspired it may have been, he refuses another's leap to a conclusion if it reveals that what was to be done was not done. He is puzzled by a work that fails to make clear distinctions (e.g., between painting and sculpture). Shrugging his shoulders he smiles. Grimly determined he makes *The Critic Sees*. ¶ The more hurricanes the better, his house is insured. Compact, opaque, often highly colored, cryptocrystalline . . . He is Other for whom to have been born is captivity. Alone he accepts the stricture as a wild animal can. Gazed at, he is of necessity arrogant.

The charcoal *0 through 9* began with an undivided space. But it was not the beginning. It was analysis of a painting in progress that used superimposed numbers as structure. It was not the work he was working on.

History of art: a work that has no center of interest does the same thing that a symmetrical one does. Demonstration: what previously required two artists, Johns does alone and at the same time. ¶ I drove to his studio

downtown. He was sitting looking at an unfinished painting (which is one of the ways he does his work): all the colors in profusion; the words red, yellow, and blue cut out of wood hinged vertically to the edges of two separately stretched canvases, the mirrored imprints of the letters legible on both; one letter not in wood but in neon; the wooden ones with magnets permitting fixing and changing the position of objects—a beer can, a coffee can, paint brushes, a knife, no fork or spoon, a chain, a squeegee and the spool from a supply of solder. The next day uptown he was working on the gray numbers, the Sculpmetal ones (*Overcome this module with visual virtuosity. Or Merce's foot?* (*Another kind of ruler.*) *Foreign colors and images.*). And the same day laboriously on the shoe with the mirror in the toe. We wonder whether, if chinaberry trees meant the same to us as they do to him (Spanish moss too, and the seashore and the flat land near it that makes him think the world is round, Negroes, the chigger-ridden forest and swamps that limit the cemeteries and playgrounds, the churches, the schools, his own house, in fact, all up on stilts against probable inundation, azaleas and oleanders, palm trees and mosquitoes, the advent of an outlandish bird in the oak outside the screened porch, the oak that has the swing with an automobile tire for sitting, the swing that needs repair (the ropes are frayed), the shark's teeth, the burrs in the sand on the way to the beach, the lefthanded and righthanded shells, and grits for breakfast)—well, we just wonder.

He told me that he was having a recurrence of them, that he had had them some years before, dreams in which the things he saw and that happened were indistinguishable from those of the day. I must have changed the subject for he told me nothing more. When I mentioned this to her, she told me what he had said: that going one day into the subway he had noticed a man selling pencils to two women—a man whose legs had been cut off, who

moved about by means of a platform with wheels. That
night Johns was that man, devising a system of ropes
and pulleys by which to pull himself up so that he would
be able to paint on the upper parts of the canvas which
were otherwise out of his reach. He thought too of
changing the position of the canvas, putting it flat on
the floor. But a question arose: How could he move
around without leaving the traces of his wheels in the
paint? The cans of ale, *Flashlight*, the coffee can with
brushes: these objects and the others were not found but
were made. They were seen in some other light than that
of day. We no longer think of his works when we see
around us the similar objects they might be thought to
represent. Evidently these bronzes are here in the guise
of works of art, but as we look at them we go out of our
minds, transformed with respect to being.

All flowers delight him. He finds it more to the point
that a plant after being green should send up a stalk and
at its top burst into color than that he should prefer one
to others of them. The highest priority is given, if he has
one out of the ground, to putting a plant in the earth.
Presented with bulbs from the south, impatient for them
to bloom, he initiated a plan for a sped-up succession of
seasons: putting them to freeze on the terrace and then
in the warmth of an oven. Flowers, however, are not left
to die in a garden. They are cut and as many varieties as
are blooming are placed together in a fierce single ar-
rangement, whether from the garden, the roadside or
the florist's: one of these, two of those, etc. (Do not be
fooled: that he is a gardener does not exclude him from
hunting; he told me of having found the blue Lactarius
in the woods at Edisto.) Besides making paintings that
have structures, he has made others that have none
(*Jubilee* for instance). I mean that were two people to tell
what the division of that rectangle is into parts they
would tell two different things. The words for the colors
and the fact that a word is not appropriately colored

("You are the only painter I know who can't tell one color from another"), these facts exercise our faculties but they do not divide the surface into parts. One sees in other words a map, all the boundaries of which have been obscured (there was in fact no map); or we could say one sees the field below the flag: the flag, formerly above, was taken away. Stupidly we think of Abstract Expressionism. But here we are free of struggle, gesture, and personal image. Looking closely helps, though the paint is applied so sensually that there is the danger of falling in love. We moderate each glance with a virtuous degree of blindness. ¶ We do not know where we stand, nor will we, doubtless, ever. It is as though having come to the conclusion that going to sleep is a thing not to do, he tells us so that we too may stay awake, but before the words have left his lips, he leaves us in order that he himself may sleep. ("We imagine ourselves on a tightrope only to discover that we are safe on the ground. Caution is unnecessary." Nevertheless we tremble more violently than we did when we thought we were in danger.) When he returned to New York from the South, she asked him how it had been. He said: It was warm. There were no mosquitoes. You could even sit out in the yard. (I missed the polka dots in the area above the lower left-hand corner. Strange; because that's what I was thinking about: the paintings *0 through 9* that are covered with polka dots.) Seeing her window over the kitchen sink, he said: That's what I want to have, a window over the kitchen sink so that I can look out to the terrace. She said: What you need is a door, so that you don't have to go to the front of the house and then all the way back on the outside again. But, he said, I don't want to go out, just look out. And then asked (imagining perhaps there was something he could learn from her to do): Do you go out? She admitted she didn't. They laughed. She pointed out the plant on the sill with last year's peppers on it and new blossoms but showing no signs of their

becoming this year's peppers. He said: Maybe they need to be pollinated. And shortly with Kleenex he was botanist, dusting and cross-dusting the flowers.

Take *Skin I, II, III, IV*. What a great difference there is between these and anything his works before or after could have led us to expect! As his generosity continues unabated, we waste the breath we have left muttering of inscrutability. Had he been selfish and single-minded it would have been a simple matter for anyone to say Thank You.

Even though in those Edisto woods you think you didn't get a tick or ticks, you probably did. The best thing to do is back at the house to take off your clothes, shaking them carefully over the bathtub. Then make a conscientious self-examination with a mirror if necessary. It would be silly too to stay out of the woods simply because the ticks are in them. Think of the mushrooms (Caesar's among them!) that would have been missed. Ticks removed, fresh clothes put on, something to drink, something to eat, you revive. There's scrabble and now chess to play and the chance to look at TV. *A Dead Man. Take a skull. Cover it with paint. Rub it against canvas. Skull against canvas.*

PAUL BRACH'S PICTURES*

by Leo Steinberg

THEY ARE VERY near invisibility.

Invisibility is of various kinds, and to list its varieties while the pictures are up helps to focus attention.

Invisibility by disappearance. An object absent, remote, or indistinct leaves a leftover emptiness and a straining to see. This seems relevant to Brach's pictures. Their vacant geometry suggests depleted voids, voided containers. Their huge suspended circles can look like extinguished suns. Solar cult emblems snuffed out. Empty icons.

Then invisibility by extinction of light. This too seems relevant. Not actual darkness—which conveys a specific degree of absence of light—but a consistency or opacity that can be neither brightened nor deepened.

And invisibility due to dimmed vision; whether through blindness or the sightlessness of inattention. Brach makes his pictures easy to resist. They court unseeing indifference or disinterest, as if to remain invisible to the averted mind.

And there is one further mode of invisibility which comprehends the others. I mean the invisibility of an encompassing, undifferentiated homogeneity. Obviously, where all differentiation is lacking, nothing will show. Oneness too is invisible.

Can it be painted, this ineffable metaphysical One? Not by leaving the picture blank, for that simply leaves the canvas an object in a worldful of objects. Paint it then: dispel its physicality to make a symbolic allusion to wholeness; then imply oneness by sacrificial negations

* Reprinted from *Art International*, Vol. 8, No. 3, April, 1964.

Paul Brach: *Whole #1*. 1962. Oil on canvas. 45″ x 40″. Photograph
courtesy of Cordier & Ekstrom, Inc., New York.

—as Brach does, asking, and make me ask, How close to all-one can multiplicity come?

Ask how much is renounced:—Color, incident, movement, composition, focus, style, signature, painterliness —all drained in romantic renunciation, until even the figure-ground differential, the first and last requirement of figuration, is at the vanishing point. And there, at the threshold of visibility, your eye toils to see.

They are difficult paintings. Their color is a gray-blue monochrome—cerulean and white, with a little umber lending imperceptible warmth and weight, and sometimes minute variations from added violet or reduced white. What varies most is the pigment's density and the pressure of buried color below.

The color was not picked for charm but for efficiency. It evolved in trial and error as the best value to make the painted surface ambiguously solid and void. And it works when you play the game (or read the language). Witness the stately conversion dance of his circles: ashen disks in a strafing light, then hollows or portholes in a dark field as you change position; then, under overhead lighting, dense massy globes. And they move forward and inward and remain unlocatable, like a coin and a moon at arm's length seen with one eye. And this is the painter's irony: to reap uncertainty from the centered symmetry of parallels, circles, and squares.

But they need the good will that accepts them on their own terms as totalities. Else they become blue pictures, blue surfaces plainly visible—and you may not even care for that shade. But Brach has felt no inclination so far to change color. His cerulean gives him in the space of a diagram the blueprint of a world-space.

They are beautiful pictures, solitary and serious.

ANDY WARHOL*

by Samuel Adams Green

*Mr. Green considers the sociological impli-
cations of Warhol's work. If Warhol is not a
social critic, his art, while presented in the
artist's own terms, creates a social awareness.*

*Samuel Adams Green was born in Boston
in 1940, was educated at Brown University,
and is director of the Institute of Contempo-
rary Art at the University of Pennsylvania.*

AMONG CONTEMPORARY artists Andy Warhol is unique.
Though he draws upon the same or similar sources, he
considers his subjects already to be statements in them-
selves. His art consists of these images unaltered; they
are merely isolated from their commonplace surround-
ings and presented as focal points for our attention.

Warhol's images, selected as they are from the accumu-
lation of ordinary manufactured commodities, at first
arouse the viewer's most literal curiosity. He may ask,
when confronted with a painting based upon a news-
paper photograph of the aftermath of an automobile
accident, "Are the victims still alive?" A reproduced
Campbell Soup can may elicit as its first response the
question, "Is it Minestrone or Pepper Pot?" Once these
questions have been answered, however, the visual
strength of the subject matter, the patterned design and
vivid colors of the presentation, continue to hold interest.

Marcel Duchamp has said: "If a man takes fifty Camp-

* This article is excerpted from the catalog introduction to the
first Warhol retrospective exhibition at the Institute of Contem-
porary Art in Philadelphia in 1965.

bell Soup cans and puts them on a canvas, it is not the retinal image which concerns us. What interests us is the concept that wants to put fifty Campbell Soup cans on a canvas."

Because they have been selected from vital and arresting commercial images, Warhol's subjects are in a traditional sense visually forceful. Yet it is, in fact, the concept that is of greatest concern to us. For in Warhol's art, the visual is only a single aspect. By implication his art moves beyond what Duchamp calls "the retinal" to encompass idea, emotion, aura, pre-existing significance and conditioned response.

His pictorial language consists of stereotypes. Not until our time has a culture known so many commodities which are absolutely impersonal, machine-made, and untouched by human hands. Warhol's art uses the visual strength and vitality which are the time-tested skills of the world of advertising that cares more for the container than for the thing contained. He selects examples from this commercial affluence which best evince our growing sameness. We are told what to think by mass media; we eat the same manufacturer's foods; our clothes come in standardized sizes. We are told that our opportunities for uniqueness are quickly diminishing, and that we grow increasingly unaware of this process as the condition becomes more advanced.

Warhol accepts rather than questions our popular habits and heroes. By accepting their inevitability they are easier to deal with than if they are opposed. Warhol revels in the intimacy we all share with totally inaccessible movie goddesses. We are involved with personalities we cannot touch. We accept the glorified legend in preference to the actuality of our immediate experiencs, so much so that the legend becomes commonplace and, finally, devoid of the very qualities which first interested us. We respond to the propaganda which commands:

Buy! Love! Find Security! We believe—or at least must learn to deal with—manufactured myths of Hollywood and advertising.

In his paintings Warhol uses these clichés as examples (icons?) of contemporary existence. With wry flattery he presents them as they are, asking as they do: Will you buy the American Way of Eating? and Dying? The American Way of Love and Pleasure? The American Paradise? The American Dream?

Andy Warhol says: "The reason I'm painting this way is because I want to be a machine. Whatever I do, and do machinelike, is because it is what I want to do. I think it would be terrific if everybody was alike." Recent artists as well as composers and choreographers have become concerned in their work with the random elements of chance which best approximate the chaos they feel in the world. They labor to erase deliberate choice and the look of choice from their work. Warhol achieves his effect differently, often with great (seemingly at least) ease, often relying on friends for suggestions of subject matter; his premise is that one person's ideas are as good as another's, that they are all alike.

Warhol will often accompany an image painting with a canvas, blank, extending the idea of making useless replicas of packages into the realm of art. In doing so he plays within the gap between art and life, setting up an often humorous exchange between the two, interchanging their roles as they imitate each other. He asks us to take both our art and our individuality a little less seriously. His personality-purged work makes the Abstract Expressionist's subconscious searching seem indulgent. By using the silk screen to make paintings exactly alike, he challenges the prejudice that a work of art must be unique.

The banality and public nature of the subject matter is aptly accommodated by Warhol's presentation, straight-

Andy Warhol: *Jackie*. 1965. Silkscreen on canvas. 20″ x 16″. Photo-graph courtesy of Leo Castelli Gallery, New York.

forward and deadpan. He tries to see how much of an experience we can take, testing the time before the point of boredom or arbitrary interpretation is reached. The stronger the emotional reaction to the image or the more we are interested in the subject, the more repetitions we are likely to tolerate. The greater our feelings for Jackie Kennedy or Marilyn Monroe, the larger the number of repetitions we find. Repetition has a hypnotic effect, and however familiar the experience, audiences return again and again for the same; like a child fascinated by the same bedtime story, repeated over and over, insisting on the same details.

The silk-screening method Warhol uses to remove himself further from his work. The more recent of Warhol's paintings and sculpture are "mass-produced" by this method. The artist's personality is reflected, but only partially, in his choice of subject matter; the work is done mechanically. He chooses the photograph he wishes to use and orders a screen made of it, sometimes in various sizes. The paint is then forced through the screen onto a prestretched canvas, more often than not by one of his assistants. Occasionally he may add a highlight by hand, but the paintings can seldom be told apart and then only by those slight imperfections which he tries to avoid.

Previous generations of painters wore their battle scars proudly. Warhol tries to keep any sign of a struggle out of his work. He does not want to be associated with any "creative" activity. He believes that anyone can paint his pictures as well as he, a feeling voiced by many viewers of modern art for years. He has done an enlarged version of a five-and-dime store painting-by-numbers, and "elevated" it by hanging it on the walls of a gallery. Abstract Expressionists entered the high realm of the soul in the painting of their personalities; Warhol confronts us instead with machine-made images for our contemplation.

It is ironic that his work raises important theoretical

questions. He does not feel responsible for such infer-
ences. Fact, not theory, is his interest. He is interested in
objects, not ideas.

Warhol's work makes us aware again of objects which
have lost their visual recognition through constant ex-
posure. We take a fresh look at things familiar to us, yet
uprooted from their ordinary contexts, and reflect upon
the meanings of contemporary existence.

HUMANISM AND REALITY—
THEK AND WARHOL*

by Gregory Battcock

THE ARTISTS PRODUCING today's new art cannot be said to constitute a single school, and few things are more misleading than facile and inaccurate categorizations of artists and their work. The common characteristics shared by the very disparate works that can be included under the heading "New Art" are not necessarily to be found in any superficial similarities of content or technique. What *is* important is the attitude of the artists and their relationship first to the Abstract-Expressionist aesthetic and, beyond that, to the whole history of western art since Impressionism, and second, to the complex, profoundly self-deceiving society in which they exist. The art of today is depersonalized, sometimes even apparently automated, but it is not inhuman (inhumanity is reserved for statesmen). Its social commentary is oblique, sardonic, ambiguous, withdrawn from any overt political or social commitment, but nonetheless powerful. The two artists discussed in this article both treat material of elemental rawness with a certain restraint that ends by celebrating the dignity of man.

The apparently "automated" sculpture of Paul Thek is a cool medium in a hot culture. Actually, Thek's work only *looks* automated: although some of its construction is farmed out to technicians, much craftsmanship by the artist is involved. But *look* automated it certainly does, and that is important toward preparing the way for pure

* Parts of this article originally appeared in *Film Culture*, No. 37, Summer, 1965.

(programmed?) art—a development that is obviously essential if art is to cope with, let alone mold, the cybernetic age.

In Thek's recent works, a hygienic-looking glass case, elegantly framed in mirror-finished stainless steel stripping encloses a realistic depiction in wax of a raw, sometimes hairy, hunk of meat. In some of his pieces, strips of surgical tubing emerge from the slab of bloody flesh and stick out through the glass, inside and outside, thus creating their own dialectic. The result is an extraordinary combination of textures in which the media speak for themselves. It could pass (if you will) as a commentary on contemporary Western man—the meat within its chrome and glass environment that just refuses to decay, that will never form part of the organic cycle of decomposition and renewal. Obviously, such works are not without psychological interest, but the suggestions of sado-masochism and necrophilia are more appropriately explored in a journal of psychology.

Thek's work is highly original in its use of space. Sculpture has generally been thought to deal with space in a three-dimensional way, or at least in a way that takes into account the negative, or outside area as well as that occupied by the art object itself. But today, "Obsession with the old patterns of mechanical, one-way expansion from centers to margins is no longer relevant to our electric world."[1] This new sculpture indicates a spatial awareness that takes into consideration direct (or actual) spatial participation on the part of the observer. There is a recognition on the part of the artist that the observer shares the space of the object.

Thek does not ignore three-dimensionality, but his pieces exhibit a peculiar restraint with regard to the outside world. They occupy a certain space and clearly delimit that space so that nothing else can also occupy

[1] Marshall McLuhan, *Understanding Media.* New York, McGraw-Hill Book Company, 1964, p. 19.

Paul Thek: *Hippopotamus*. 1965.
Mixed media. 19¾″ x 11″ x 11¼″.
Photograph courtesy The Pace Gallery, New York.

it. And beyond that, they tentatively and cautiously, even temptingly, reach out into the other space and acknowledge *its* presence. At the same time, through use of a clear or tinted transparent casing and the placing of material inside of that barrier, the observer is drawn, once again tentatively, and with the caution of a *voyeur*, *into* the statue's space. Thus the piece claims its own space and refuses to intrude on, even though it acknowledges, the space of the viewer, or the outside world. The inside, the sculpture's own space, allures the viewer by its seeming inaccessibility and invites active participation from without.

Compared to its steel, glass, and plastic surroundings, the waxen slab of flesh makes a thoughtful contrast. Our society's distorted value structure would probably consider the "flesh" somehow obscene, and the shock effect of the work depends precisely on the prevalence of such a value structure. The naked, hairy slab is never presented to our contemporary culture without its facade; and the facade provided by Thek is quite capable of enforcing, by its demand for a type of voyeurism, the frankness and challenge of these sculptures.

While Thek's works are distantly removed from the familiar images characteristic of all Warhol's inventions, both artists have a similar approach toward a rediscovery of our common environment and identification of its particular reality. Warhol's work, too, emphasizes and pleads for an awareness of man's state and has its own humanism, its own reality.

For example, in the film *Blowjob* as in many of his other films, Warhol presents a slice of life in the most literal sense. In *Blowjob* the process of making the film basically demeans the dignity of the subject-actor, yet leads to a human conclusion through a human situation. The aspects of the film of particular interest are the

subject, the actor and his expression, the time element, the composition, and the artist's definition of reality.

Subject

The presentation of the material in *Blowjob* is, once again, "anthological"—a mirror image, so to speak, presenting demands on our attention that are entirely without regard for that image's relation to the dialectic of the story. One of these demands arises through the use of the actor.

The Actor

The film is about a youth getting a blow job, or in a word, sex. The lengthy (35-minute) act is accentuated by the paucity of expression demonstrated by the beautifully inept actor. Like the protagonist of other Warhol films, he is left to his own devices, and since he is obviously either incapable of or uninterested in coping with the situation, he finds himself in a rather ludicrous situation. He seems to expose himself utterly in this new revelation of the gulf between acting and experience. In effect, this gulf has been closed; the experience cannot be separated from the acting, and the question of determining whether or not he *is* acting or simply experiencing is thrust upon the audience. In this sense the actor becomes an element, or tool, used in a way never before considered for the film medium, and the audience is given an insight into the very nature of the medium. This is an example of Warhol's formidable ability to extend and redefine reality—a preoccupation intrinsic to art.

Expression

The expressions registering emotion and acknowledgment of the act on the part of the actor are limited and repetitive. They are enacted and re-enacted with the regularity of a formula, but they nonetheless suggest at various times, boredom, mild ecstasy, some interest in the act, aloofness, and awareness of the camera.

That this could well be an accurate mirroring of a common reaction to sex is not without interest. One should note that at no time in this film is there any actual allusion to or depiction of sex. Sex is never plainly illustrated. Except for the collar of his leather jacket that occasionally appears on the screen, both the actor and the act are without Identity. It is neither a homosexual nor a heterosexual incident, but rather personal, human, and catholic.

Time

The film illustrates a complete act from beginning to end with a minimum of peripheral activity. The length of the film is probably exaggerated to clarify the artist's dedication to the time element, as time is possibly the most important limitation distinguishing the film medium from the other fine arts. And, if in most films, events are telescoped so that lengthy acts often appear much shorter on the screen, in a Warhol film they often appear longer in their transition from actuality to the reality of the medium.

Composition

In *Blowjob*, as in other Warhol films concentrating on the image of a single face, that face is not centered squarely on the picture and frequently seems to tip off a bit. Often the image may center itself, then gradually move back to the side of the frame, or to the other side. Such limited movement becomes of major importance, for a simple gesture becomes, in the Abstract-Expressionist sense, an event. The very idea of pictorial composition is thus dispensed with.

Reality

In this film elements of reality have been extended or invented by the film-artist. A commonplace situation is presented as art through the film medium for the first time, and in a totally new, complete, and startlingly simple manner. The properties of film have rarely been more thoroughly considered as far as its message is con-

Andy Warhol: Two frames from the film *Blowjob*, 1964.

sidered—the films of Andy Warhol are the best illustration of the concept popularized by Marshall McLuhan that the medium is the message. The deliberate recognition of the message=medium idea may partially explain why it is seemingly unnecessary to see a Warhol film. There is actually little to see that can't be adequately described. In fact, this is a characteristic common to much of the new art. It is the intellectual aspect of this new art that often overshadows the visual. But not to see a Warhol film is, in effect, to deny its time element, and this element is, in itself, too important to be discarded. A real and total involvement in this new film art seems to be effected only by a "sitting through" of the film. (Napping, talking, "turning-on" permitted.)

It is not surprising that Warhol's favorite film is (so it is said) *The Humanoids.* Warhol's own films are so extraordinarily close to reality. Like Paul Thek's sculptures, they maintain great dignity and likable reserve. The basic theme of these artists is humanity. Their work reflects art's concern with humanism (reality) and constitutes a valuable contribution to our culture's coming to terms with reality.

TOWARD A TRANS-LITERAL
AND TRANS-TECHNICAL
DANCE-THEATER

by Kenneth King

Kenneth King recently graduated from Anti-och College, where he studied Philosophy. He has created and performed in a number of dance-theater works at The Bridge and else-where in New York. As he explains in this article, Mr. King is critical of mere specializa-tion in one art; his interest is in a new theater that grows out of such dimensions as dance, dialogue, character, psycho-pantomime, and lighting, and forms a new art medium.

NEW DIRECTIONS in theater are developing from the activi-ties of painters, sculptors, film-makers, actors, dancers, and choreographers.

The interpenetration of techniques and disciplines as well as collaborations among different artists are bring-ing about new synthesized forms. Traditionally each art had its own forms and could evolve only within those boundaries. Painting, for example, meant paint on a canvas. Today a painting can move, and, incidentally, movies often seem to stand still.

The new theater is an arena of transacting techniques assimilated from what we previously called "play," "modern dance," "sculpture," "painting" and "movies."

The concept of Western theater is being blown-out. The notion of theater is an attribute of the literal-mindedness which has prevailed at least as long as the ancient Greek playwrights. Whitehead has said that

Western philosophy is but a footnote to Plato. Western theater is but a footnote to Aeschylus, Euripedes, and Aristophanes.

THE EXPLOSION OF THE CINEMA AND TELEVISION AS WELL AS THE OTHER COMMUNICATIONS NET- WORKS PUTS A NEW PERSPECTIVE ON THEATER.

Around the middle of the nineteenth century the invention of the daguerreotype (and later the camera) had an importance for painters and later for other arts, like the novel. The camera changed the idea of focus and perspective, and helped wire circuits for Impressionism, and Cubism in painting. The motion-picture camera, too, has made a tremendous impact on other arts. The camera can be taken to Reel Scenes to record Real Actors doing Unreal psychological programs with the accessibility and believability that the theater lacks.

MEANWHILE, TWO VANGUARD FILM-MAKERS, JONAS MEKAS AND ANDY WARHOL, QUIETLY TAKE CARE OF BUSINESS.

Jonas Mekas's *The Brig*, the filming of Kenneth Brown's play, won the Grand Prix de St. Mark last year as the best documentary at the Venice Film Festival. The judges didn't know it was a filming of the Living Theater's stage play. Thus, Mekas has achieved the seeming impossibility—Hollywood's Long-Cherished Hope, and the Dream of every method actor and director—to destroy the invisible fourth wall. The film is a Reel Illusion.

The "subjects" of Andy Warhol's films are either extremely simple or complex, depending on the viewer's

Frame of Reference. Real-life events are Reeled off as events (*Haircut, Empire, Kiss, Eat, Sleep, Blowjob*, etc.). But the filmed activities do not "develop"; they are static actions that endure as forms. (Yet, in Warhol's later films such as *Poor Little Rich Girl* the spectator knows that the situations are mock-amateur play-events.)

THE STILL CAMERA AND MOVIES WERE ONLY THE
BEGINNING OF THE BLOW-OUT OF THEATER.

Just as Quantum Mechanics and the Theory of Relativity sought to explain events in terms of both space and time *as* dimension, so the painter blew-out both painting and theater by extending the idea of space from a flat canvas into a performing area where actions, manipulations of objects (including humans) transact sequentially. He blew-out dance too. For example, "painter" Robert Rauschenberg and "sculptor" Robert Morris trans-connect time-space *as* Theater Events in which paint, objects, light, sculptured forms and human beings all become objects or performers. In Morris's *Waterman Switch* the objects and dancers moving in a prepared landscape become a theater-painting. A tape of rolling and sliding stones accompanied make-believe stones (foam rubber) rolling onto the stage, as Lucinda Childs, neutralized by male attire, set up two parallel planks on which nude Morris and Yvonne Rainer transversed in tight embrace. Then a Verdi aria accompanied Miss Childs's moving slowly next to the couple, guardian-like, unraveling a spool of twine. In old terms, Morris's media-effect is more painterly than "theatrical" for there is no apparent meaning or significance except the activity of "painting" the dance over a stage-landscape.

In one section of my *cup/saucer/two dancers/radio*

a taped narration explains in analytical detail the movement of the objects and that they are all of equal importance. Phoebe Neville and I spill colored solutions over ourselves and repeat a series of everyday actions, which are juxtaposed in repetitive sequences. Though each of the six sections are pre-set, the arrangement of the sections and the transitions differ for each performance, and so does the "development" and syntax of the actions. The tape also explains that it is not clear where one section begins or ends.

Happenings and Theater Events blew-out the idea of "structure" and the need for "motivated" actions of "characters." Many happenings had pre-set instructions to indicate a course or program of events, and often "roles" were assigned to the participants. But the actions, which were usually spontaneous, generated relationships *during* the performance. Chance methods and random elements were injected into Theater Events and Happenings to offset any controlled literary development.

The Happening is a direction of theater in which response is immediate, although not necessarily rational or cohesive. To the uniniated the event is often beyond understanding, that is, beyond (or below) their idea of theater. It is a radical departure in the direction of the kind of theater envisioned in Artaud's *Theater and Its Double.* Artaud was wiring circuits for a "post" or "trans" literary theater. The Happening prevents a logical literary explication by improvisation or indeterminate methods which strip the performance of connotation and specific meaning by the use of repetition, juxtaposition of objects and acausal relationships.

The Happening stripped theater of "purpose" and unloaded the need for specific content. Understanding via analysis and one's rational sequential perceptions is limiting. The new theater effects a different response, often so much so that audiences don't and can't *know* what to say about it. Conventional criticism, too, stumbles in its

attempt to analyze these new developments since it has not opened up to them.

THE NEW CHOREOGRAPHERS ARE OPENING AND CROSSING CIRCUITS—NOT BEING HUNG-UP ON WORDS OR MOVEMENT THEY ARE GIVING LANGUAGE AND THEATER A NEW CHARGE.

There are now no rules for a choreographer. He is no longer wholly dependent on dance movement as *the* medium, and now extends his actions into theater.

The new dance-theater in New York has grown out of and around several years of furious experimentation at Judson Memorial Church. One interesting phenomenon of this group was the launching of young choreographers —generally under thirty—who offered original, provocative forms. Movement was used in a relative context of other media. For example, in her *New Untitled Partially Improvised Solo with Bach's Toccata and Fugue in D Minor* Yvonne Rainer walks briskly onto the stage with black paint evenly covering her face, extended roughly on the neck. She holds a plumbing fixture (such as is used to connect pipes) in the hand and does a series of repetitive, simple, stark movements reminiscent of everyday activities, but *abstracted* so as not to be recognized as specific actions. Modern dancers have often used the classics to communicate private emotions, but here the Bach filters out emotion, setting off the dance as Miss Rainer's obliterated face does—leaving the work as neutral, non-emotive, movement-as-movement.

In another work with Robert Morris, *Parts of Some Sextets*, more familiarly the *Sleep Dance*, Miss Rainer used fragmented vocal ejaculations with stacatto movement as a supermodern pas-de-deux.

Another phenomenon is the use of objects and their *role* in dance-theater. Formerly objects were technically

subordinated to the performer as props to set off human-centered action. But objects are now used primarily, as objective media, and have changed the perspective from one of point of view to one which is all-inclusive as a trans-actional process. The new use of functional, non-emotive "cool" movement grows out of the trans-action of objects and replaces the former strenuous anthropomorphic movement of modern dance. Ballerinas wore toe shoes to defy the sense of gravity. Modern dancers took off the shoes and surrendered to the weight of gravity. Emotion and tension were built into the dynamics of modern dance, in part, to reflect man's subjective nature and condition. Because the new generation is stripping movement of its emotional connotations they have been criticized for their concern with dehumanization. The deadpan expression is part of the medium to give the performer an objective presence. In this way objects encounter performers and vice versa, reflecting man-in-Nature.

But the change to objective perspective, which has its counterpart in functional and free movement, also has its literary and graphic extensions. In *Nausea* Sartre used *objects-in-themselves* to comment existentially on the human condition. Robbe-Grillet's novels did away with point of view by the use of objective and material descriptions and cinematic perspective. The painters changed their concern from abstraction to objectivism, e.g., Jasper Johns's flags, numbers; Rauschenberg's clock, wheels, etc., frozen into the surface of a canvas; Warhol's soup cans and grocery-store cartons.

The new functional movement-as-movement strips stress and subjective import from dance and trans-connects performer to and with the environment. I am reminded again of Miss Rainer's neutral plumbing object as a pure object, i.e., its identity has no relevance or significance for the dance except as an object, and also

Judith Dunn's use of a stone in *Assignment* (formerly *Before Any Beginning*). It is the relationship between objects that makes dance objective; i.e., the experience is visual and immediate, rather than subjective and interpretative.

After a performance of my *self-portrait: dedicated to the memory of John Fitzgerald Kennedy* the audience sat quietly after I left the stage at an undecided moment. They remained quiet and didn't applaud. Later, many refused to accept what happened as dance: a simultaneous occurrence of tape with a collage of unset movement. The tape was a collage of everyday sounds intercut with the late President's fragmented voice. The movement-activities were a series of repeated everyday actions involving an attaché case, a watch and a newspaper.

When I was making my dance I realized that any specific movement sequence could be as interesting as any other sequence, and as good since the relationships generated by the ordering of the movement would change the presentation and effect. Instead of deciding myself and imposing a single point of view, I came to see my role as setting up a situation and its variables so that the performance structured itself.

In another of my works, SPECTACULAR, each of the four performers have specific activities designated by instruction cards which are shuffled before each performance. In my new work, BLOW-OUT, each of the three dancers is programmed with various instructions, including dialogue, characterizations, and movement. They order the movement in the process of performance and use rehearsals to work out the different uses of dynamics and tempo as well as other trans-media effects. The movement is functional, and does not indicate character; each dancer has three prepared, psycho-pantomimic characterizations and the dynamics of the movement may be tempered for the quality of the character. They go through physical

changes that have no ordered sequences. The characterizations are rehearsed independently of the movement and dialogue.

When improvisation is used within a field of fragmented (specialized) literal variables, the result is a *trans-literal* and *trans-technical* effect, because the way the variables are assembled changes with each performance, as does the structure between the form and the content. In this way indeterminate points of view or interpretations are viable rather than eliminated. Thus performing is structured like a game with unspecific results. In this way the range is open, public, and plural rather than specific and private.

What the new dance-theater does, then, is *re-program* symbolic actions, objects, and movement. Dance need no longer be a minor art with segregated specialization of mere movement, as theater need no longer rely solely on symbolic and psychological explication. The theater as man's extension of experience is able to go beyond the devices of language and become *trans-literal* by the juxtaposition of literary symbolism with movement, film, paint, light, etc.—all forms are now processed in the medium of dance-theater.

ENDOWMENTS FOR THE
GREAT SOCIETY*

by Martin Ries

*In the concluding article Martin Ries specu-
lates on the possible future of art in America.*

*Mr. Ries was born in Washington, D.C., in
1926 and is assistant director of the Hudson
River Museum in Yonkers, New York. He re-
ceived his education at the American Univer-
sity and at Hunter College where he now
lectures on art history and appreciation. His
paintings have been exhibited widely.*

OUR POPULATION is exploding, cars are multiplying; mass-
cult, midcult, and the avant-garde are all flourishing;
culture is being consumed in greater enriched quantities;
the arts go onward and upward—The Boom is booming.
Is The American Dream of the Great Society, in Paul
Bunyan's Promised Land, with its diamond as Big as
the Ritz, really coming true?

Scientific and technological advances have brought
great prosperity, which in turn brings educational and
cultural achievement. We are experiencing technological
change at the fastest rate man has ever known. The first
circumnavigation of the earth in 1500 took about three
years; in 1957 a rocket circled the earth in one and a
half hours. It took thirty-five years for radio to develop
from discovery to a commercial product. It took twelve
years for television to reach fruition, and five years for
transistors to find their way from laboratory to market.

* This is a revised version of an article that was originally pub-
lished in *Art Voices*, Vol. 4, No. 3, Summer, 1965.

And if we're not civilized, we're at least cultivated. From 1953 to 1960, spending on the arts rose 130 percent; in the latter year Americans spent more than twice as much on the arts as on recreation, and six times as much as on sports. The year 1964's $3 billion culture market is expected to more than double by 1970.[1] "Conspicuous esthetics" is the *in* status symbol.

Just as the technological marvels of the past twenty years required vast subsidies and endowments, so the arts, too, need capital. There is nothing new or reprehensible about the idea. From the Pharaohs of Egypt, the Hellenic priests and tyrants of Athens, to the Medicis of Florence, the Popes of Rome, the Bourbon kings and Napoleon, support and endowment have made great art.

Art and culture already receive considerable financial support from American business, and the government is showing more and more interest in fostering culture and education. The problem today is the quality of the works and institutions that benefit from these subsidies. In 1963, United States business supported United States culture to the tune of $25 million, and the sum is yearly increasing. In Hartford, Connecticut, twenty-nine businesses took out memberships for their employees in the Wadsworth Atheneum. IBM has been an art patron; GM recently sent its employees 100,000 copies of several art books; the Basic-Witz Furniture Company commissioned a concerto in honor of its seventy-fifth anniversary.

Ars ad infinitum.

Patrons have rarely been altruistic, and art has frequently been made to serve as the handmaiden of political and military conquest. The Medicis of today are no different from their predecessors in this respect. Many corporation collections are bought for "the spin-off benefits of investment, prestige-building and public relations." The Lytton Financial Corporation, which

[1] "The Arts Become Good Business Too," *Business Week*, January 19, 1963, p. 68.

purchased $400,000 worth of art for display in its California offices, stated: "A thing of beauty is a profit forever . . . it tends to increase in resale value, bring staff and customer satisfaction and greater community acceptance."

The presence of museums and cultural centers benefit local businesses and industries in a variety of ways. The Corning Glass Center in New York is estimated to have increased the gross income of Corning by $7 million per year. Certainly museums in New York State contribute to the tourist business, New York's third most important industry. A recent government survey shows that an average of only twenty-eight tourists per day visiting a town for its cultural attraction will bring in as much money during the year as a new business with a $100,000 annual payroll.[2]

All over the country, communities are hastening to develop cultural attractions, from New York City's $160 million Lincoln Center to Rocky Mount, North Carolina's cultural center made from a converted railroad water tank and pumping station. In 1932 there were eleven museums for every million population for the United States and Canada. Today there are more than twenty-one museums for every million of population in a total of 194 million.[3]

Present trends are expected to continue into the future. The Twentieth Century Fund postulates an anual national income of nearly one trillion dollars by 1975, with an average family income approaching $10,000 and the work week falling well below forty hours. Meanwhile, automation is pushing men into enforced leisure as it mechanizes the service and administrative branches of

[2] U.S. Department of Commerce, Office of Area Development, *Your Community Can Profit from the Tourist Business* (U.S. Government Printing Office, 1957), p. 1.

[3] Frank Stanton, "The Irretrievable Opportunity of Serving the Young," *The Museologist*, June, 1964, p. 5.

labor. If computers eventually provide enough wealth to supply all mankind with the necessities, we will have a problem of luxury and leisure—at best. Unless we find the right solutions to the right problems, our civilization can turn into one of the most backward eras of all time— with a cultural center on every corner and *Kitsch* in every home. We already spend $300 million on chewing gum and $3 billion on pets; Robert Moses's Fair is our Parthenon and Disneyland our Versailles. Will Keane fill our future museums? Will our cultural centers be filled with dropouts playing tiddledywinks and under-achievers painting pictures by the numbers?

Are we in for "Tasteful" involvement with art as re-creation and a rash of hobby-happy exhibitions? Will a Cultural Consumers' Index guide the development of the new placebo art? In this Age of Scientific and Technological Revolution, with its unprecedented mechanical marvels, its wealth of labor-saving devices, and its plethora of technical aids, will our fat-dripping prosperity drop into an intellectual midden of esthetic rubbish?

Mechanical brains confront us with the prospect of machines capable of surpassing man's calculating efficiency. But it is a purely mechanical efficiency confined to quantity. As the old saw has it: one machine can do the work of ten ordinary men, but no machine can do the work of one extraordinary man. Creativity and art are inaccessible to machines. Art cannot be manufactured, it has to be invented. It doesn't pay; it costs.

Art goes to the deepest roots of our existence, and through it man gives form to his conception of existence. With or without endowments and subsidies, man will continue to be creative. But high art and great culture are achieved by surges of creative power, sustained by economic appreciation. Great art requires a great audience.